3 1000 00247197 0

W9-BUI-673

MAR - - 2008

Canadian Paintings, Prints and Drawings

Canadian Paintings, Prints and Drawings

ANNE NEWLANDS

FIREFLY BOOKS

BELLEVILLE PUBLIC LIBRARY

A FIREFLY BOOK

Published by Firefly Books Ltd. 2007

Copyright © 2007 Anne Newlands

All rights reserved. No part of this publication may be reproduced, stored in a retrieval system, or transmitted in any form or by any means, electronic, mechanical, photocopying, recording or otherwise, without the prior written permission of the Publisher.

First printing

Publisher Cataloging-in-Publication Data (U.S.)
Newlands, Anne.
Canadian paintings, prints and drawings / Anne Newlands.
[] p. : col. ill. ; cm.
Includes bibliographical references and index.
Summary: A survey and reference on the paintings, prints and drawings of over 160 Canadian artists from the 18th century to the present. Captions provide a short biography along with commentary on each work's style and subject matter.

ISBN-13: 978-1-55407-290-3
ISBN-10: 1-55407-290-5

1. Art, Canadian – 18th century. 2. Art, Canadian — 19th century . 3. Art, Canadian — 20th century. I. Title.
760.0971 dc22 N6544.N495 2007

Library and Archives Canada Cataloguing in Publication
Newlands, Anne, 1952-
Canadian paintings, prints and drawings / Anne Newlands.
Includes bibliographical references and index.

ISBN-13: 978-1-55407-290-3
ISBN-10: 1-55407-290-5

1. Painting, Canadian. 2. Prints, Canadian. 3. Drawing, Canadian.
4. Artists—Canada. I. Title.

ND240.N48 2007 769.971 C2007-901305-8

Published in the United States by
Firefly Books (U.S.) Inc.
P.O. Box 1338, Ellicott Station
Buffalo, New York 14205

Published in Canada by
Firefly Books Ltd.
66 Leek Crescent
Richmond Hill, Ontario L4B 1H1

Front cover: Emily Coonan, *Girl in Dotted Dress*, c. 1923; oil on canvas; 76.0 cm x 66.4 cm; Art Gallery of Hamilton; Gift of the Spectator, 1968
Back cover: Christiane Pflug, *Kitchen Door with Ursula*, 1966; oil on canvas; 164.8 cm x 193.2 cm; Collection of the Winnipeg Art Gallery; Purchased with the assistance of the Women's Committee and the Winnipeg Foundation; Photo by Ernest Mayer/The Winnipeg Art Gallery

Cover and interior design by Sari Naworynski
Printed in Canada

The publisher gratefully acknowledges the financial support for our publishing program by the Government of Canada through the Book Publishing Industry Development Program.

FSC
Mixed Sources
Product group from well-managed forests and other controlled sources
Cert no. SW-COC-1271
www.fsc.org
© 1996 Forest Stewardship Council

For my family.

TABLE OF CONTENTS

INTRODUCTION

*"Artistic expression is a spirit, not a method,
a pursuit, not a settled goal, an instinct,
not a body of rules."*

FOREWORD, GROUP OF 7 EXHIBITION OF PAINTINGS,
EXHIBITION CATALOGUE,
ART GALLERY OF TORONTO, 1922

This book introduces 164 of Canada's best known artists from across the country whose paintings, prints and drawings span a period from the 17th century to the very beginnings of the 21st. It offers an odyssey through the rich diversity of expression by male and female artists, First Nations and Inuit artists, and those of European descent. Over the huge range of time, place and identity, the challenge for all remained the same: a confrontation with a flat two-dimensional surface, a blank slate—be it rock, hide, paper or canvas—that awaited the hand, the gesture, the mark of the image-maker. And while exclusions are infinite, it is important to mention that in the immense arena of Canadian art, the selections for this book inevitably rule out sculpture, installation art, photography, video, textile arts, glass, ceramics and all art in three dimensions.

In selecting only 164 artists from among the tens of thousands who have been documented, I was interested in the regional and ethnic diversity across the country, from the past and the present. I have also sought to present the vast artistic imagination brought to the timeless themes of the figure, portraits, landscapes, beliefs, abstraction, fears and dreams. Preference has also been given to works in public collections in the hope that readers may someday have the opportunity to encounter the original works.

The difficult challenge of selecting artists was compounded by the equally formidable task of choosing a single image to represent an artist's prolific career. Although the work featured is often typical of an artist's production, it is important to see it not as a summing up but, rather, as a glimpse into a lifetime of creative expression.

The artists are arranged alphabetically, which removes them from predictable associations and chronological relationships and frees them from the standard linear narratives of traditional art histories. On these pages, art and artists forge new connections that raise fresh questions and invite renewed consideration of their distinct individuality. In the accompanying texts, I have concentrated on the visual quality of the work and on the artist's use of the language of art—colour, line, shape and texture—as powerfully expressive tools. Looking at art is an active and creative process that demands opening oneself to new worlds and new ways of seeing. Looking at art takes time and promises the patient viewer an odyssey of insights and adventures.

Finally, in the paragraphs that follow, as a complement to the alphabetical layout, I have situated the artists and their work in their historical contexts, sweeping over time and geography with very broad brushstokes.

Detail I

Detail II

The story of painting in Canada could perhaps be thought of as a spiral, opening, enlarging and unfolding in time as other artists and new imported traditions appeared on the scene. The heart of the spiral begins with the painting traditions of Canada's First Peoples and works known as pictographs. These ancient paintings on stone are found across the country—on the Canadian Shield, from Quebec to Northern Saskatchewan, in the foothills near Calgary, and on cliffs in the interior of British Columbia. These paintings were linked with the activities of shamans painting their helping spirits or creatures from vision quests. Although these works are difficult to date, it is believed that the one reproduced here by an unknown Anishnaabe (Ojibwa) shaman (detail I; full work on p. 22), was painted in the 18th or 19th century. Using a flat rock face, and painting with red ochre mixed with grease, the artist used his fingers to give visual form to the unseen but powerful presence of Mishipeshu, the sacred underwater god. Here, the expression of spiritual beliefs is integrated with the land, also regarded as a spiritual entity.

In the 17th century, visiting French artists introduced European artistic traditions to New France. At this time, the Roman Catholic Church was the primary patron of the arts, seeking paintings and sculptures to decorate newly built chapels. This art, however, went beyond mere ornamentation. Its function was also to teach, to remind new settlers of their faith, and to convert the Huron and Abenaki peoples living in the region. In Claude François'

Detail I: Anishnaabe Artist, *Mishipeshu*, date unknown; Agawa Rock, Lake Superior Provincial Park
Detail II: Claude François (Frère Luc), *La France apportant la foi aux Hurons de la Nouvelle France*,
c. 1670-1671; Musée des Ursulines de Québec, collection du Monastère des Ursulines

painting *France Bringing Faith to the Hurons of New France* (detail II; full work on p. 110), Christianity is imported to the shores of the St. Lawrence River. An Aboriginal man cloaked in a cape embroidered with the *fleur-de-lys* kneels before the personification of the French monarchy, who presents a painting of an enthroned Christ. Using oil paints, canvas and the tools of perspective, the artist created an illusion of a three-dimensional space, offering us a window into an imaginary world—a world that we can envision entering. Despite the differences of materials and subject matter, both the Aboriginal artist and the French painter were giving form to the unseen, and addressing the subject of belief in their own traditions, materials and visual languages.

Works from the late 18th century to about 1850 are extremely varied and set the stage for the ever-increasing diversity of subject matter and style that will characterize Canadian art in the years to come. The subject of portraiture was introduced, in what is now Quebec, in the 17th century, by male and female members of French religious communities. By the 18th century, native-born artists such as François Beaucourt sought commissions from the rising merchant classes eager to immortalize their likenesses and confirm their status in society. While the Aboriginal population was sometimes painted by artists such as Antoine Plamondon and Joseph Légaré, it is important to note that Huron artist Zacharie Vincent (detail III; full work on p. 330), who was inspired by Plamondon, took up the brush as well. Exploring European traditions and materials, Vincent's portrait of himself and his son, wearing both wampum and trade silver, reveals a period of change and assimilation. Although Quebec had the largest number of artists at this time, the burgeoning Maritimes attracted itinerant artists such as Robert Field; and, in what was to become Ontario, artists such as George Berthon (detail IV; full work on p. 46) pictured the ruling classes in all their finery.

Landscape is also a subject that began to flourish during this period. Many British gentleman soldiers, trained at the Woolwich Academy in England, used watercolour, which was light, easy to transport and fast-drying, to create small, meticulous paintings designed to document the terrain, forts and aspects of garrison life during their Canadian sojourns. In their leisure time, artists such as Thomas Davies and George Heriot brought a picturesque sensibility to their delicate and detailed landscapes, while naval officers such as George Back (detail V; full work on p. 30) recorded the perilous sides of northern exploration.

Detail III

Detail IV

Detail V

Detail III: Zacharie Vincent, *Zacharie Vincent and His Son Cyprien,* c. 1851; Musée national des beaux-arts du Québec • Detail IV: George Théodore Berthon, *The Three Robinson Sisters,* 1846; Art Gallery of Ontario; on loan from the Estate of Mr. and Mrs J. B. Robinson, 1944 • Detail V: George Back, *Broaching to, — Canoe crossing Melville Sound*, August 1821; Library and Archives of Canada

In the west, Peter Rindisbacher captured the multi-ethnic dynamics of the Red River Colony, while Paul Kane, travelling across the Prairies and to the Pacific coast, made portraits of Plains and Coast Aboriginal peoples and secured images of their habitats and customs.

From about 1850 to 1900, one of the dominant trends for Canadian artists working in the European tradition was the influence of an academic training acquired abroad, especially in Paris. Focusing on a faithful study of human anatomy and the creation of three-dimensional volume through contrasts of light and dark, artists such as Robert Harris and George Reid integrated their new skills with an admiration for European Old Master paintings to create new and powerful Canadian narratives. Many works by their contemporaries also show Canadians at their leisure and portray music and sound—from the humble harmonica playing of Ozias Leduc's *Boy with Bread*, to the soft tones of the piano in the Kerr-Lawson, and the riotous merrymaking of the Krieghoff canvas. This attention to the figure is similarly reflected in the work of women artists, such as Frances Anne Hopkins (detail VI; full work on p. 136), who depicted her travels with her husband, a Hudson's Bay Company official, and Charlotte Schreiber, who painted highly realist works inspired by literature.

Detail VI

Detail VII

Native artists also painted stories, using stretched hides and pigments and tools from the land, for both ritualistic and narrative purposes. In the example of Plains artist Running Rabbit, the pictographic traditions of Plains Indians are used to recount war exploits and brave deeds. In contrast, the Haida artist (detail VII; full work on p. 122) uses the distinct formlines associated with early Haida art, and bold red and black colours to depict a shaman and his helping spirit.

The natural beauty of the Canadian landscape—now more accessible with the advent of railways—continued to attract artists who often brought their late-Victorian views to soften the realities of Canadian topography. Lucius O'Brien (detail VIII; full work on p. 232) presented a sublime rendering of a sunrise on the Saguenay River, while Homer Watson and Horatio Walker created dramatic cultivated landscapes that glorified the hardships of rural life.

Detail VIII

By the turn of the 20th century and into the 1930s, many of the innovations in Canadian painting were seen in the realm of landscape painting. Central to this development were artists such as James Wilson Morrice and Maurice Cullen whose explorations of Post-Impressionism—simplifying form

Detail VI: Frances Anne Hopkins, *Canoes Manned by Voyageurs Passing a Waterfall*, 1869; Library and Archives of Canada • Detail VII: Haida Artist, *Drum*, before 1900; Courtesy of the Royal British Columbia Museum, Victoria, B.C. • Detail VIII: Lucius O'Brien, *Sunrise on the Saguenay, Cape Trinity*, 1880; National Gallery of Canada

and analyzing light effects—paved the way for future artists seeking a modern interpretation of Canadian terrain.

Prior to the First World War, a group of Toronto painters, many of whom worked as graphic artists, took sketching excursions outside the city on weekends. The group, which included Tom Thomson, painted in Algonquin Park, and used bold colours and swift brushwork to capture the rugged beauty and spirit of this distinctly Canadian region. Following the war, Lawren Harris (detail IX; full work on p. 124) organized sketching trips to the Algoma region of Ontario and, in 1920, he, J.E.H. MacDonald, A.Y. Jackson, Arthur Lismer, Fred Varley, Franklin Carmichael and Frank Johnston held their first exhibition as the Group of Seven at the Art Gallery of Toronto. Although the Group continued to exhibit together until 1932, throughout the 1920s and 1930s they explored the country as individuals, discovering places that resonated with them personally: Harris and Varley went to the west coast; Lismer to Georgian Bay; and Jackson, who perhaps travelled more widely than the others, returned briefly to his native Quebec. But the Group of Seven did not hold a monopoly on Canadian painting of this period. Clarence Gagnon created nostalgic views of the Charlevoix region, and David Milne in Ontario sought essences of nature in dynamic arrangements of colour and line.

Detail IX

At the same time, a number of Montreal artists, such as Emily Coonan (detail X; full work on p. 84), Prudence Heward and Lilias Torrance Newton explored a modernist approach to the figure, distilling details and focusing on expression, some of which alluded to the difficulties of the inter-war years. In contrast, Toronto artists such as Kathleen Munn and Bertram Brooker (detail XI; full work on p. 62) investigated Cubism and abstraction as a means to express spirituality and inner worlds.

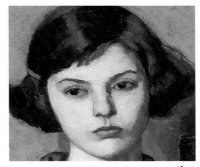

Detail X

The impact of the stock-market crash of 1929 and the economic and social deprivations of the Great Depression that pervaded the next decade were mirrored in artists' works. Louis Muhlstock's drawing of an unemployed man, haggard and huddled in his own misery was echoed in Prudence Heward's painting of sisters, whose young faces bear the weight of uncertain times. Artists such as Yvonne McKague Housser, Carl Schaefer, and Illingworth Kerr produced expressive landscapes that embodied the shared austerity of this period, while others such as Marc-Aurèle Fortin and Emily Carr found escape and solace in nature's beauty and abundance.

Detail XI

Detail IX: Lawren S. Harris, *Lake and Mountains*, 1928; oil on canvas; 130.8 cm x 160.7 cm; Art Gallery of Ontario • Detail X: Emily Coonan, *Girl in Dotted Dress*, c. 1923; Art Gallery of Hamilton • Detail XI: Bertram Brooker, *Untitled (Sounds Assembling)*, 1928; Collection of the Winnipeg Art Gallery

Detail XII

Detail XIII

The hardships of the 1930s were followed by the violence and devastations of the Second World War. A work by Charles Comfort captures the essence of ravaged lands in swiftly rendered watercolour. On the home front, some artists reflected the chaos of war in portraits of the 1940s that show the tensions of adversity, while others, such as Alfred Pellan, Marcelle Ferron (detail XII; full work on p. 102) and Paul-Émile Borduas in Montreal, were attracted to Surrealism, which encouraged artists to create work inspired by dreams and the subconscious. Looking to inner realities rather than the anarchy and turmoil of the external world, they created new abstract worlds, applying paint thickly and spontaneously, free of preconceived ideas. In 1948, Borduas and his followers advocated an open, emotional approach to art, and issued the manifesto *Refus global (Total Refusal)*, a cry against social and political oppression and a plea for a new order in art and society. By the 1950s, many artists across the country embraced abstraction and developed highly diverse and personal visual languages. In 1953, Toronto artists such as Alexandra Luke, Jack Bush and Harold Town exhibited with others as Painters Eleven, and in 1959, Ronald Bloore and Roy Kiyooka were among The Regina Five.

At the same time, other artists continued to paint in a realist mode. Works by L.L. FitzGerald and Alex Colville (detail XIII; full work on p. 80) reflect the eternal fascination with the complextity and order of the natural world.

The spirit of rebellion, experimentation and political and social radicalism that characterized the 1960s was abundantly reflected in the extremely diverse nature of Canadian painting in the decades that followed. Across the country, artists were pushing the boundaries of established forms of expression. Abstract paintings often tended to be large in scale, engulfing viewers in a wide variety of styles. In Montreal, the vibrant colours and hard edges of the work of Guido Molinari (detail XIV; full work on p. 216) and Claude Tousignant contrasted with the gestural canvases of Jean McEwen and Charles Gagnon. In Toronto, Michael Snow began his iconic Walking Woman series, Joyce Wieland explored feminist themes, while Gershon Iskowitz invented a highly personal, abstract response to the land.

In the Arctic, the establishment of government-sponsored print workshops encouraged many Inuit, especially women, to explore drawing and printmaking as a way to subsidize their living. From the drawings of birds by Kenojuak Ashevak, the stories of life on the land by Pitseolak Ashoona, the

Detail XII: Marcelle Ferron, *The Dorset Signal*, 1959; The Montreal Museum of Fine Arts; © Estate of Marcelle Ferron/SODRAC (2007) • Detail XIII: Alex Colville, *Horse and Train*, 1954; Art Gallery of Hamilton

scenes of everyday life by Helen Kalvak and the heraldic images of woman by Jessie Oonark (detail XV; full work on p. 236), Inuit art communicated the traditions and changing realities of Arctic life.

The civil rights and women's liberation movements were reflected in increasing activism by Aboriginal peoples that also found its reflection in art. The Indians of Canada pavilion at Expo '67 propelled the richness and diversity of native art into the mainstream. The success of artists such as Alex Janvier in the northwest, Gerald Tailfeathers on the prairies, and Norval Morrisseau (detail XVI; full work on p. 220) and Daphne Odjig in Ontario paved the way for a new generation of Aboriginal artists seeking to express the complexity of native identity.

At the same time, artists everywhere continued to invent new responses to the land—from images of its transformation by modern highways as illustrated in the work of Jack Chambers, to the enduring appeal of uninhabited terrain pictured by prairie artists such as Dorothy Knowles, Ivan Eyre and Takao Tanabe, and Ontario artist Paterson Ewen. The classical theme of the cycle of life was explored in works by Jack Shadbolt in British Columbia and Mary Pratt in Newfoundland, while artists such as William Kurelek, Maude Lewis and Christiane Pflug examined the personal mythologies of everyday life.

The selection of works from 1980 and into the early years of the 21st century is the largest in the book, and reflects the ever-increasing number of artists with an expanding repertoire of subjects—an ever-widening spiral as artists re-evaluate and what has gone before and invent new images rooted in the issues of their times. Themes of the figure and the land continue to dominate, but are frequently presented on a very large scale and often emanate an air of urgency. While the increasingly established cohorts of Aboriginal artists look to the ancient symbols of their indigenous heritages, the concerns and subjects of their paintings, prints and drawings are often shared by non-native artists as well.

The approach to the figure in this period is much more varied than in previous decades—we find both small- and very large-scale multi-figured narratives for example, in the works of Allen Sapp and Attila Richard Lukacs, radical close-ups in the work of Tony Scherman, and fragments of the body in the work of Joane Cardinal-Schubert. Many works also overtly integrate images

Detail XIV

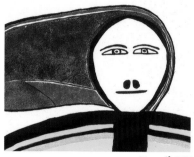

Detail XV

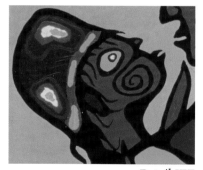

Detail XVI

Detail XIV: Guido Molinari, *Rhythmic Mutation No. 9*, 1965; National Gallery of Canada; © Estate of Guido Molinari/SODRAC (2007) • Detail XV: Jessie Oonark, *Woman*, 1970; National Gallery of Canada; Courtesy Public Trustee for the Northwest Territories; The Estate of Jessie Oonark • Detail XVI: Norval Morrisseau, *Artist's Wife and Daughter*, 1975; McMichael Canadian Art Collection

associated with the past—Robert Houle includes an interpretation of Benjamin West's *Death of General Wolfe*, and Gerald McMaster embraces native pictographs. As Joane Cardinal-Schubert notes, the use of "Indian history as subject matter" is no different from any contemporary artist using personally meaningful subject matter as a departure point for a work of art. Indeed, Fred Ross's adaptation of the structure of Renaissance painting to tell a story from Canadian history affirms the prevalence of this approach.

Beyond the dreams of the Group of Seven, contemporary artists conjure visions of the land endowed with timely, pertinent messages. Eleanor Bond's (detail XVII; full work on p. 52) fictional view of an urban environment invites debate about our future as citizens of the world, while Wanda Koop's desolate waterscape and John Scott's charred mountain landscape underline humanity's vulnerability in the face of nuclear disaster. From Lawrence Paul Yuxweluptun's surreal vision of clear-cut logging to Anne Meredith Barry's plea for the whales and oceans of Newfoundland, artists across the country remind us of the fragility of nature.

Detail XVII

Detail XVIII

Detail XIX

Many late-20th-century artists' paintings, prints and drawings reflect the impact of other forms of visual communication such as photography, film and mass-media advertising. Carl Beam, for example, mixes silkscreen, photography and expressionistic painting in a large work that reflects on the negative assimilation of Aboriginal peoples, while Joanne Tod (detail XVIII; full work on p. 320) borrows the big scale and realism of advertising to comment on high and low culture and power relationships in society. Social issues and critical voices are similarly the purview of conceptual artists: General Idea confronts the AIDS epidemic, and Garry Neill Kennedy subversively looks to the names of house paints to create a new kind of history painting.

In the north, a new generation of Inuit artists such as Andrew Qappik and Shuvinai Ashoona, who grew up in settled communities with access to modern telecommunications, explore their new realities with three-dimensional form and a perspectival space that departs from the artistic expression of many of their ancestors.

Finally, the theme of beliefs introduced by the shaman artist's rock painting and the 17th century French artist promoting Christian faith continues to be echoed in late-20th-century art. Working with acrylic paint on canvas, Métis artist Rick Rivet (detail XIX; full work on p. 270) integrates a Dorset

Detail XVII: Eleanor Bond, *Rock Climbers Meet with Naturalists on the Residential Parkade*, 1989; MacKenzie Art Gallery, Regina • Detail XVIII: Joanne Tod, *The Time of Our Lives/Having Fun?*, 1984; National Gallery of Canada; © Joanne Tod • Detail XIX: Rick Rivet, *Whaler Mask*, 1999; Indian Art Centre, Department of Indian Affairs and Northern Development, Canada

mask into a field of abstract colours. Seeking "a visual language which uses the visible universe as a metaphor for the invisible," Rivet proposes a dialogue between indigenous and long-ago imported traditions.

As we move into the 21st century, it is certain that Canadian artists will continue to impress and surprise us with their insights and talent. And although it is unwise to predict the future, it is probable that an increasingly ethnically diverse population of artists will expand the field of painting, prints and drawings—not only in terms of technique, but also in terms of subject matter, building on well established themes, and bringing new ones—born from their personal experiences—to the fore. Certainly nature and the environment, Aboriginal and ethnic identity, the tragedy of human suffering, the threats of global insecurity, and the escalating pace of contemporary life will continue to find their reflections in art. At the same time, images of the enduring beauty of the land and the infinite expression of the human face and body will surely persist as artists across the country expand and question our views of ourselves and our places in society. International trends have always been present in Canadian art. Since the first French artists crossed the Atlantic Ocean in the 17th century, Canadian artists have participated in a vast global trade of styles and ideas that will continue to nourish artistic expression. Technology has always influenced the look of art—from the development of new paints, inks, and drawing instruments, to the invention of photography, video and other forms of mass-media communication. These too will manifest changes in ways that are equally difficult to forecast. So, while predictions may be suspect, we know that Canadian artists will continue to inspire us, and through their works, encourage us to discover new places and experiences that, without them, we could not even imagine.

Anne Newlands
Ottawa, 2007

Luke Anguhadluq (1895–1982)

Drum Dance

date unknown; coloured pencil and graphite on wove paper; 79.9 cm x 58.3 cm;
Art Gallery of Ontario; Gift of Samuel and Esther Sarick, 2002;
Photo by Carlo Catenazzi/AGO

*I*n Inuit life, communal dances and songs as well as celebrative and religious ceremonies are performed to the hypnotic beat of the skin drum. For Luke Anguhadluq, a powerful camp leader and a hunter of considerable prowess, the depiction of the drum dance, along with his many images of the hunt and fishing, reflected the dominant memories of his life on the land in the Back River area of the Keewatin region of Nunavut.

Often sitting on the floor to draw and rotating the paper as he defined each of the figures assembled for the event, Anguhadluq captured the circular movement of the drummer, whose instrument becomes the giant yellow centre from which the men facing us and the women in profile radiate like beams from the sun. Anguhadluq's characteristically bold drawing style and distinctive use of colour embody the essence of community, central to Inuit life.

Anguhadluq moved into Baker Lake at the age of 73 and began to make art as a source of income. Encouraged by artists Jack and Sheila Butler, who had been hired by the federal government in 1969 to establish a print shop at Baker Lake, Anguhadluq went on to become a most prolific draughtsman. He supplied drawings for over 70 prints published in the Baker Lake print collections from 1970 until his death in 1982.

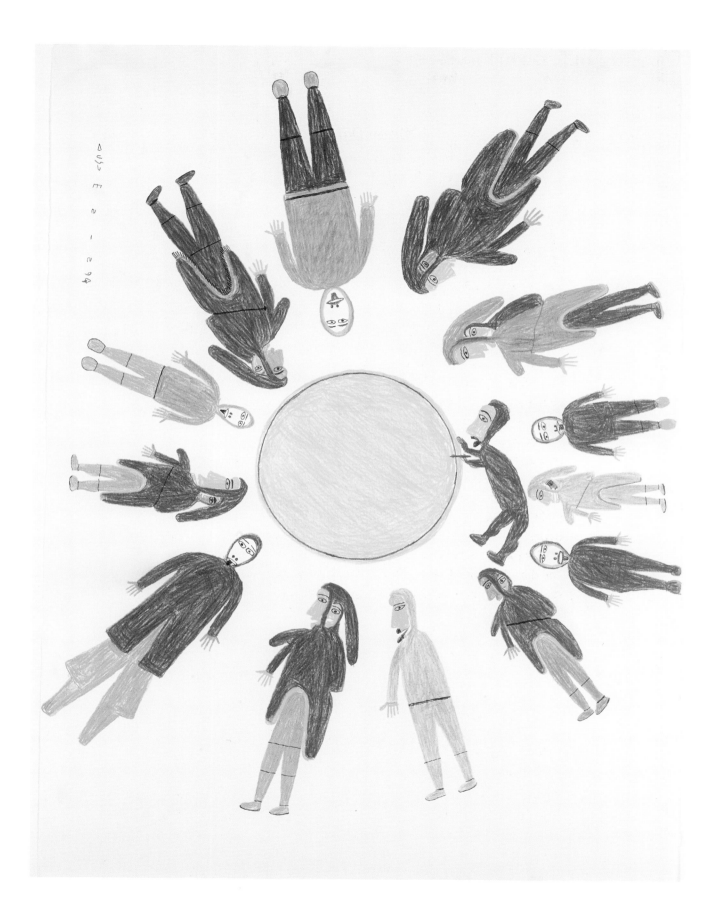

Anishnaabe Artist

Mishipeshu

date unknown; red ochre on stone; Agawa Rock, Lake Superior Provincial Park;
Photo by Ian Wainwright, Canadian Conservation Institute, Ottawa

For the Anishnaabe, who inhabited the land northeast of Georgian Bay for tens of thousands of years, the Agawa Rock on the shores of Lake Superior was a sacred site that many thought was the home of the Great Lynx, Mishipeshu. Readily identified by his large horns, the clumps of fur protruding from his cheeks and the erect dragonlike scales extending along his spine, Mishipeshu is the chief spirit of the underwater and underground realms, commanding the weather on the lakes by unleashing high winds with a wave of his mighty tail. To his left, the crescent shape is a canoe with passengers respectfully invoking his favour for safe passage. Just below, the long, sinuous lines are water serpents, loyally accompanying the master of their watery domain.

These images are believed to have been painted within the past 500 years by Anishnaabe shaman artists, who applied a red-ochre wash to the rock's surface, thereby establishing the spirituality of the site, and then drew the images with their fingers. Composed of an iron oxide extracted from a nearby mine, the red ochre was associated with life and was therefore used in cures and body paint in the desire for longevity. In painting the image, the shaman paid homage to Mishipeshu, whose help he sought to increase his healing and spiritual powers. Even today, visitors remark upon the spiritual aura of these pictographs.

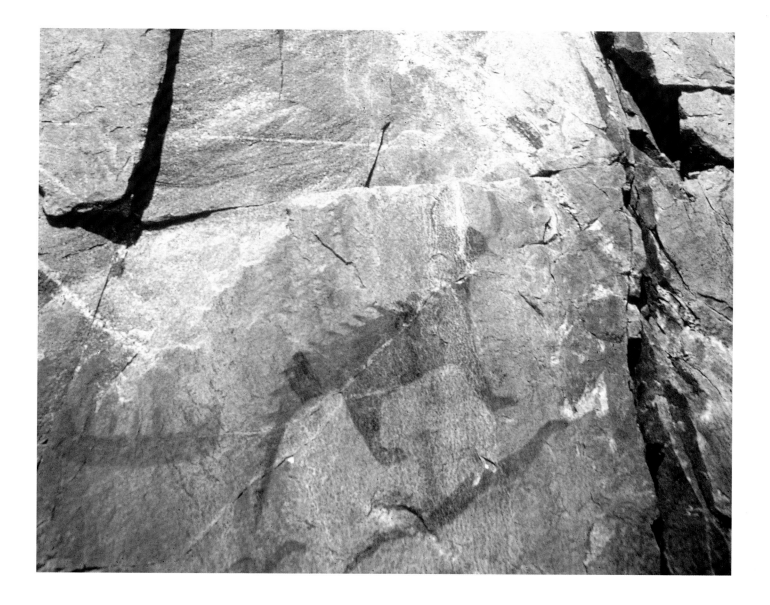

Kenojuak Ashevak (1927–)

The Enchanted Owl

1960; Stonecut, 38.5 x 58.2 cm, Printed by Eegyvudluk Pootoogook (1931–)
Canadian Museum of Civilization, image #S99-10062

Kenojuak Ashevak is one of the most celebrated and prolific Inuit artists. She began to draw in the late 1950s, while she was living on the land along the south shore of Baffin Island. Her sense of graceful form and fluid design was already manifest in the shapes and patterns she used to decorate skin bags and clothing for her family. As the first woman to provide drawings for the Cape Dorset printmaking co-operative established by James Houston in 1959, Kenojuak became one of its most productive artists, supplying thousands of drawings, more than 200 of which have been issued as prints.

The Enchanted Owl, whose head feathers spin out like the rays of the sun and whose tail sweeps up joyously, is one of the most famous images in Inuit art. In 1970, to commemorate the centennial of the Northwest Territories, it was reproduced on the six-cent postage stamp. Although birds are a dominant subject in her art, Kenojuak has said that she draws without preconceived ideas: "I may start off at one end of a form not even knowing what the entirety of the form is going to be; just drawing as I am thinking, thinking as I am drawing...I try to make things which satisfy my eye, which satisfy my sense of form and colour." While birds in their many imaginative permutations frequently emerge when she draws, their simple forms and potential for abstract elaboration are suited to Kenojuak's intent "to make something beautiful, that is all," rather than to tell a story or to depict a particular event.

In 1966, while awaiting the birth of her ninth child, Kenojuak moved into Cape Dorset so that her children could attend school. About that time, her drawings became more complex, and she was also exploring sculptures and painting. In all media, her work shows the interconnectedness of humanity and nature and, in some cases, verges on abstraction as birds and animals become intertwined in intricate patterns. In the late 1980s, Kenojuak also explored landscape subjects. In recognition of her outstanding contributions to Canadian art, Kenojuak was appointed a Companion of the Order of Canada in 1982.

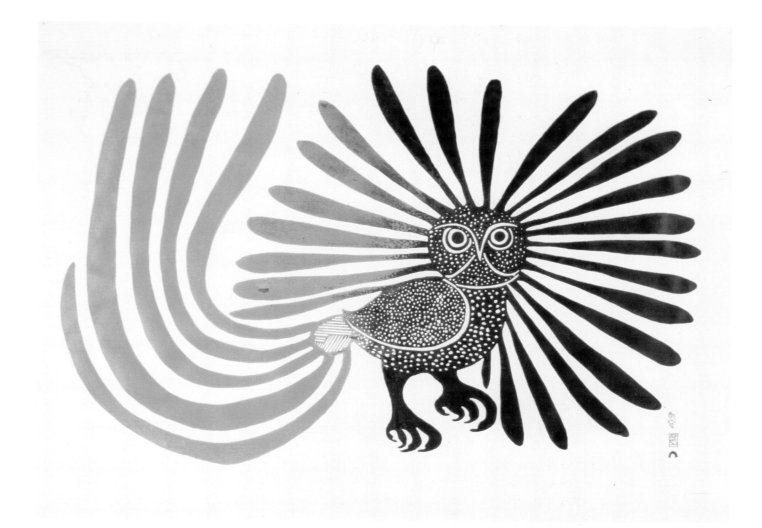

Pitseolak Ashoona (1904–1983)

Summer Camp Scene

c. 1974; felt pen on wove paper (watermark: "RIVES"); 50.8 cm x 65.6 cm;
National Gallery of Canada; Gift of the Department of Indian Affairs and
Northern Development, 1989; Reproduced with the permission of Dorset Fine Arts

Drawing on her memories of growing up on southern Baffin Island, Pitseolak Ashoona renders a rare moment of relaxation from a woman's perspective. The women, with their signature *amauti*, or parkas, smile and chat in the opening of a summer sealskin tent, while children play and men carrying bows and arrows return from the hunt. Even the wildlife seems to be enjoying the day, striking almost comical poses that contribute to the feelings of joy. Pitseolak's skilful use of the felt-tip pen captures the textures of life, with different strokes distinguishing the varied surfaces of rock, tundra and caribou clothing. "The old life was a hard life, but it was good," she once said. "It was a happy life."

Pitseolak was a widow with young children to support when James Houston introduced her to drawing in the early 1960s, after she moved to Cape Dorset. Houston established an artists' workshop that would become one of the most important printmaking centres in the Arctic. Pitseolak supplied thousands of drawings, more than 200 of which were released as prints between 1960 and 1981. A book of her early recollections—"the things we did long ago before there were white men"—entitled *Pictures Out of My Life*, was published in 1971. In 1977, she received the Order of Canada for her singular contributions to Canadian art.

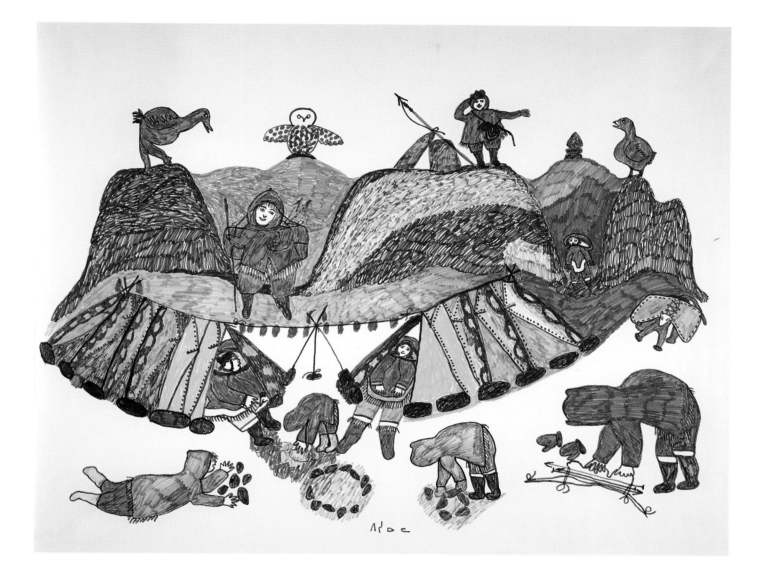

Shuvinai Ashoona (1961–)

New Town

2003-2004; pencil crayon and ink; 50 cm x 65 cm;
Collection of Dorset Fine Arts, Division of West Baffin, Cape Dorset Co-Operative

Along the lower edge of this work, in the tiny, precise letters that characterize her meticulous and detailed drawings, Shuvinai Ashoona identifies "New Town" as the subject of her drawing. In contrast to the scenes of life on the land famously depicted by her grandmother, Pitseolak Ashoona, and her aunt, Napatchie Pootoogook, Shuvinai pictures imaginary townscapes where a few individuals — dressed in southern clothing and Inuit parkas — are subsumed by a futuristic box-town, complete with electrical wires and staircases. Beyond the near-empty foreground where two men stand by a truck, a town constructed like a modern highway, curves and bends creating overpasses, underpasses and tunnels where small, colourful dwellings appear beneath the complicated pathways. While it is possible that images such as this one were inspired by the angular architecture of Cape Dorset, television scenes, or trips to the south, Shuvinai's aunt insists that "she draws from her imagination...She doesn't think the same as we do...That's why what she sees is quite different...There is something special about her."

Born in Cape Dorset, self-taught, and encouraged to draw by her parents and other artist relatives, Shuvinai began selling her drawings to the West-Baffin Eskimo Co-Operative in 1993. While the early drawings were mostly rendered in black felt-tipped pen, in recent years she has embraced coloured pencil, favouring a vivid palette of primary colours that offers a personal view and a unique sense of space.

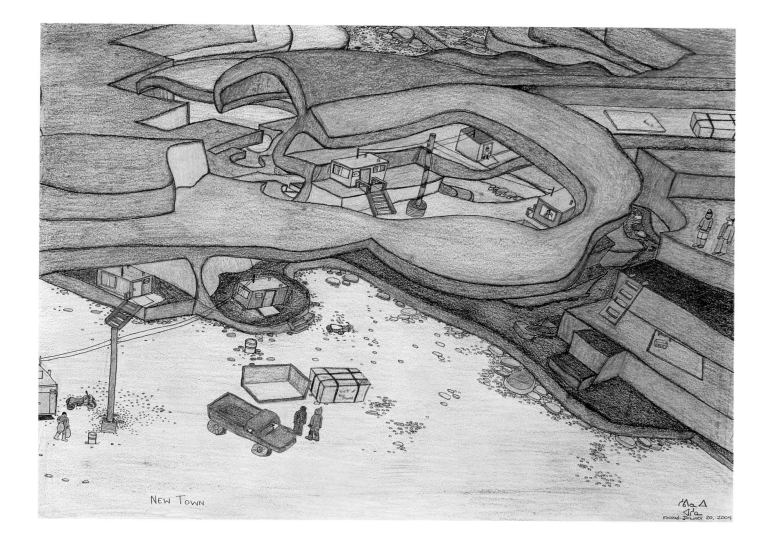

New Town

Finished-January 20, 2004

George Back (1796–1878)

Broaching to, — Canoe crossing Melville Sound

August 1821; watercolour/from Sketchbook II; 11.1 cm x 18.3 cm;
Library and Archives of Canada/C-141501

Despite exhaustion, near starvation and wet, frigid weather, George Back kept a detailed diary and sketchbook of his heroic voyage with Lieutenant John Franklin on his first overland Arctic expedition to the Coppermine River (1819–22). Today, that record sheds fascinating light on the experience. In his diary entry for August 23, 1821, Back relates the hazardous circumstances and the curious beauty to be observed in a crossing of Melville Sound: "When we were about mid-channel, a sudden squall came on—it rained hard—and the rays of the sun...cast a beautiful yellow tinge over the white foam of the dark green sea. We were admiring this spectacle with delight when a huge wave...broached our canoe and we narrowly escaped sinking." In this sketch, executed on terra firma, Back contrasts the shimmering light of the sun against the stormy grey sea and depicts the vulnerability of the canoes about to be engulfed by the raging water.

Unlike other naval officers, who learned their artistry in British military academies, Back is said to have acquired his while he was a French prisoner of war from 1809 to 1814. Although it was his versatility as an artist that secured his position with Franklin in 1819 and again in 1825 to Great Bear Lake and the Arctic coast, it was Back's singular accomplishments as an explorer on these and later expeditions that earned him a knighthood in 1839.

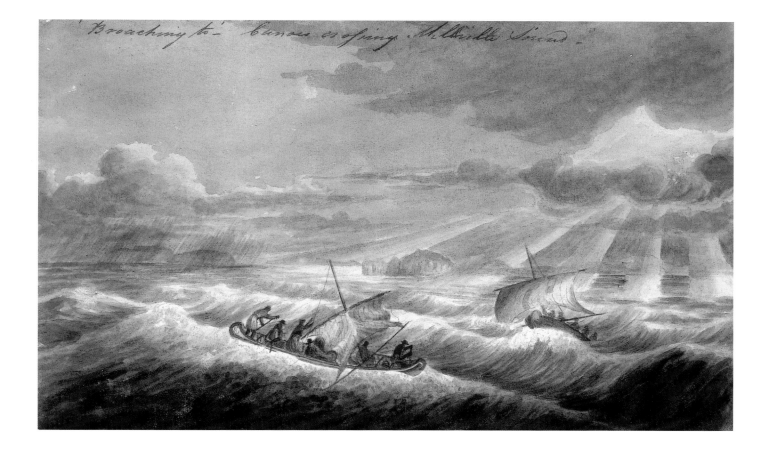

'Broaching to' Canoes crossing M.tMville Sound

Marcel Barbeau (1925–)

Lower St. Lawrence

1964; acrylic on canvas; 203.6 cm x 152.7 cm; National Gallery of Canada; Purchased 1965;
© Marcel Barbeau / SODRAC (2007)

Against a violet-blue background, sinuous yellow lines create an undulating vertical pattern like a current in a river, exciting an optical vibration which gives the impression that the painting, at one moment concave and the next convex, is energized with life and swaying before us. The artistic trajectory of Marcel Barbeau has been similarly dynamic—in a process of constant change and productivity in a variety of media over the span of his long and prolific career.

From 1942 to 1947, Barbeau studied at the École du meuble in Montreal, where he adopted a spontaneous approach to abstraction, then being explored by the artists associated with Paul-Émile Borduas and the Automatistes. He signed the *Refus global* in 1948, thereby joining the group's cry for a new social and artistic order following the war. In 1959, Barbeau abandoned the gestural techniques and "accidental" dream-inspired imagery promoted by the Automatistes. As he pursued the nature of space in painting, his work became more structured and geometric. In 1962, his encounter in Paris with the work of Victor Vasarely, a pioneer in the Op Art of the 1960s, opened the door for Barbeau's own exploration of powerful optical effects. "I am an intuitive painter," he said in 1966. "I don't have a particular theme that I pursue. I sense a certain approach or attitude to follow, rather than having a clear, defined strategy."

Anne Meredith Barry (1932–2003)

Whale Song #10

1989; oil on canvas; 185.4 cm x 125.1 cm; The Rooms Provincial Art Gallery;
The Scott Meredith Barry Memorial Collection

From her studio window in a small outport on Newfoundland's southern shore, Anne Meredith Barry studiously observed the graceful movements of the whales and contemplated their fragile plight and threatened environment. After extensive research into their anatomy and habitat, she decided how she wanted to portray them: "as gentle leviathans who have existed since the dawn of time, who are singing a song we do not understand and who are, in the long run, probably headed for extinction." To address the whales' ancient and primeval character, Barry turned away from academic traditions and employed a deliberately rough drawing style, applying the colours flatly to give a sense of the power and weight of nature. "I decided to do these paintings almost as petroglyphs," she explained, "white lines crudely incised into wet black gesso." In *Whale Song #10*, the whales dive and surface from ominous dark waters, creating circular movement and emitting colourful sounds into the glorious yellow and aqua light of the sky.

A native of Toronto and a graduate of the Ontario College of Art in 1954, Barry lived in Newfoundland since 1987. Although she admired the work of artists as varied as Matisse, Gauguin, Canada's Paterson Ewen and a number of Japanese painters, Barry derived her greatest inspiration from her relationship with nature amid the rugged beauty of Newfoundland.

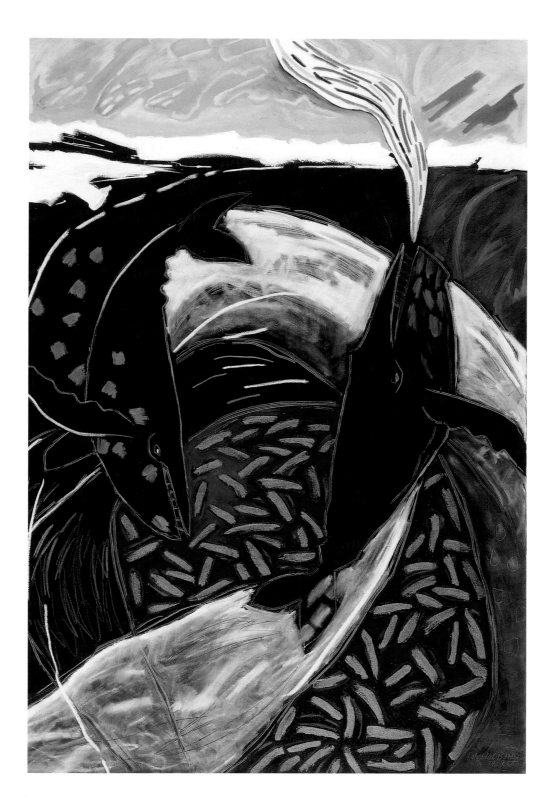

Carl Beam (1943–2005)

The North American Iceberg

1985; acrylic, photo-serigraph and graphite on plexiglas; 213.6 cm x 374.1 cm (assembled);
Purchased 1986; National Gallery of Canada

The title of this work is a reference to The European Iceberg, an exhibition held at the Art Gallery of Ontario in 1985 that presented contemporary European art little known to North Americans. Adapting this notion of marginalization to contemporary native experience on this continent, Carl Beam employed silkscreen images and text on Plexiglas using the technique of photo transfer popular with American artists such as Robert Rauschenberg.

Here, Beam combines encyclopedia texts and a photograph of Geronimo—the Apache chief from the American Southwest—with pictures of Indians dressed as Europeans. Flanking these, 19th-century portraits contrast with mug-shot-style self-portraits of Beam. The words "The Artist Is Flying Still" link the self-portraits to film stills of an eagle, its actions likewise imprisoned by the camera. While the images are thematically related and disclose an obvious criticism of the forced assimilation of the native peoples, the chaotic arrangement of the texts combined with the erratic use of colour, gestural brushwork and dripping suggest a story whose complex narrative has yet to be unravelled. "My guides," said Beam, "have been the wise men of traditions who interpret reality and get hold of meaningful things."

Of Anishnaabe heritage from Manitoulin Island, Beam studied art at both the University of Victoria and the University of Alberta.

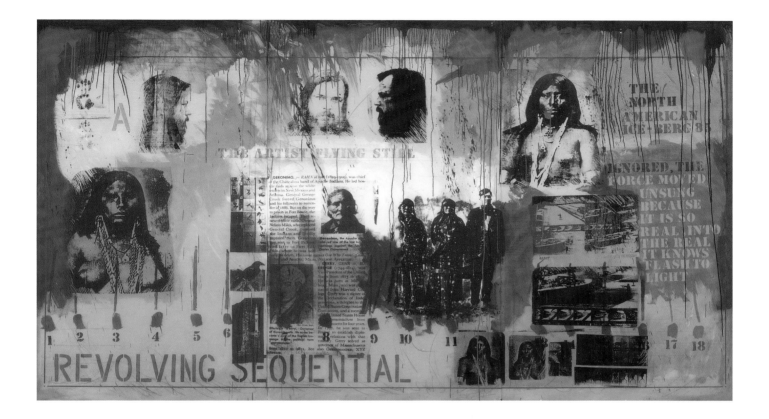

François Beaucourt (1740–1794)

Eustache-Ignace Trottier dit Desrivières/ Madame Eustache-Ignace Trottier dit Desrivières, née Marguerite-Alexis Mailhot

1792 or 1793; oil on canvas; 79.0 cm x 63.3 cm / 79.5 cm x 63.5 cm;
Musée national des beaux-arts du Québec; 56.297/56.298; Photo by Patrick Altman

These paintings are among the earliest examples of Canadian portraits of individuals accompanied by attributes that reflect their status in society. On the left, M. Trottier, a prosperous Montreal merchant, sits proudly in a red-back chair, dressed fashionably in a dark green coat with gold buttons and an embroidered white silk waistcoat, an elegant ruffle of lace at his throat. His wry, confident smile and look of good fortune are reflected in his hand, the ace of hearts already played and the stack of nearby coins.

Smiling with polite reserve, Marguerite Mailhot turns toward an imaginary centre to face her husband. With a miniature painting of her son fastened around her neck, she is stylishly attired in a blue dress and jacket that are softened by the scarf on her shoulders and a white bonnet, which was routinely worn indoors. An elegant samovar echoes the blue of her dress and affirms her participation in the genteel ritual of tea preparation befitting the aspirations of her class. The small gold box in her hands probably contains tea, a precious commodity. That the couple chose François Beaucourt to paint their portraits further mirrors their good taste. Quebec-born and initially educated by his artist father, Beaucourt could boast the prestige of academic training in France—the only other 18th-century Quebec artist besides François Baillairgé to have been able to do so.

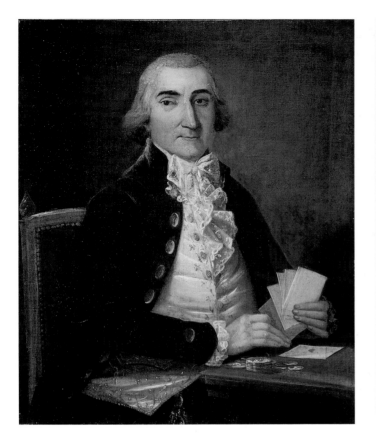 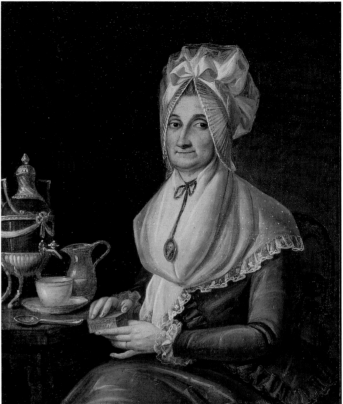

Léon Bellefleur (1910–2007)

Dance of the Drowned

1950; oil on cardboard; 81.3 cm x 60.2 cm; National Gallery of Canada; Purchased 1952

A red eye and a crying mouth stare out at us from the centre of the canvas, as a single white arm beckons with a helpless open palm. The rest of the body is lost in a frenzy of overlapping shapes and colours from whose chaos more grim faces emerge, identified by gaping eyes, clenched mouths and spiky hands grasping for each other in the midnight waters of the dance of the drowned. "I paint by instinct," said Léon Bellefleur in 1953, "without philosophical or pictorial reasoning. It's a world I invent poetically and in exaltation."

Bellefleur studied at the École des beaux-arts in Montreal, and in the early 1940s, he became acquainted with artists associated with Paul-Émile Borduas and Alfred Pellan, whose explorations of Surrealist theories promoted an approach to art inspired by dreams and the subconscious. Bellefleur also admired the work of Swiss artist Paul Klee, whose simplified and whimsical compositions reflected his own enthusiasm for children's art. In it, Bellefleur saw a freshness and spontaneity of expression that many 20th-century artists also wished to recover. In his "Plea for the Child," first published in 1947, Bellefleur championed the child's natural inclination to reverie, "the way of mystery and the infinite…Only those who have retained or rediscovered the ability to dream, to play, to feel moved and to pursue an ideal can hope to make their life a great and splendid thing."

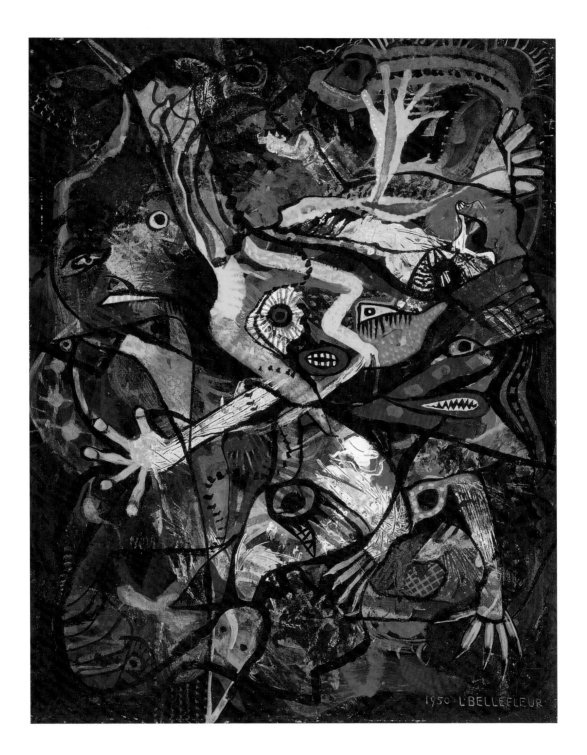

Rebecca Belmore (1960–)

Untitled

2003; (reconfiguration)/ Mawu-che-hitoowin: A Gathering of People for Any Purpose 1992;
Materials: plywood, paint, vinyl and audio cassette; Dimensions: 490 cm x 490 cm (installed);
Collection of the MacKenzie Art Gallery, purchased with funds raised by the MacKenzie Gallery
Volunteers in celebration of their 40th Anniversary and with the financial support of the
Canada Council for the Arts Acquisition Assistance Program

In the 1992 National Gallery of Canada exhibition *Land, Spirit, Power*, Rebecca Belmore created an installation consisting of a circular grouping of seven chairs arranged on a sixteen square foot (1.5 m2) painted and collaged floor piece. Each chair was equipped with a headset where visitors could listen to the stories of the seven women who donated the chairs. In this situation, the floor contributed to the evocation of a domestic space such as a kitchen where people gather and chat. Eleven years later, Belmore decided to isolate the floor and present it as a wall painting, reworking the collaged patterns of linoleum flowers and enhancing the leaf patterns in the centre. Aboriginal art historian Lee-Ann Martin writes that the work is "reminiscent of Anishnabe floral beadwork patterns, the shapes also recall the forms, light and shadows of the forest." With its wood-grain patterns and warm tones, the floor suggests Mother Earth, and readily links the painting's imagery to the powerful role of women in Aboriginal culture.

Belmore is an Anishinabekwe (Ojibwa) artist who grew up in Upsala, Ontario, and studied at the Ontario College of Art. In her varied expressions as a painter, and performance and installation artist, the recollections of her own female relatives have had a powerful impact on her art and on the assertion of her native identity. "I have with me the influence of my Kokum [grandmother] and my mother," she said. "I can see their hands at work. Hands swimming through the water, moving earth and feeling sky: warm hands. I can see their hands touching hide, cloth and bead, creating colour beauty: working hands."

William Berczy (1744–1813)

The Woolsey Family

1809; oil on canvas; 59.9 cm x 86.5 cm; National Gallery of Canada;
Gift of Major Edgar C. Woolsey, Ottawa, 1952

With the poise and restraint of a classical frieze, members of the Woolsey family gather in their Quebec City drawing room, suspended in quiet conversation. The soft pastel tones of their clothing are echoed by the refined Regency interior decoration and confirm the affluence of John William Woolsey, a wealthy Quebec merchant, auctioneer and broker. An inscription written by Woolsey on the back of the canvas identifies the sitters: Woolsey stands behind his wife and forms the apex of a triangle that includes their four children, his mother and his brother-in-law, who is holding a flute. Birth and death dates record the ill fortune and sickness that would soon diminish the family ranks.

The enterprising William Berczy was born in Germany and worked as a painter and an architect before coming to Canada, via the United States, as an immigration agent. First settling in York in 1794, he moved to Montreal in 1805, where his talents as a portrait painter, a church decorator and an architect were highly esteemed. In 1808, John Woolsey commissioned Berczy to paint this portrait for 80 pounds—a hefty sum, given that Woolsey's rent was 55 pounds per year. The dog, whose collar bears the family name, was painted free of charge. Completed after the artist undertook a year of preparatory sketches, the painting is considered one of the triumphs of Berczy's career.

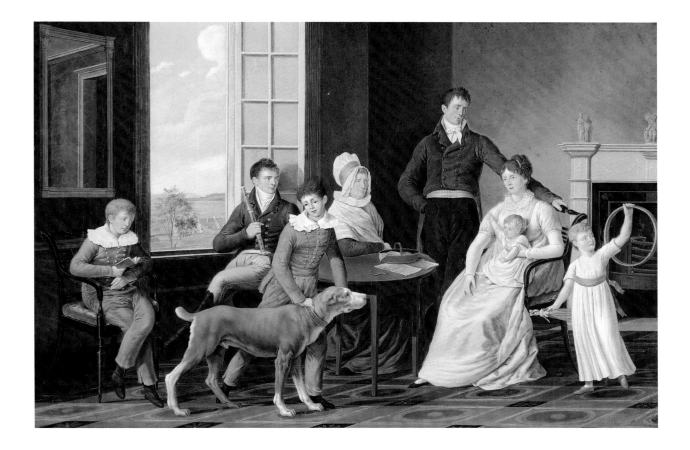

George Théodore Berthon (1806–1892)

The Three Robinson Sisters

1846; oil on canvas; 111.8 cm x 83.8 cm; Art Gallery of Ontario;
on loan from the Estate of Mrs J. B. Robinson, Toronto;
Photo by Carlo Catenazzi/AGO

Three 19th-century graces gather in their finery for a portrait that will be a surprise gift to their parents. Augusta, the eldest, dressed in black velvet, looks demurely to the side, while the younger sisters—Louisa in white silk and Emily in pink—agreeably meet our gaze. With their porcelain skin, silky brown curls and sartorial splendour, the three exude the gentility and reserve befitting their station as the daughters of eminent Chief Justice Sir John Beverley Robinson. The portrait was presented to the girls' parents in April 1846, on the day of Louisa and Emily's double wedding. It had been commissioned by the three sisters' husbands, all members of the Toronto ruling class and all related to influential persons whose portraits had also been painted by George Berthon. In a letter to Berthon, Robinson wrote: "Our dear little girls are, as we think, faithfully and characteristically portrayed."

The son of a court painter to Napoleon Bonaparte, Berthon was born in Vienna and immigrated to Toronto in 1844, bringing with him his neoclassical training, as displayed in this skilfully composed portrait. He rapidly established himself as the preferred portraitist of Canada West's most powerful citizens and, soon after his arrival, was commissioned to paint the portrait of the formidable Bishop John Strachan (Augusta's father-in-law). In 1845, he did a portrait of Chief Justice Robinson himself.

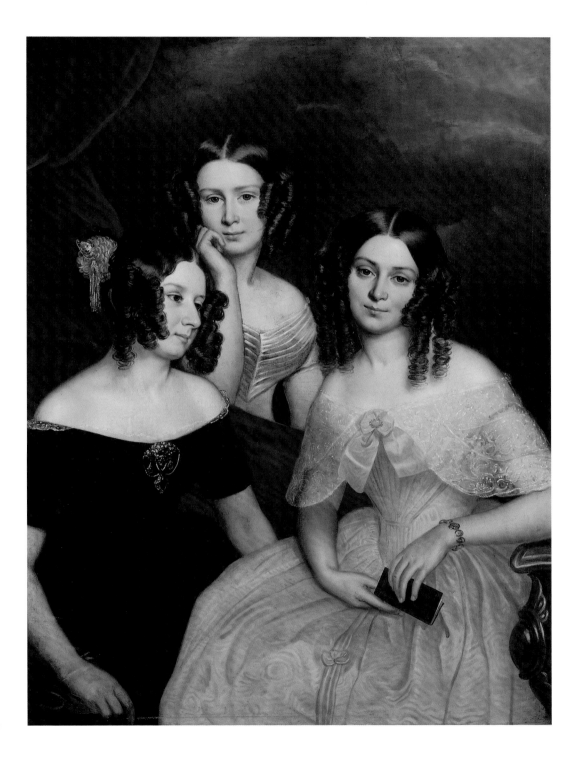

David Blackwood (1941–)

Uncle Eli Glover Moving

1982; etching; 35.6 cm x 86.4 cm; Collection of the artist; © David Blackwood

*L*ike a phantom in a dream, a large boat hauls the house of Uncle Eli Glover 25 kilometres across the dark waters from Bragg's Island, the home of David Blackwood's maternal grandparents, to mainland Newfoundland. The light glowing from behind creates silhouettes of the sombre figures on board and illuminates the lonely façade of the house, its front door fixed with a plank. The austerity of the composition, with the stark contrasts of blue-black and white afforded by the etching process, embodies the severity of life and the wrenching anguish for many uprooted Newfoundlanders in the government's resettlement project of the early 1950s.

When Blackwood speaks of Wesleyville, his birthplace on Newfoundland's east coast, his destiny as a printmaker seems to have been predetermined: "The region is very flat and barren, the dominating features are the sea and the sky...all shades of grey, black and white. That's the big influence." Blackwood was born into a family of fishermen, who supported him in his artistic endeavours, and in 1961, he enrolled at the Ontario College of Art, where Jock Macdonald encouraged him to look to his provincial heritage as the source of his art. By 1963, Blackwood had created his first series of prints and had launched a career that would chronicle, with a singular drama and emotion, the past lives of the Newfoundland coastal communities.

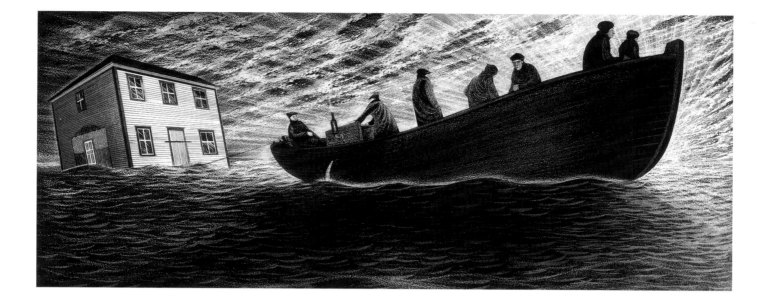

Ronald Bloore (1925–)

Painting

1959; stovepipe enamel and oil on hardboard; 221.8 cm x 220.0 cm, measured square;
National Gallery of Canada; © R.L. Bloore

"Art," said Ronald Bloore, "is a serious not a casual activity. It cannot be approached simply by the recognition of the spectator's past experience. Any truly creative work should be a revelation to the beholder, an extension of his experience in life, not a confirmation of what he already knows." In *Painting*, Bloore challenges our notions of art and experience by producing a work that first, by its tipped orientation, upends the traditional expectation that a painting is a window onto the familiar world. Here, the painting is an object in its own right. The shiny surface of the black stovepipe enamel scraped over a bed of brown and blue oil paint forms an irregular grid, a newly invented image.

Bloore studied art and archaeology at the University of Toronto and in the United States and England, returning to Canada in 1957 to teach in Toronto. At that time, he turned to nonfigurative abstraction. In 1958, he was appointed director of the Norman Mackenzie Art Gallery in Regina, Saskatchewan, where he presided over the invitation of American artist Barnett Newman to lead an artists' workshop at Emma Lake, Saskatchewan. In 1961, an exhibition entitled "Five Painters from Regina" illustrated the very individual excursions into abstraction explored by Bloore, Ted Godwin, Kenneth Lochhead, Arthur McKay and Douglas Morton.

Eleanor Bond (1948–)

Rock Climbers Meet with Naturalists on the Residential Parkade

1989; oil on canvas; 243.8 cm x 365.0 cm; MacKenzie Art Gallery, Regina;
Purchased with the assistance of friends in the memory of Ian Phillips;
Photo by Don Hall

High above an industrial city distinguished by a busy harbour, factories and skyscrapers, "the residential parkade"—a parking garage for mobile homes—spirals upward like a small mountain, its exterior offering lush grass and rock faces for recreation. Engulfed by the monumental scale and perspective of the painting, the viewer experiences a feeling of vertigo and a sense of hovering over a vast but unpeopled site that towers above a dark, sinister-looking city.

As one of a series of eight equally large paintings that propose fictional views of urban environments, the work raises questions about our social future and the relationships among humanity, culture, architecture and nature. Eleanor Bond explained: "My intention is that the viewer enter this projection, this debate—that these sites function as forums, not as landscapes in the traditional sense. The debates are those that surround us…health care, housing, the position of women and the elderly in our society…the culture of nature…The intentional blurring, the hazy effects, the multiple vantage points suggest an absence of authority." Bond leaves us in limbo, uncertain of whether the vision is utopian or dystopian.

A Winnipeg native, Bond began her studies in interior design at the University of Manitoba, graduating in 1976 from the university's School of Art. She has exhibited widely, both nationally and internationally.

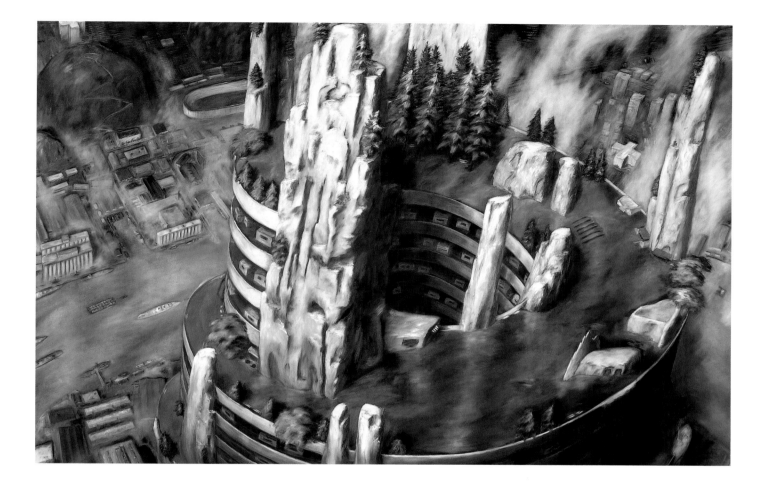

Paul-Émile Borduas (1905–1960)

3+4+1

1956; oil on canvas; 199.8 cm x 250.0 cm; National Gallery of Canada; Purchased 1962;
© Estate of Paul-Émile Borduas/SODRAC (2007)

As vice-president of the Contemporary Arts Society in 1939, Paul-Émile Borduas was well aware of modern European art movements such as Cubism and Surrealism that offered artists a new abstract language with which to express inner states and emotions. Like many artists, Borduas was attracted to the writings of the Frenchman André Breton who defined Surrealism as "pure psychic automatism, by which it is intended to express verbally, in writing or in any other way, the true process of thought…free from the exercise of reason."

In the early 1940s, Borduas produced a series of abstract paintings in gouache, a water-based medium that allowed him to work "automatically" and spontaneously without pre-conceived ideas. This attempt to give pictorial form to the workings of the subconscious made a huge impact on younger Montreal artists who similarly sought new freedoms in art as well as in the Church-dominated repressive society of Quebec. Following the exhibition of their abstract work in 1947, a critic dubbed Borduas and his colleagues "the Automatistes."

In 1948, Borduas and the Automatistes issued a manifesto called *Refus global* (*Total Refusal*), condemning injustice and exalting freedom of expression: "Our duty is clear, we must break with the conventions of society… and reject its utilitarian spirit…We refuse to keep silent! Make way for magic! Make way for love!" The manifesto's provocative and rebellious language caused a furor and cost Borduas his teaching position at the École du meuble.

In self-imposed exile, Borduas moved in 1953 from Quebec to New York City, and in 1955, to Paris, where his paintings became increasingly austere. In *3+4+1*, irregular black shapes—loosely grouped in the numbers of the title—float on a thickly painted white ground. Without the intermediary of colour, the surface appears two-dimensional, presenting a space so shallow that the black and white areas seem to alternate as foreground and background. One of Borduas' daughters recalled the shock of seeing these paintings when they were returned to Canada after his death in Paris. For her, they were an attempt "to reconcile the irreconcilable and to make it sing."

Bob Boyer (1948–2004)

A Minor Sport in Canada

1985; acrylic and oil on cotton blanket; 188 cm x 221 cm;
overall with attachments: 208 cm x 240 cm; National Gallery of Canada; Purchased 1987;
© Ann Boyer

Here, the image of the Union Jack is painted over with the geometric designs of the Plains Indian and is juxtaposed with splatterings of dark red paint that suggest spilled blood, creating a clash of imagery which alludes to the violent persecution of aboriginal peoples by the Europeans. The artist's use of a cotton blanket as the painting's support is equally eloquent and addresses the spread of disease in the 19th century through the trade in blankets contaminated with smallpox.

Bob Boyer was inspired to paint on blankets following a 1983 trip to China and Japan, where he saw prayer cloths and banners conveying political messages. "I came back with a real hatred of oppression," he said. This anger was directed not only at social injustices but also at the art establishment's exclusion of aboriginal artistic expression. Boyer's first blanket painting was a deliberate break with the materials of Western art—oil paint on canvas. Using a cotton blanket nailed to the wall, Boyer was negating the convention of "framing" and affirming the continuity of art and life central to traditional native art. The title is characteristically ironic, suggesting an attitude of paltry amusement inappropriate to the massive destruction of the native population.

Boyer, who studied at the University of Saskatchewan, explored an individual aesthetic that reflected his mixed identity of European and native ancestries.

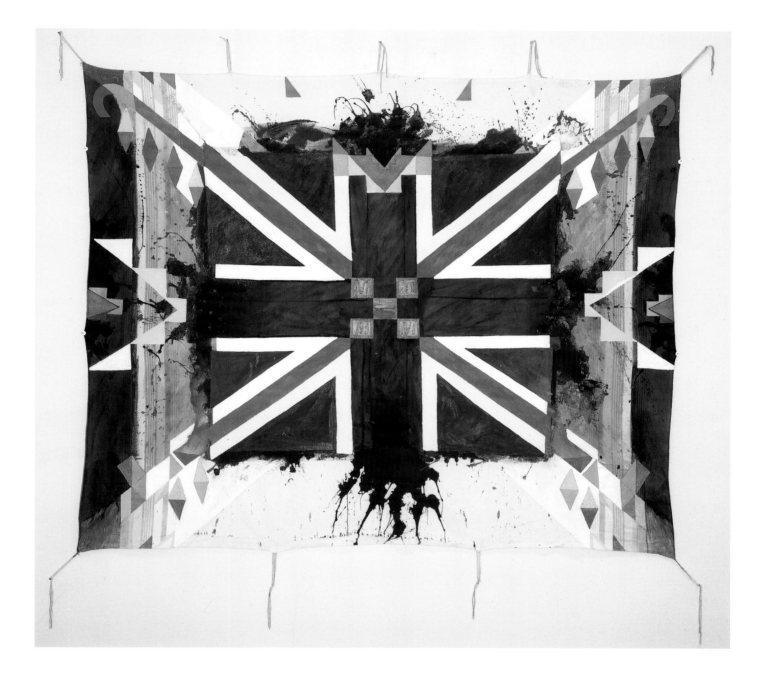

Claude Breeze (1938–)

Transmission Difficulties: The Operation

1968; acrylic on canvas; 172.4 cm x 239.0 cm; National Gallery of Canada; Purchased 1969

Here, we are confronted by a painting of a giant television screen, where the bright pink body of a man on a blue table is juxtaposed against a strident yellow background. With mouth agape, eyes sunken pools of darkness and arms flailing helplessly, the man's torso erupts into a volcanic explosion of colour that is as curiously joyful as it is macabre. The prismatic spectrum of colour gushes out of the television screen into our space, while multihued bubbles float from the man's mouth with a disturbing comic sensibility.

Claude Breeze was born in British Columbia and studied with Ernest Lindner in Saskatoon and later with Art McKay and Roy Kiyooka in Regina. In 1962, Breeze combined figurative painting with abstract aesthetics as a means to address his concerns for the human condition. In 1966, he embarked on the Home View TV series, which denounced the disengagement of television viewers from the circumstances of violence. The notion of "transmission difficulties" suggests aberrations in communication, technological or otherwise, while the depiction of an abandoned "operation" smacks of indifference to society's vulnerable. These issues were also reflected in works about the American civil-rights movement and the atrocities perpetrated during the war in Vietnam. Breeze's continuing fascination with the "media screen" has, in recent work, been manifest by the inclusion of a computer monitor.

Miller Brittain (1912–1968)

The Rummage Sale

1940; oil on masonite; 63.5 cm x 50.9 cm; National Gallery of Canada; Purchased 1976

*I*n the foreground, a knot of women lean, stretch and bend, eagerly diving for bargains. Their rounded bodies overlap and push against each other, creating a feeling of crowdedness and confusion. In the centre, two women dispute the ownership of a red dress, and behind them, thinner women with fur collars and more elaborate hats look with reserved disdain at the theatre before them. While the little faces of the waiting children betray their boredom, the bright colours of the women's clothes lend an air of gaiety to the necessity of thrift. As Miller Brittain observed, "A picture ought to emerge from the midst of life."

Brittain studied at the Art Students League in New York in 1931–32. There, he came into contact with artists associated with the American Ash Can School, so called for their frank portrayals of dreary urban neighbourhoods and the impoverished inhabitants. He admired in particular the different faces of disillusionment seen in Raphael Soyer's office girls and Reginald Marsh's derelicts.

In the decade following his return to his native Saint John, New Brunswick, Brittain painted the people of his city going about their daily business in the shops, bars and harbour and on the public transportation systems. His ability to survey a crowd and capture characteristic behaviour with both sympathy and satire earned him the nickname "the Canadian Brueghel."

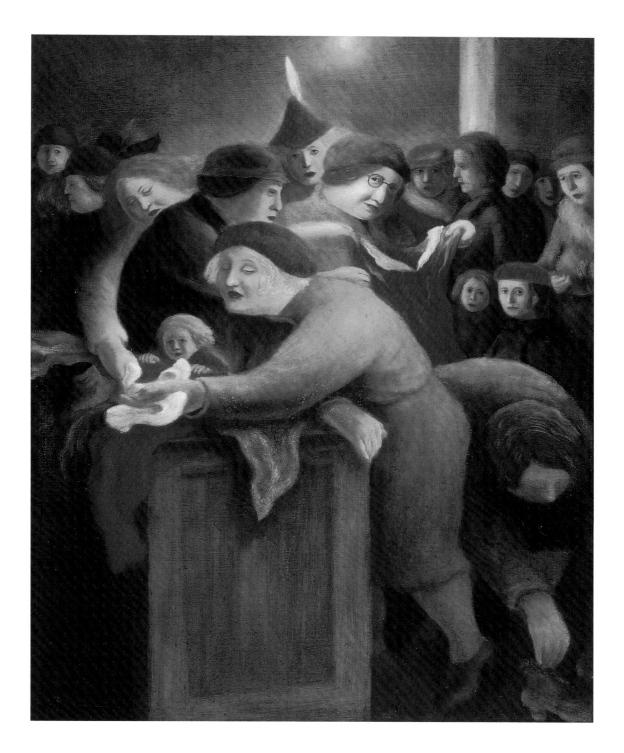

Bertram Brooker (1888–1955)

Untitled (Sounds Assembling)

1928; oil on canvas; 112.3 cm x 91.7 cm; Collection of the Winnipeg Art Gallery;
Photo by Ernest Mayer/The Winnipeg Art Gallery

"I plunged into painting in 1927 without any knowledge," wrote Bertram Brooker, "...attempt[ing] to paint the experiences I derive from music...some sort of replica of the colour, the volume and the rhythm I experienced while listening to music." Here, orange, yellow, green and blue rods zoom into the picture plane, thrusting toward blue rings that project pale-coloured poles with flat ends, creating an imaginary space which expresses the invisible inner energy and excitement inspired by the joyful accumulation of music evoked in the painting's title.

Born in England, Brooker settled in Manitoba in 1905, where he was employed as a labourer, a clerk and a journalist before moving to Toronto in 1921 to work as an advertising executive. In 1923, he joined the Arts and Letters Club, where he met Lawren Harris and other members of the Group of Seven, whose work he admired for "liberating young artists from the stuffy tradition of strict realism." He was influenced by discussions with Harris about the spirituality of art and was inspired by the writings of Russian artist Wassily Kandinsky, whose book *Concerning the Spiritual in Art* proposed music as a model for the artist seeking to express his inner soul. In 1927, Brooker was the first artist in Canada to exhibit abstract art and, in 1936, the first to win the Governor General's Award for fiction for his novel *Think of the Earth*.

William Brymner (1855–1925)

A Wreath of Flowers

1884; oil on canvas; 122.5 cm x 142.7 cm; National Gallery of Canada;
Royal Canadian Academy of Arts diploma work, deposited by the artist, Ottawa, 1886

"*T*he difficulties of painting children the size of mine are awful. Keeping the pose for two minutes and then doing something altogether different for ten nearly drives me wild sometimes," protested William Brymner in a letter written in 1883 from the picturesque fishing village of Runswick Bay, Yorkshire, England. There, on the slopes of an orchard perched over the sea, he painted this, his largest canvas.

Our path along the hill is halted by the gathering of three small girls. Two are absorbed in making daisy chains, while the third turns sulkily from her knitting and looks toward them. In the distance, another child approaches with freshly picked flowers. In contrast to the detailed description of the children in the foreground, the surrounding landscape has been painted more spontaneously, exhibiting Brymner's exploration of Impressionist techniques to render the fleeting effects of nature. While the children's clothing tells of a bygone era, their expressions timelessly evoke the bored leisure of childhood.

In 1876, Brymner left his native Montreal to study art in Paris, where he mastered an academic style of painting characterized by a faithful depiction of the human figure and a highly finished naturalism. In 1886, he returned to Canada and, for the next 35 years, was one of the most influential teachers at the Art Association of Montreal.

Jack Bush (1909–1977)

Dazzle Red

1965; oil on canvas; 205.7 cm x 264.2 cm; Art Gallery of Ontario;
Purchase, Corporations' Subscription Endowment, 1966;
© Estate of Jack Hamilton Bush/SODRAC (2007); Photo by Carlo Catenazzi/AGO

When Jack Bush painted *Dazzle Red* in 1965, he had already spent over 10 years probing abstraction, achieving an eloquence of expression that would earn him an international reputation before he received a national one. Here, horizontal bands of colour stacked one upon the other are soaked into the fabric of the canvas, the hot red kept in check by the orange and mauve above and the green and blue below. The deep yellow on either side defines the edges of the central monolith and maintains the flatness of the picture plane. Drawing on the *experience* of life rather than its appearance, Bush is said to have been inspired by a mannequin in a store window who was wearing a brightly coloured blouse and skirt, belted at the waist with a colourful sash. "I paint from my belly," explained Bush. "It's instinct, a gut feeling."

Bush studied in Montreal from 1926 to 1928. He then moved to Toronto, where he worked as a commercial artist, taking evening classes at the Ontario College of Art from 1929 to 1939 and exhibiting with established art societies such as the Royal Canadian Academy of Arts and the Ontario Society of Artists. After the Second World War, Bush and other young Toronto artists began to learn of modern art through magazines such as *Time* and *Life* and through the Skira art books, which introduced them to the work of artists such as Picasso and Matisse. By the early 1950s, the Toronto artists were travelling regularly to New York City. As Bush recalled, "We were very influenced by the abstract expressionists, where paint was thrown on and scooped around and was a very wild sort of free painting." Excited by the expressive possibilities and boldness of this approach to abstraction, Bush and 10 others organized the first Painters Eleven exhibition in 1954. But Toronto was not ready for this kind of art, according to Bush. "It upset everybody," he said, "critics and older artists, so we got the hell pasted out of us in the press."

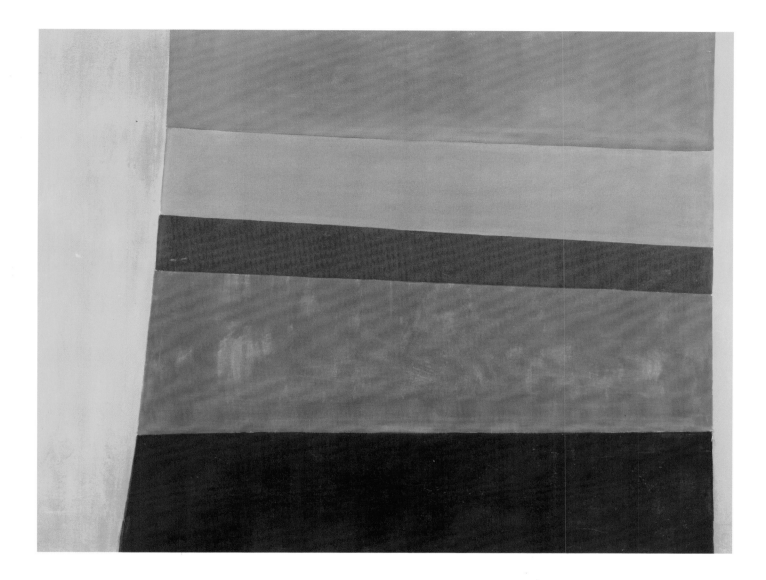

Joane Cardinal-Schubert (1942–)

The Warshirt Series: My Mother's Vision — This is the Spirit of the West, This is the Spirit of the East, This is the Spirit of the North, This is the Spirit of the South

1986; oil on wove paper with mixed media: graphite, charcoal, pastel, conte;
Quadratych: 4 x (121.0 cm x 80.7 cm) unframed; Canadian Museum of Civilization,
image numbers 13659-61, 13489

In four large, richly coloured drawings, Joane Cardinal-Schubert repeats the image of the war shirt worn by her Blood ancestors as sacred protection in battle to combat today's environmental destruction. Using iconography inspired by pictographs from sites such as Milk River and Writing-on-Stone in Alberta, she paints hands protectively touching the shirts. In the domelike spheres below, which resemble the shape of the native sweat lodge—a place of ritualistic purification—the hands search, wave and reach, ambiguously seeking connection in a chaotic world that has lost its respect for nature. Together, the drawings portray the four cardinal directions symbolized by the stencil-like silhouettes of the animal spirits that confirm the unity of humanity and nature. "I use Indian history as subject matter," said Cardinal-Schubert, "but, more important, as a personal expression of a contemporary artist—no different from any contemporary artist who seeks the essence [of that] which transcends any culture or historic period."

Cardinal-Schubert was born in Red Deer, Alberta, and studied at the Alberta College of Art and the University of Calgary. In addition to painting and drawing, she also creates installation work inspired by memory, native history and social injustice: "As artists, our only weapon in this battle for survival…is our knowledge, responsibility and…commitment to share our world view with others."

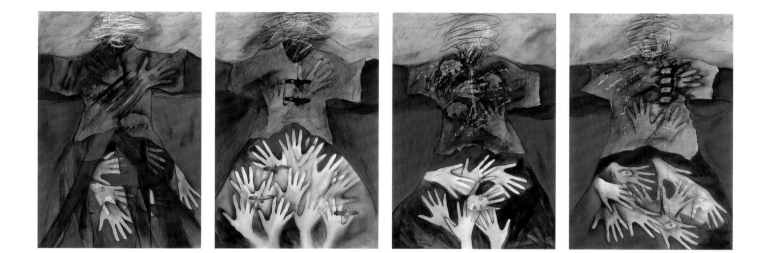

Franklin Carmichael (1890–1945)

Bay of Islands

1930; watercolour on paper; 51.3 cm x 64.4 cm; Art Gallery of Ontario;
Gift from Friends of Canadian Art Fund, 1930; Photo by Larry Ostrom/AGO

Across a bay of smooth grey islands that jut out of the water like ancient beasts, Franklin Carmichael offers us a panoramic view of the north shore of Lake Superior, animated by windswept trees in the foreground and a lively sky of billowing clouds. Carmichael, the youngest member of the Group of Seven artists, frequently accompanied the Group on sketching trips to northern Ontario, but he sought his own innovations in his response to the land. Through the sensitive and versatile medium of watercolour, he captured the breadth and brightness of the wide-open spaces flickering with light and shadow. For Carmichael, watercolour was a medium "capable of responding to the slightest variation of effect or mood…clean-cut, sharp, delicate and forceful or subtle, brilliant or sombre."

Carmichael's introduction to art occurred when he worked as a carriage decorator in his father's shop in Orillia, Ontario. In 1911, he moved to Toronto and was employed as a designer at Grip Ltd., where he met Tom Thomson and other artists who would later form the Group of Seven. Encouraged by Arthur Lismer and F.H. Varley, Carmichael travelled to Antwerp, Belgium, in 1913 to study at the Royal Academy of Art. With the outbreak of the First World War, he returned to Canada, resuming his career as a commercial artist, teacher and highly acclaimed designer and illustrator.

Emily Carr (1871–1945)

Red Cedar

1931; oil on canvas; 110.0 cm x 68.5 cm; Collection of the Vancouver Art Gallery;
Gift of Mrs. J.P. Fell; VAG 54.7; Photo by Trevor Mills

In her autobiography, *Growing Pains*, published posthumously, Emily Carr describes the importance of "the deep sacred beauty of Canada's still woods...the deep lovely places that were the very foundation on which my work as a painter was to be built." And although Carr depicted First Nations villages and totem poles throughout her career, it was always nature—primarily the forest and the towering sky—in which she found her most personal expression. In *Red Cedar*, the luminous orange-red trunk stands majestically centred in the canvas, tossing its silken green foliage in an undulating pattern that is echoed in the sea of undergrowth on the forest floor. Delicate tendril-like branches float downward, repeating the vertical rhythm of the trees and reflecting Carr's wish to distil the forms of nature to their very essence, simplifying and capturing pure movement.

In 1933, in her early sixties, Carr purchased an old caravan that she towed to various sites outside her hometown of Victoria, British Columbia, during the summer months. These venues inspired new subjects for her art. "Wouldn't be good to rest the woods?" she wrote. "Am I one-idea'd, small, narrow? God is in them all." Painting views of the cliffs, beaches, sea and sky, she also made technical innovations. Combining oil paint and turpentine (to make the paint thin and fluid) and working on paper which was light and easy to transport, she captured living, breathing nature with a newfound spontaneity and freedom.

From her beginnings in staid 19th-century Victoria, and through ill health and financial limitations, Carr went to extraordinary ends—travelling to California, England and France—to educate herself as an artist. Returning home in 1911, she produced a large body of work inspired by visits to First Nations villages. After a fallow period from 1914 to 1927, during which she ran a boardinghouse and painted little, an invitation to exhibit her work in eastern Canada and a meeting with the Group of Seven artists helped Carr to rekindle her creative spirit and to discover her own voice as an artist. She received the Governor General's Award in 1941 for her publication *Klee Wyck*.

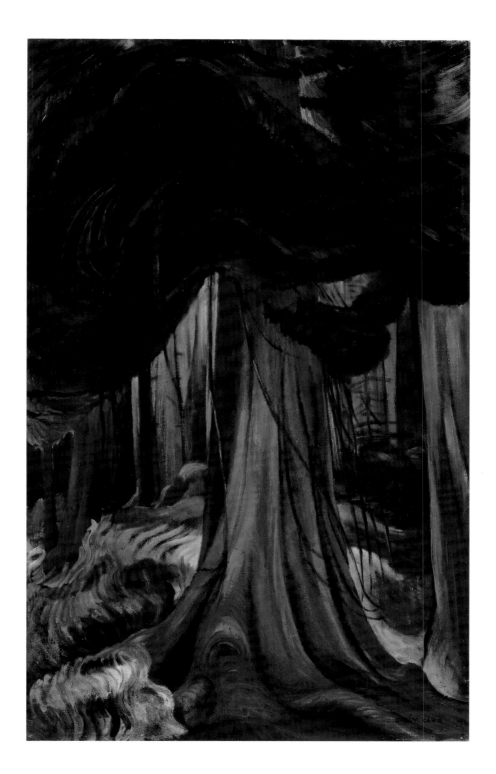

Alfred Joseph Casson (1898–1992)

Hillside Village

1927; watercolour and black chalk on wove paper; 55.6 cm x 47.6 cm; Art Gallery of Ontario;
Gift from the Reuben and Kate Leonard Canadian Fund, 1928; © A.J. Casson Estate;
Photo by Larry Ostrom/AGO

With an assured hand and an astute eye, A.J. Casson applied thin washes of watercolour, bringing to life the sunny tranquillity of an Ontario hillside town. The rhythm of delicately drawn architecture creates rectangular patterns enlivened by the red, white and yellow walls of the buildings that are embellished with blue and green trim. A church perched on the rocky horizon completes our journey up the sun-bleached road, where the blue sky is dappled with paper-white clouds. Invited to join the Group of Seven in 1926, Casson embraced the Ontario hillside town not only as a means of exploring characteristically Canadian subject matter but also as a way to distinguish his art from that of the rest of the Group. "I began to dig out places of my own," he said later. "I also loved to paint villages…and I'm glad, because they're pretty much gone now. They've all changed, fallen down or been destroyed."

Born in Toronto, Casson was raised in Guelph and Hamilton. In 1919, he returned to Toronto to work at the commercial art firm of Rous and Mann, where he was apprenticed to Franklin Carmichael. Casson shared Carmichael's love of watercolour and accompanied him on sketching trips. In 1925, along with commercial artist Frank Brigden, they formed the Canadian Society of Painters in Water Colour, which still exists today.

Jack Chambers (1931–1978)

401 Towards London No. 1

1968–1969; oil on mahogany; 183.0 cm x 244.0 cm; Art Gallery of Ontario;
Gift of Norcen Energy Resources Ltd., 1986; Photo by Carlo Catenazzi/AGO

In this large painting dominated by a vast autumn sky, ethereal white clouds cast sharply defined shadows on the strip of land where the ribbon of highway cuts through the countryside. To capture this "eternal present," Jack Chambers used photography, securing the details of a scene usually perceived in a blur from a car. The photograph was, for Chambers, an "object to see with…rather than a thing just to see." The roar of the highway has been stilled to a vista of contemplation and the seeming banality of the subject transformed by the overwhelming presence of light and by the delicacy of the brushwork, celebrating the ordinary as an aesthetic experience. In his notebooks, he wrote: "Perception's gleam is of wonder, not memory, and its beauty is the beauty of encounter, not comparison."

Chambers began his art studies in his native London, Ontario, and in 1953, he left for Europe and studied at the Academia de Bellas Artes in Madrid. In 1961, he returned home and produced dreamlike images of domestic interiors, landscapes and fantasy subjects inspired by personal history. In 1969, the year in which he finished this painting and was diagnosed with leukemia, he published "Perceptual Realism," an essay influenced by his Roman Catholicism as well as his readings of French phenomenologist Maurice Merleau-Ponty.

Paraskeva Clark (1898–1986)

Petroushka

1937; oil on canvas; 122.4 cm x 81.9 cm; National Gallery of Canada; Purchased 1976;
© Clive Clark family

When Paraskeva Clark arrived in Toronto in 1931, she brought with her the Socialist ideals of the Bolshevik Revolution adopted during her artistic training in her native St. Petersburg. A friend of Norman Bethune and active in the Committee to Aid Spanish Democracy in the late 1930s, Clark passionately stated her views on the responsibility of the artist: "Those who give their lives, their knowledge and their time to social struggle have the right to expect great help from the artist. And I cannot imagine a more inspiring role than that which the artist is asked to play for the defence and advancement of civilization."

This work was inspired by newspaper reports of the killing of five striking steelworkers by the Chicago police in the summer of 1937. To express her feelings of social injustice, Clark has adapted the story of Petroushka, or the Peter puppet—a traditional Russian symbol of suffering humanity—to a North American context. The puppet show reaches its climax when the proletariat robber is arrested by the police and the rich capitalist waves his money in triumph. The audience seems restless and disapproving: The older people in the lower right raise their fists in protest; others seem apprehensive, while the narrator with the drum points a cautionary finger. In the background, the buildings tip and sway uneasily, alluding to the tensions in society.

Alex Colville (1920–)

Horse and Train

1954; glazed tempera on board; 41.2 cm x 54.2 cm; Art Gallery of Hamilton;
Gift of Dominion Foundries and Steel, Ltd., 1957

In *Horse and Train*, a lone riderless horse gallops confidently toward an approaching train. Its graceful black body is silhouetted against the dying light and contrasts with the narrow linearity of the silver-coloured railroad tracks, cold and bright against the dimly lit landscape. As the single-eyed mechanical Cyclops steadily advances, hissing white smoke across the horizon, our minds race, anticipating collision and destruction of the beautiful beast. Startling in its exacting brushwork and precise definition of the objects and space, the painting hovers between the real and the super-real, and results from Alex Colville's meticulous preparatory drawings and methodical application of tiny brushstrokes.

Unlike most of Colville's work, which springs from his personal life, the people, animals, and places he holds dear, *Horse and Train* was inspired by the poem *Dedication to Mary Campbell* written by South African poet Roy Campbell, that included the lines: "Against a regiment I oppose a brain / And a dark horse against an armoured train." On one level, the painting reflects the antagonisms of animal and machine, but in light of Campbell's intentions and Colville's inclinations, the horse is a symbol of the independent individual, and the train, bound to its track, a symbol for unthinking mass behaviour. Importantly, as art historian David Burnett has proposed, "Its meaning is suspended in the precision of its presentation and the associations it opens in the spectator's mind."

Colville was born in Toronto and moved with his family to Nova Scotia in 1929. He graduated in 1942 from Mount Allison University in Sackville, New Brunswick, where he studied with painter Stanley Royle, an English Post-Impressionist. That same year, Colville joined the army and, from 1944 to 1946, he worked as a war artist in Europe, an experience which profoundly influenced his artistic vision. Moved by the senseless sacrifice of humanity and the fragility of life, Colville probes the essence of what it is to be alive. "Art," he once explained, "is one of the principal means by which a human tries to compensate for, or complement, the relentlessness of death and temporality." In 1982, Colville was made a Companion of the Order of Canada.

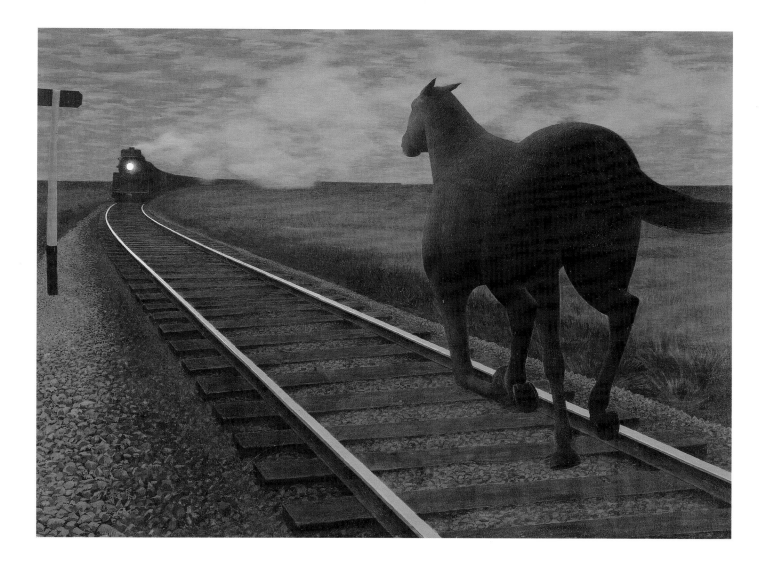

Charles Comfort (1900–1994)

Wrecked ME410

1944; watercolour; 35.5 cm x 51.7 cm; AN 19710261-2314; Beaverbrook Collection of War Art;
© Canadian War Museum (CWM)

In his memoirs, *Artist at War*, Charles Comfort writes about the downing of an enemy plane ME410 one morning in the spring of 1944, while stationed with the 1st Canadian Infantry Division in Ortona, Italy. Not knowing how long he would have to portray the wreck before shooting resumed, Comfort worked quickly, filling the space of his paper with broad washes for the sky and land and deftly sketching in the details of the wreck. In the background, a devastated landscape looms with trees reduced to skeletons and the spring sky obliterated by billows of blue-grey smoke. On closer inspection of the plane, Comfort discovered that the first two lines of the French national anthem, *la Marseillaise,* had been written in the centre of the black-edged white cross. Speculating that the plane had been assembled in France, he noted, "Someone had written those lines at considerable risk and it was a stirring experience to discover them."

The Scottish-born Comfort began his prolific career as a commercial artist in Winnipeg, and following studies at the Art Students League in New York City, he moved to Toronto in 1925. A painter of dreamlike landscapes, expressive portraits and murals, he was appointed senior official war artist in 1943. In this capacity, he produced hundreds of watercolour field sketches and a large number of oil paintings that combine eyewitness events with broader historical narratives. A professor at the University of Toronto (1938-60), Comfort was president of the Royal Canadian Academy of Arts (1957-60) and was the first artist to direct the National Gallery of Canada (1960-65).

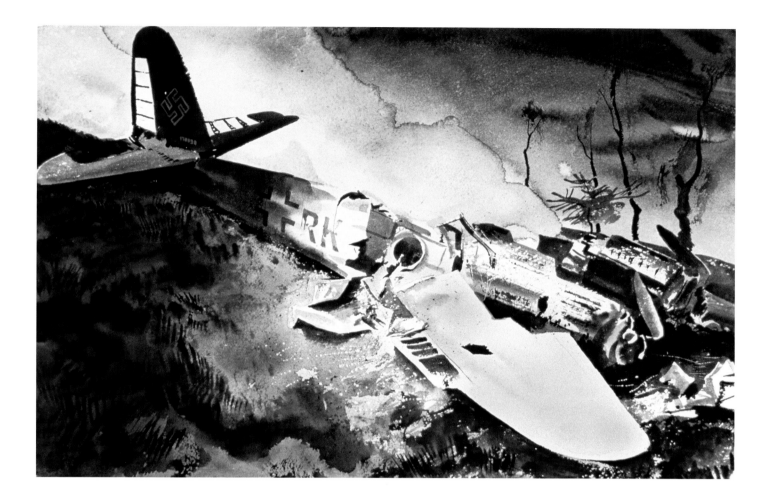

Emily Coonan (1885–1971)

Girl in Dotted Dress

c. 1923; oil on canvas; 76.0 cm x 66.4 cm; Art Gallery of Hamilton;
Gift of The Spectator, 1968

The solemn, almost brooding expression of the young girl seated in a chair sets the mood for this delicately painted study of colour and form. Light from the left allows for a refined sculptural modelling of the subject, whose slight proportions seem to be overwhelmed by the generous folds of her dotted mauve dress. Centred on a cool grey background, her solitary figure casts a dark shadow to the right, creating a quiet, melancholy atmosphere.

Emily Coonan was born in Montreal and, in her youth, was recognized for her artistic ability. As a student of William Brymner at the Art Association of Montreal in 1912–13, Coonan benefited from his lessons in the academic study of the figure and, like him, admired the paintings of James Wilson Morrice, whose modernist distillation of colour and form advanced the exploration of Post-Impressionism in Canada. Associated with the Beaver Hall Group, she was acclaimed for her individuality in the 1920s, and she and Lilias Torrance Newton were the first women to be invited to exhibit with the Group of Seven in 1923. Following Brymner's advice to be independent, Coonan pursued a path of her own, drawing the praise of a critic in 1925, who wrote that "her art is unlike anyone else's, and these days, that is enough to give her distinction." Coonan's direct style marked her as part of the 1920s avant-garde in Canada.

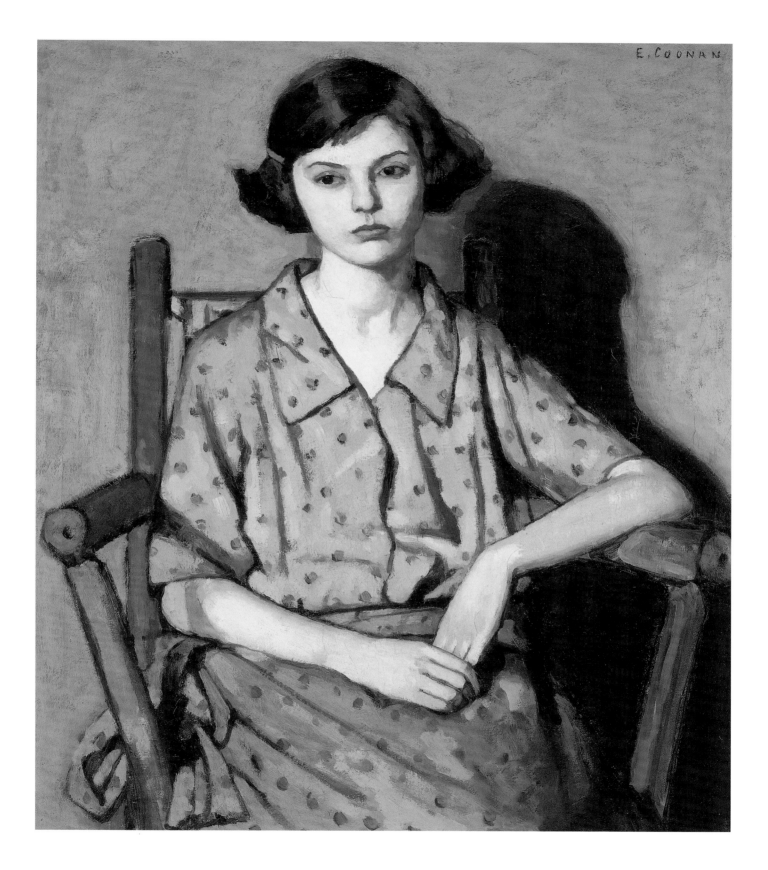

Maurice Cullen (1866–1934)

Wolfe's Cove

1904; oil on canvas; 144.6 cm x 176.2 cm; Musée national des beaux-arts du Québec; 49.75;
Photo by Jean-Guy Kérouac

Newfoundland-born Maurice Cullen began his study of art in Montreal in the sculpture studio of Louis-Philippe Hébert. In 1889, Cullen travelled to Paris to study at the École des beaux-arts, where he decided to shift his attention to painting. He soon turned his back on the academic tradition and embraced the colourful, light-filled and loosely painted style of the Impressionists. Returning to Montreal in 1895, Cullen continued to paint in an Impressionist style. He made small oil sketches out of doors, and later, the sketches would be used as departure points for the larger works that he painted on canvas in the studio. "At some hour of the day," observed Cullen, "the commonest subject is beautiful."

The luminous and dramatic landscape around Quebec City was a favourite sketching spot for artists, and Cullen often painted there in winter. This view of Wolfe's Cove, however, depicts an autumn scene, when the golden light of the season casts the last rays of warmth over the steep slopes of Cap Diamant, jutting boldly into the St. Lawrence. Below, the houses along the shoreline hug the curving road, which carries our eye across the smooth waters to Lévis, on the opposite shore, and up into the breathtaking vastness of the sky. Cullen's talent in capturing the clarity of the light in a brilliant palette of complementary colours drew the praise of the art critic in Montreal's *Gazette* when this work was exhibited, along with five others, in the 1904 Royal Canadian Academy of Arts exhibition: "All show startling originality in composition, treatment and colour scheme. He is in no small degree a mood-painter."

Although the general public was slow to appreciate his sensitive and imaginative interpretations of the Canadian landscape, Cullen was greatly admired by contemporary artists. James Wilson Morrice, with whom Cullen had painted abroad and at home, insisted, "He is one artist who gets to the guts of things." And for younger Montreal artists at the turn of the 20th century, he was, in the words of A.Y. Jackson, "a hero" for introducing them to "the fresh and invigorating movements going on in the art circles of France."

Greg Curnoe (1936–1992)

Zeus 10-Speed

1972; acrylic on plywood and wood; 105.7 cm x 42.2 cm x 2.0 cm; Art Gallery of Ontario;
Gift of Mr. and Mrs. Fredrik Eaton, Toronto, 1985; © Estate of Greg Curnoe/SODRAC (2007);
Photo by Sean Weaver/AGO

In 1972, Greg Curnoe, also an amateur cyclist, began making portraits of his bicycles, which were unique assemblages of parts from an assortment of manufacturers. While many of these works were paintings on paper, with text that listed the bicycle's pedigree or featured nationalistic slogans, *Zeus 10-Speed* is painted on plywood cut out in the shape and size of the actual bicycle. In a gallery, it leans against the wall with the informality and directness that distinguish Curnoe's art.

He once claimed that he had learned nothing at the Ontario College of Art, where his teachers promoted abstract expressionism and believed, he said, "in a culture that had no connection with popular culture." However, in Toronto, Curnoe met artists such as Michael Snow and Michael Sanouillet, a professor who introduced him to Dada, a First World War anti-art nihilistic movement that suited his anarchistic view of the art establishment.

Curnoe's art was rooted in his birthplace of London, Ontario, and reflected views from his studio window of the city hospital, his family, local and historical heroes, jazz bands and bicycles. Executed in a range of media, from painting to collage and assemblage, his work was characteristically animated by bright flatly painted colour and undisguised methods of construction. In November 1992, Curnoe was killed in an accident while cycling with the London Centennial Wheelers.

Ken Danby (1940–)

At the Crease

1972; egg tempera on gessoed panel; 71 cm x 101.6 cm; Private Collection

*L*ike an armoured warrior crouched for battle, the goalie squats and tenses in anticipation of an unwelcome speeding puck. While his barricaded body dominates the composition, it is his masked face which seizes our gaze, transporting a moment in this iconic Canadian sport to the realm of the universal, mysterious and ritualistic. Inspired by his first experience of being confronted by a masked goalie while playing hockey, shortly after masks were introduced to the game, Ken Danby remarked, "I have tried to capture the loneliness and vulnerability that beset a goalie…I felt in portraying this subject I was describing a contemporary hero of Canadian sport, as popular in his way as the discus thrower in ancient Greece." The tension and cohesion of the narrative is further reinforced by Danby's skillful embellishment of the abstract elements of the composition. The stark black and white pattern of the mask is echoed in reverse in the padded glove, while the rounded shapes of his body contrast with the intricate geometry and transparency of the net. Finally, the strong diagonal of the hockey stick links foreground and background in a single breathless stroke.

Danby studied briefly at the Ontario College of Art in the late 1950s, and then left school to pursue his own path of highly polished images that reflect his love of sports, the human figure, and the ever-changing landscape. A believer in the essential importance of drawing and communicating emotion through his art, Danby recently insisted, "My work is the result of analysis, distillation and restructuring, and is not limited to simply realist image making, as is often suggested." Danby was appointed a Member of the Order of Canada in 2001.

Robert Davidson (1946–)

Eagles

1991; gouache and watercolour on paper; 101.0 cm x 101.3 cm;
Collection of the Vancouver Art Gallery, Acquisition Fund VAG 94.3;
Photo by Trevor Mills/Vancouver Art Gallery

Robert Davidson, a great-grandson of the legendary Haida sculptor Charlie Edenshaw, was born in Hydaburg, Alaska, in 1946, and in 1947 the family moved to Old Masset on Haida Gwaii (the Queen Charlotte Islands). There Davidson carved small wooden and argillite totem poles with the encouragement of his father and grandfather. In 1965, he moved to Vancouver and immersed himself in the study of Haida art in the local museums. He met Bill Reid in 1966 and embarked on an apprenticeship during which he augmented his knowledge of Haida design and learned the techniques of gold and silver engraving. Studies at the Vancouver School of Art (1967–68) honed his drawing skills, a talent he would later exercise in his paintings and designs for silkscreen prints.

Davidson's carving of a 12.2-metre crest pole in 1969—the first to be raised in Masset in over 50 years—proved seminal: It opened the door to his participation in Haida rituals and increased his confidence in the realm of Haida art. His involvement in Haida ceremony nourished his creation of new art forms. "We now sing an old song called 'Eagle Spirit,' " he said. "The song is old, but we have created a new dance that expresses who we are today."

As a member of the Eagle clan (all Haida belong to either the Eagle or the Raven clan), Davidson demonstrates his expertise with two-dimensional design in executing works that rejuvenate ancestral imagery. In *Eagles*, the painting that serves as a model for the silkscreen print *Eagle Transforming*, Davidson employs bold ultramarine blue for the formline and adds red and turquoise to produce a joyful pattern where eagles, young and old, in profile and frontal view, spread their wings in a cohesive celebration of Haida iconography.

As a painter, printmaker and jewellery maker, and in his numerous national and international commissions, Davidson continues to celebrate Haida culture and identity, paying homage to the canons of traditional Haida art, and endowing it with innovation and a modern sensibility. "Art is a gift from the spirit world," said Davidson. "When we crystallize these ideas...we are giving birth to new images, new ideas, new directions... which is no different from what our forefathers did."

Thomas Davies (c. 1737–1812)

View of the Great Falls on the Ottawa River, Lower Canada

1791; watercolour over graphite on wove paper; 34.6 cm x 51.4 cm;
National Gallery of Canada; Purchased 1954

In 1755, young Lieutenant Thomas Davies attended the Royal Military Academy in Woolwich, England, where he also received training in watercolour before embarking the following year on the first of his four postings to Canada. In his leisure time, whether in war-torn Louisbourg, Nova Scotia, during his first sojourn or in the more peaceful environs of Quebec City during his last, Davies depicted the forts, harbours and landscapes of his surroundings, infusing them with his British sense of the picturesque and an orderly taming of the rugged environment.

With a true military penchant for accuracy, Davies added a precise inscription identifying the view of Great Falls on the Ottawa River. In the foreground, a bank of flat rocks and a line of small trees sweep up to the right, framing our view of the fast-moving Chaudière Falls. In the middle ground, several indigenous people in red and blue clothing provide colourful relief to the expanse of rock, while on the opposite shore, tiny figures portage canoes. Davies' view was a highly personal one, detailed and enhanced by the brilliance of the colour, the refinement of the painting and the delicacy of the drawing. While Davies' output was extremely varied, reflecting the diversity of his travels in Canada, his vision was always ordered and peaceful, perhaps as he wished to remember his military excursions.

Paterson Ewen (1925–2002)

Cloud Over Water

1979; acrylic on galvanized steel and gouged plywood; 244.0 cm x 335.0 cm;
Art Gallery of Ontario; Purchase with assistance from Wintario, 1980; © 2000 Paterson Ewen

With the primal vigour of the elements themselves, Paterson Ewen gouges giant sheets of plywood with an electric router to create images that overwhelm the viewer with the authoritative power of nature. Here, a single white-metal cloud is suspended like an undetected missile over a black body of water animated by orange and turquoise streaks reflecting the waning sunny brilliance above. The sheer weight and evident texture of the wood evoke the brute forces of nature, while the irregularities of knots and gouging suggest its unpredictable temperament. Ewen explained, "I call my work 'Phenomascapes,' because they are images of what is happening around us as individuals—rain, lightning, hail, wind…They are sometimes inner phenomena. I observe, contemplate and then attack."

Born in Montreal, Ewen studied at McGill University and, from 1948 to 1950, at The Montreal Museum of Fine Arts with W. Goodridge Roberts. In the early 1950s, he exhibited abstract art with the Automatistes. Ewen moved to London, Ontario, in 1968, and in 1970, while hand-gouging a piece of plywood in preparation for a woodcut, he discovered that by applying paint to the surface with rollers, his work was complete and he had no need to make a print. Armed with this new technique, Ewen embraced his long-standing interest in meteorological events, the Earth, the moon and outer space.

Ivan Eyre (1935–)

Wildcat Hills

1976; acrylic on canvas; 142.2 cm x 304.8 cm; The Montreal Museum of Fine Arts; Purchase, Horsley and Annie Townsend Bequest; 1976.38; Photo by Marilyn Aitken/MMFA

*E*voking the timeless beauty of a medieval tapestry, a luminous panorama stretches before us, meticulously detailed and evenly textured. Trees from different seasons border rambling fields that extend far into the distance and, it would seem, beyond the frame.

Although this and other landscapes might recall the prairie vistas of Ivan Eyre's youth, they are, in fact, invented places—"geographies of the spirit," sometimes tinged with unhappiness—created from the artist's memories of real places. Here, the absence of living creatures and of a single focal point lends an eerie feeling to this display of nature's bounty. "As Joseph Conrad knew," wrote Eyre, "there is darkness in every human heart...in my recent work...the darkness has moved underground, but there are some who still see it lurking behind the membrane of subject matter."

Eyre was born in Tullymet, Saskatchewan, and studied drawing with Ernest Lindner and, later, Eli Bornstein in Saskatoon. He graduated from the University of Manitoba School of Art in 1957 and taught there from 1959 until his retirement in 1992. In 1965, a Canada Council grant enabled him to travel throughout Europe, where his discovery of Japanese and European old masters confirmed his belief that "the degree to which the human spirit is locked into a work of art measures the work's 'nowness' and the artist's greatness."

Gathie Falk (1928–)

Nice Table with Raspberries

1993; oil on canvas; 51.0 cm x 76.0 cm; 122.0 cm x 122.0 cm; 76.0 cm x 51.0 cm;
Collection of Ron and Jacqueline Longstaffe; Photo by Trevor Mills/Vancouver Art Gallery

In her long and prolific career as a painter, sculptor and performance artist, Gathie Falk has always drawn on her immediate environment and the stuff of everyday life as subjects for her art. From heaps of apples to tidy rows of shoes in sculpture, to paintings of gardens, chairs and skies, she embraces the ordinary, transforming it with both humorous and unsettling effects.

For the *Nice Table* series of paintings executed from 1993 to 1994, she presented tables set with fruit and other objects, in the sheltered patio between her house and studio in Vancouver. In *Nice Table with Raspberries*, the orderly arrangement of the bowls of raspberries contrasts with the unruliness of the garden that almost threatens to overwhelm the table and architecture. While the bowls of fruit and flowers suggest life and abundance, the cool white light casting shadows under the table, the dark sky and greyish foliage create an ominous mood evocative of death. Little block letters spell out the word NICE, and denote the beauty of everyday life in the context of Falk's Amish-Mennonite heritage, but they are portentously cast in shadow. Evoking the form of the medieval triptych, Falk balances the deep perspective of the central panel with alternate points of view in the flanking panels. Juxtaposing nature and culture, Falk contrasts the bounty of the fruit with language (NICE) on the left, and the riot of red and white flowers with the built table on the right.

Born in Manitoba and raised by Mennonite parents, Falk studied at the University of British Columbia. In 1997, she was appointed a Member of the Order of Canada for her outstanding achievements as a Canadian artist.

Marcelle Ferron (1924–2001)

The Dorset Signal

1959; oil on canvas; 142.2 cm x 304.8 cm; The Montreal Museum of Fine Arts;
Purchase, Canada Council grant and Horsley and Annie Townsend Bequest;
© Estate of Marcelle Ferron/SODRAC (2007); 1960.1239; Photo by Brian Merrett/MMFA

Marcelle Ferron studied under Jean-Paul Lemieux at the École des beaux-arts in Quebec City in 1942, then moved to Montreal, where she became associated with Paul-Émile Borduas and the Automatistes. As a signatory to the 1948 manifesto *Refus global*, Ferron embraced a style of abstraction inspired by Surrealist theories of automatism, where the artist worked spontaneously from dreams and the subconscious. This nonrepresentational and gestural expression was a call for a new order in art as well as in society.

For *The Dorset Signal*, Ferron ground her own pigments and blended them with poppy-seed oil to achieve colours of unusual brilliance. She applied the paint with a broad trowel-like instrument, mixing it directly on the canvas. Here, swatches of red-black sweep down from the top, while a symphony of blues and blue-greens collides with orange to create an image of energy and excitement. This allover patterning of colour, in which no single element of the composition dominates, may reflect Ferron's beliefs in social egalitarianism, but it may also be an expression of the joy and liberty she experienced following her move to France in 1953. The repressive Church-dominated society of Quebec had been unsympathetic to her artistic vision. In France, however, where artistic expression was embraced, Ferron's feelings of emancipation were manifest in bigger and brighter paintings.

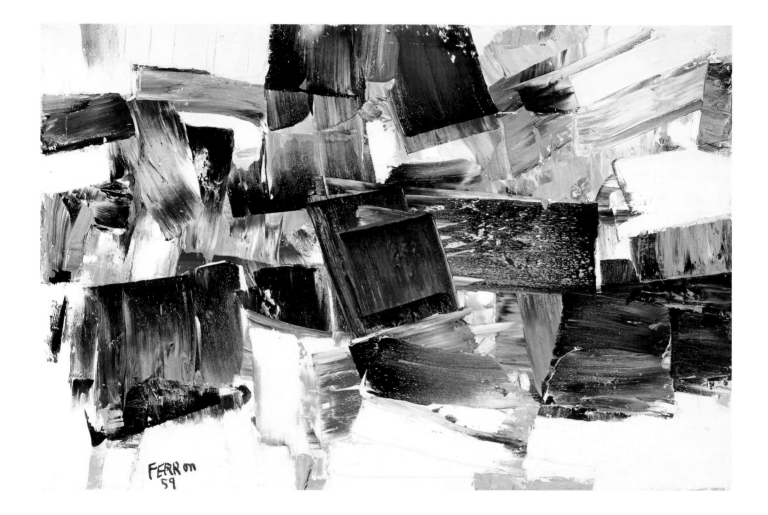

Robert Field (1769–1819)

Lieutenant Provo William Parry Wallis, R.N.

1813; oil on canvas; 76.2 cm x 63.5 cm; National Gallery of Canada; Purchased 1950

The capture of an American frigate on the Atlantic Coast by the H.M.S. *Shannon*, commanded by the young Second Lieutenant Provo William Parry Wallis in the War of 1812, provided the occasion for this portrait. Shortly after the event, Wallis sat for Robert Field, Halifax's most eminent portrait painter.

With the dignified bearing of a classical bust, the 22-year-old Wallis looks at us with serene confidence, fresh from victory. He is presented as a romantic hero, set against a background of stormy clouds, his boyish expression and steady gaze complemented by a head of brown curls tousled in an imaginary wind. He is elegantly attired in the undress uniform of a British lieutenant, and the gold of his epaulette and crisp white frill of his shirt add to his flair.

British-born and trained at the Royal Academy in London, Field learned a manner of portrait painting that combined an admiration for classical art with a hint of romanticism. Like many artists of his time, Field travelled widely in search of commissions. After 14 years in cities along the east coast of the United States, he arrived in Halifax in 1808. To promote his skills as a portraitist, he placed a notice in the *Royal Gazette* and attracted enough business painting portraits of Halifax's wealthy elite and ruling government officials to sustain his stay in the city until 1816. Three years later, Field died of yellow fever in Jamaica.

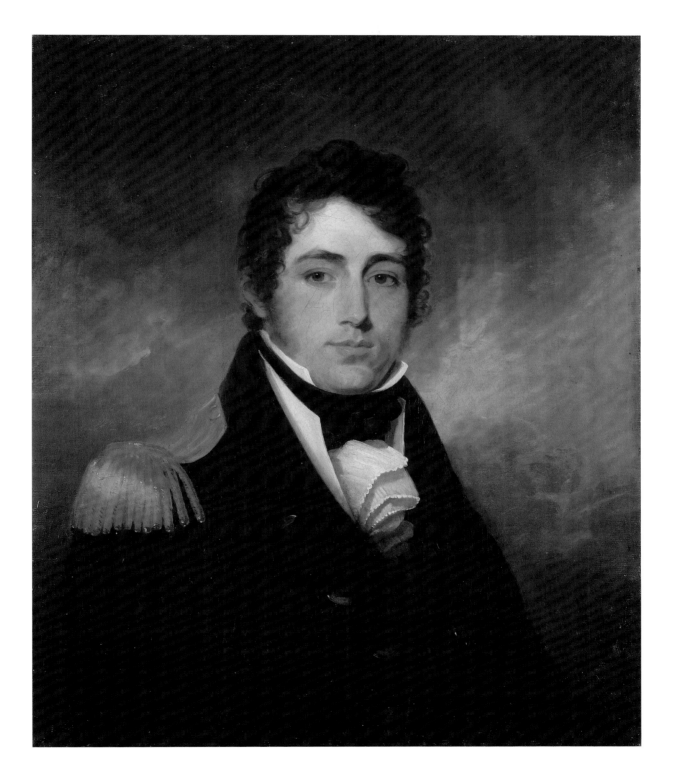

Lionel LeMoine Fitzgerald (1890–1956)

From an Upstairs Window, Winter

c. 1950–1951; oil on canvas; 61.0 cm x 45.7 cm; National Gallery of Canada; Purchased 1951

Lionel LeMoine FitzGerald's development as an artist, from his training in evening classes in Winnipeg at the age of 19 through his study at the Art Students League in New York City at 31, entailed the gradual purging of all extraneous detail from his art. While this slow and painstaking approach was very much a product of the Manitoba-born artist's contemplative personality, it was also influenced by his admiration for American artists such as Charles Sheeler, who pruned his own view of urban architecture to a near-abstract pattern, a path that FitzGerald himself would take in the last decade of his life.

In the foreground of *From an Upstairs Window, Winter*, a small white jug, a pencil and thin grey notebook are framed by the rectangular shape of the window. In contrast to the orderly arrangement of geometric volumes inside, the view to the outside offers a tangle of curving lines and intersecting planes where leafless trees tower over snow-covered roofs and vacant yards. Rendered with meticulous brushstrokes and a subdued palette of soft greens, browns, greys, and whites, the painting exudes a state of timelessness and serenity. "We can only develop an understanding of the great forces behind the organization of nature by endless searching [of] the outer manifestations," FitzGerald wrote, "and we can only know ourselves better and still better by this search...I pray that I shall never [lose] the inspiration that comes from the constant communication with living forms...I want to walk in the light that is never ending with an open heart and open mind."

In a 1945 issue of *Canadian Art*, Group of Seven artist Lawren Harris—who had a particular affinity with the artistic approach of the contemplative FitzGerald—wrote an appreciation of the latter's work: "There is a grace and ease of technical accomplishment in these paintings which, in its mastery, could only have been achieved by an utter simplicity of mood and dignity of spirit."

Marc-Aurèle Fortin (1888–1970)

L'Orme à Pont-Viau (*The Elm at Pont-Viau*)

c. 1935; oil on canvas; 137.0 cm x 166.4 cm; Musée national des beaux-arts du Québec; 37.20;
© Musée Marc-Aurèle Fortin/SODART 2007; Photo by Patrick Altman

A massive elm tree dominates the foreground and commands our attention as a symphony of green defines its abundant foliage. Dwarfed by its size, casting fishermen create elegant black lines that are almost lost against the verdant land and the strip of sleepy blue river. Behind billowing white clouds, the sky darkens to a violet-blue, and a storm, announced by a fork of lightning between the church steeples, threatens the idyllic quiet.

The image's tranquillity belies the spontaneous method with which it was painted. Subsequent to his 1935 trip to Europe, Marc-Aurèle Fortin began to experiment with his *manière noire*, or black manner, whereby he covered the entire surface of his canvas or board with black enamel. Once it was dry, he deposited colour directly from the tube and then later extended these applications with a brush, achieving an intense luminosity and brilliance of colour.

Fortin was born in Ste-Rose, Quebec, once a suburban village north of Montreal, and for his entire life, he was devoted to landscape painting that celebrated the beauty of nature. Even when depicting the port or suburbs of Montreal, such as Pont-Viau, he focused on the bucolic aspects of regions not yet encroached by modern urbanism and remained faithful to the role of the artist as a celebrator of nature's beauty. "Painting," he said, "is silent poetry."

Claude François (Frère Luc) (1614–1685)

La France apportant la foi aux Hurons de la Nouvelle France

c. 1670-1671; oil on canvas; 227 cm x 227 cm; Musée des Ursulines de Québec, collection du Monastère des Ursulines; Photo by Patrick Altman, Musée national des beaux-arts du Québec

In August 1670, Parisian artist Claude François, a Récollet priest also known as Frère Luc, arrived in Quebec City. He travelled with the intendant Jean Talon, who had been charged by Louis XIV to reestablish the Récollets in New France. Whether François painted this work has been a matter of some debate, but the fact that he was a member of a religious order known to be loyal to the Crown fits with the didactic and allegorical nature of the painting.

On the shores of the St. Lawrence River, a woman who personifies the reigning French monarchy points toward the heavens, where the Roman Catholic Trinity is assembled with saints. On the ground, she presents a painting, which depicts an enthroned Jesus Christ, to a kneeling man, whose native garb has been replaced by a cloak embellished with the insignia of the French monarchy.

The painting, on one level, is a reflection of the common practice in 17th-century New France of importing works of art to remind settlers of their religious beliefs and to further the conversion of the native peoples. Also, in the context of the struggle between the state and the monarchy for control of the Church in New France, the painting implies that religious authority is in the hands of the monarchy, since it is "la France" that is literally, as the title suggests, "bringing the faith to the Indians."

Charles Gagnon (1934–2003)

(Steps) December

1968–1969; oil on canvas; 203.2 cm x 274.2 cm; The Montreal Museum of Fine Arts; Purchase,
The Saidye and Samuel Bronfman Collection of Canadian Art; © Michiko Yajima Gagnon;
1969.1623; Photo by Brian Merrett/MMFA

Greyish white brush strokes crisscross the large surface of the canvas like a blinding blizzard obscuring our view. In contrast to the gestural freedom of the white space, the severity of the black border is still, functioning as a window frame to a limitless space. Most pronounced is the ambiguity created by the illusion of a bright space that appears both shallow on the surface and illusionistically deep, receding behind the black border. These dynamic contrasts of black and white, combined with the free brushwork and the large scale of the painting, are a testimony to Charles Gagnon's study of art in New York City from 1954 to 1960. A resident during the heyday of abstract expressionism, Gagnon admired the dramatic effects of a reduced palette, gestural application of paint and simplified structure in the work of artists such as Franz Kline and Robert Motherwell.

Returning to Montreal in 1960, Gagnon—who is also a photographer and a filmmaker—worked with a variety of media. "Media are to be used," he has said. "I don't see any difference between film and photography and sculpture and painting and thinking and farming…It's life that interests me." Because he is not limited by narrow definitions of media, Gagnon seeks to express his personal vision and appreciates that painting, photography and film all allow him to explore the illusion of space on a flat surface.

Clarence Gagnon (1881–1942)

Laurentian Village

1927; oil on canvas; 73 cm x 92 cm; Musée national des beaux-arts du Québec; 34.637; Purchase, 1928; Photo by Patrick Altman

Along the road through a small Quebec village, we follow in the wake of a horse-drawn sled, whose green and red hues harmonize with the equally colourful architecture flanking its path. Set against the Laurentian Mountains looming cool and blue in the distance, the gaily painted houses and the sweeping lines of the traditional rooftops create a picturesque view of times past, so dear to the artist Clarence Gagnon.

Gagnon was born in Montreal in 1881 and in 1897 studied with William Brymner at the Art Association of Montreal. Gagnon was attracted to Brymner's paintings that idealized rural life and landscape in the manner of the French Barbizon painters, and soon followed his teacher's advice to explore the Laurentians and Charlevoix regions of eastern Quebec. There Gagnon discovered small agricultural communities, rolling landscapes, and an adherence to a pre-industrial way of life that would inspire his art for many years to come.

In 1904, Gagnon went to Paris and studied briefly at the Académie Julian. For the following few years, he divided his time between travelling throughout Europe in search of subjects for his art, and painting and print-making. Praised for his meticulous and atmospheric etchings of quaint European villages and tourist spots, his prints won many awards and attracted the attention of collectors and museums in Europe and North America. Despite this success, Gagnon soon abandoned etching, and returned to painting, embracing subjects that reflected his French Canadian roots and his love of "the abundance of colour in the lives of the habitants."

Over the next three decades while maintaining a studio in Paris, Gagnon frequently traversed the Atlantic, returning to his beloved Charlevoix to hunt and fish, and to paint in the quiet of the countryside. In 1928, Gagnon embarked on his most famous oeuvre: the 54 paintings for the deluxe edition of Louis Hémon's novel *Maria Chapdelaine*. Drawing on a lifetime of observations and sketches of the people, customs and landscape of rural Quebec, he created jewel-like images of the changing seasons and rituals of these people who lived close to the land.

Yves Gaucher (1934–2000)

Triptych: Signals, Another Summer; Signals, Very Softly; Silence/Silence

1966; acrylic on canvas; each panel 203.2 cm x 152.7 cm (overall installed dimensions: 203.2 cm x 483.6 cm) ; Art Gallery of Ontario; The Canada Council Special Purchase Assistance Program and Wintario, 1977; © SODART 2007; Photo by James Chambers/AGO

Born in Montreal, Yves Gaucher studied at the École des beaux-arts from 1954 to 1960, specializing in printmaking. In the early 1960s, he attended contemporary music festivals in Paris, where he felt challenged and disturbed by the music of composers such as Pierre Boulez and Anton von Webern.

"The music seemed to send little cells of sound into space," explained Gaucher, "where they expanded and took on a whole new quality and dimension of their own." These musical cells would later become "signals" in paintings such as *Triptych*, composed of three monochromatic panels punctuated with short horizontal lines arranged rhythmically over their surfaces. The relationship between the boldly coloured primaries of the panels and the more softly coloured signals evokes distinct moods that suggest an unexpected poetry within the cool geometric format. This lyricism is echoed in the artist's titles for each of the panels: *Signals, Another Summer* (red); *Signals, Very Softly* (yellow); and *Silence/Silence* (blue).

The work of American abstractionist Mark Rothko also influenced Gaucher, who was struck by the capacity of Rothko's large, minimally detailed coloured surfaces to captivate his attention to the extent that he lost a sense of time passing. This led Gaucher to create paintings that invited a similar mood of contemplation.

General Idea (active 1968–1994)

AIDS

1987; acrylic on canvas; 182.9 cm x 182.9 cm; Private Collection, Chicago

In 1968, three Toronto-based artists known by the pseudonyms AA Bronson, Felix Partz and Jorge Zontal banded together under the title of General Idea, a name whose ambiguous evocations of the military and of commercial corporations forecast the cryptic and elusive nature of its multi-discipline expression. Believing that "three heads were better than one," they debunked the notion of the artist as an individual genius. They appropriated and manipulated the formats of mass media and popular culture, staging performances and producing installations, sculptures, paintings, graphics and even their own magazine, *File*, an artistic spoof on *Life*.

Although the tone of their work darkened in the late 1980s with the focus on AIDS-related subjects, their fascination with exaggeration and the impersonality of mass production continued unabated. Invited in 1987 to participate in an "Art Against AIDS" benefit, the artists turned to Robert Indiana's well-known word-image *LOVE*, borrowing his red, blue and green palette, and compressing the AIDS' capitalized letters into a giant painting almost two metres square. Conflating the original symbol of sixties free love with the grim reality of disease and death was an audacious move. "Often, there was observable a sublimely awkward moment when LOVE + AIDS collided and mentally imploded," they wrote. Following the example of Indiana, whose *LOVE* image was disseminated in a wide range of media in popular culture, General Idea similarly produced graphics, sculptures, wallpaper, and low-cost posters pasted in the street and on public transportation, "like advertisements for a most undesirable commodity."

In 1994, Partz and Zontal died of AIDS-related illnesses, ending the trio's collaboration. AA Bronson continues to makes art exploring his identity as an individual. He received the Governor General's Award in Visual and Media Arts in 2002.

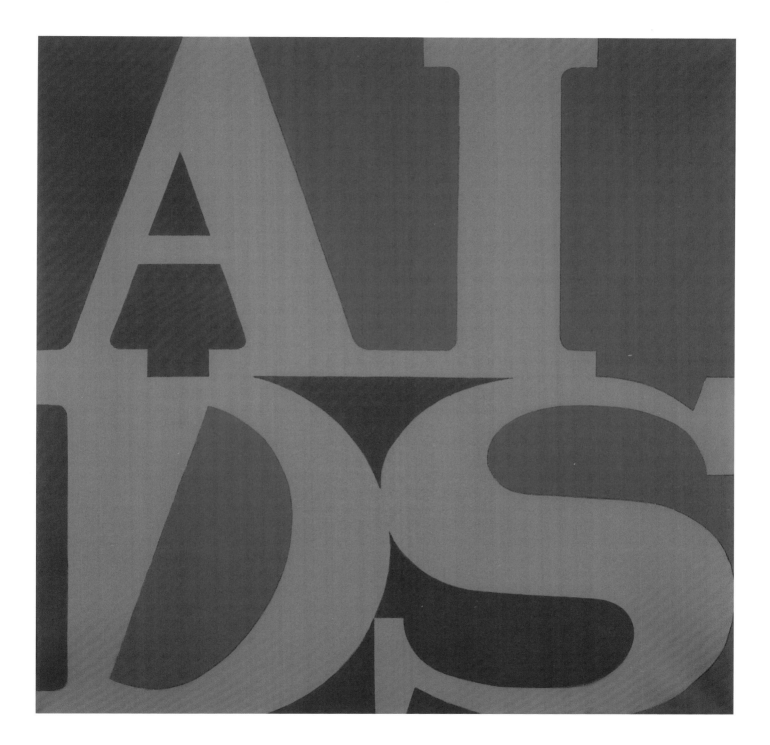

Betty Goodwin (1923–)

Moving Towards Fire

1983; oil, coloured chalks, graphite and watercolour on three sheets of thin wove paper;
291 cm x 108 cm (each sheet; 291 cm x 324 cm installed); Art Gallery of Ontario, Purchase, 1985;
© Betty Goodwin Collection of the Art Gallery of Ontario

In the early 1960s, before Betty Goodwin attracted critical acclaim for a series of etchings based on men's vests, she knew that a work of art "must possess an intense reality revealing more than the visible." Earlier, the largely self-taught Montreal-born Goodwin had been exhibiting her still lifes and figurative work, which showed her compassion for postwar suffering in an expressive style of social realism. Despite the positive reception of this work, Goodwin knew that she had yet to discover an effective visual language to express her inner self.

In 1968, she attended an etching class given by Yves Gaucher at Sir George Williams University (later Concordia) in Montreal and began to experiment with printing, using clothing and other objects pressed into the etching plate. "The Vest series was related to experiences that had been submerged," she explained. "It was something I totally identified with…and for that reason, it was a point of incredible satisfaction and the starting point of everything else."

Although Goodwin has explored a vast array of materials and subjects over the course of her career—producing sculpture, paintings, prints, drawings, and installations—the theme of the body, its presence and absence, has endured as a central preoccupation.

The impact and powerful drawing of *Moving Towards Fire* is made intense not only by the work's huge scale—almost three metres high—but also by the near life-sized red figure descending stiffly into the transparent green waters, leaving a red wash in his wake as if he were bleeding or dissolving. The delicate drawings of a bridge to the left, and the arrival of another swimmer in the top-right corner, raise questions about the swimmer's mysterious drama. Embracing the ambiguity of this narrative, Goodwin addresses the uncertainties and fragility of life. Speaking of the Swimmer series, she said: "It has to do with the idea that water certainly is a giver of life, but it's also a taker of life…there's a struggle between moving out or being pulled down…water is all-giving but treacherous. I like that dichotomy."

In 2003, Goodwin was made an Officer of the Order of Canada for her distinct contributions to Canadian art.

Haida Artist

Drum

before 1900; stretched hide; D: 62.4 cm; H: 9.0 cm;
Courtesy of the Royal British Columbia Museum, Victoria, B.C./Cat. No. 10630

A 19th-century Haida artist designed this drum following the dictates of tribal traditions prescribing the use of a strong outline, or formline, embellished on the interior by a series of oval and elongated ovoid shapes that were inspired by the contour of a fish's head. Here, the artist's hand sweeps gracefully across the surface of the deerskin drum, painting lines that curve and swell continuously like the waves of the sea. Using a porcupine brush and vermilion-red paint obtained from Chinese traders, the artist repeated the drum's steamed and bent wooden form in depicting a round-headed shaman whose skeletal body and open palms are vulnerable to the forces of good and evil. Also inscribed in a circle is a frog, the shaman's helping spirit, which protects him from the barrage of arrows flying toward his head.

A painting that tells a story is rare in Haida art, since the usual purpose of painting objects with images of animals was to acknowledge the owner's ancestral crests or affiliations. The shaman's robes, mats, drums and other paraphernalia, however, could be painted with additional images to empower him when he performed ceremonies. The brilliant colour and line drawn on the deerskin surface of the drum have been preserved because it was beaten from the other side. The image faced the shaman, and its powers flowed toward him.

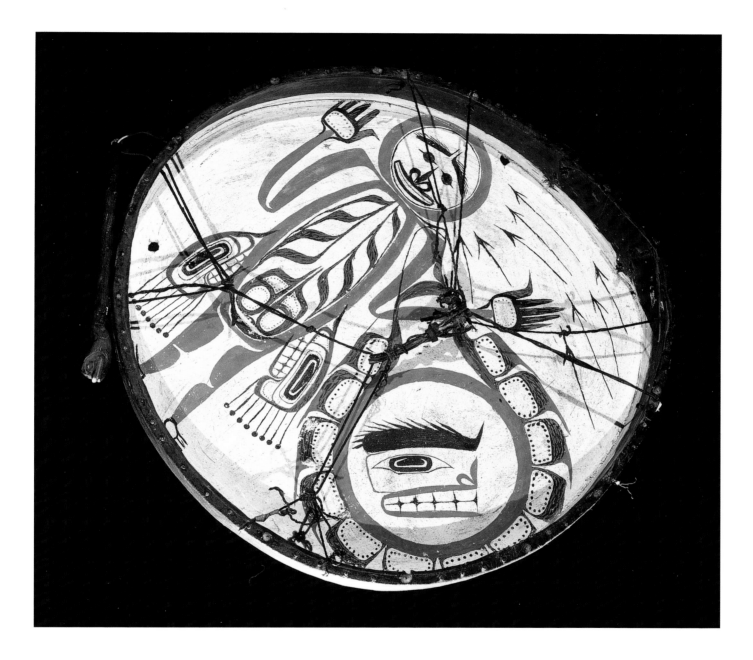

Lawren S. Harris (1885–1970)

Lake and Mountains

1928; oil on canvas; 130.8 cm x 160.7 cm; Art Gallery of Ontario;
Gift from the Fund of the T. Eaton Co. Ltd. for Canadian Works of Art, 1948;
Photo by Carlo Catenazzi/AGO

When Lawren Harris saw J.E.H. MacDonald's exhibition of landscape sketches at the Arts and Letters Club in Toronto in 1911, he was profoundly moved by the way the sketches captured the feeling of the land. Earlier, following his studies and travels in Europe, Harris had begun to dream about a distinctly Canadian art that would express, as he wrote, "the character, the power and clarity and rugged elemental beauty of our own land." He and MacDonald became friends, and in 1913, they saw an exhibition of modern Scandinavian paintings in Buffalo, New York. Impressed by these artists' approach to similar northern subjects, they were convinced of their mission to create a manifestly Canadian art using a new visual language. By 1914, however, the impetus of these and other like-minded Toronto artists, known as "the Algonquin Group," was cut short by the First World War.

Following the war, Harris led sketching trips to the Algoma region of northern Ontario, and in 1920, he was central in the organization of the first Group of Seven exhibition at the Art Gallery of Toronto. Thereafter, although the artists continued to exhibit as a group until 1932, they tended to go their separate ways. The spiritually minded Harris, influenced by his reading of Wassily Kandinsky's *Concerning the Spiritual in Art* and by his interest in theosophy, sought a landscape that would better express his spiritual beliefs. After a number of excursions to, and a great many famous paintings inspired by, the austere grandeur of the north shore of Lake Superior, Harris explored the Rockies in 1924. There, he found "a power and a majesty and a wealth of experience at nature's summit."

In *Lake and Mountains*, the blue triangular shapes of mountains soar upward to brilliant white clouds whose erratic, clawlike forms contrast with the stable monumentality of the ancient rock. In the foreground, smooth landforms define the shores for the gently rippling waters that lap silently in their shadows. For Harris, this simplification and distillation of nature's forms evoked an ascent to spiritual awareness that would later find its most complete expression in the purified realm of abstraction.

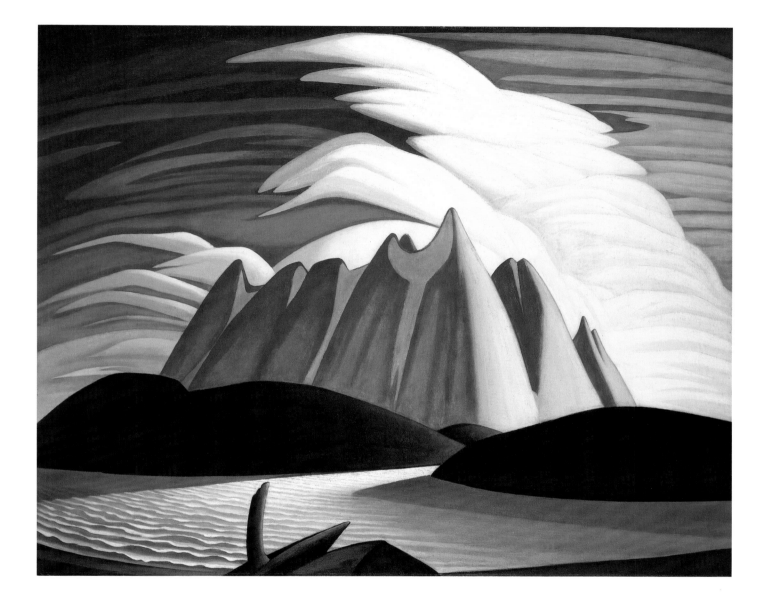

Robert Harris (1849–1919)

A Meeting of the School Trustees

1885; oil on canvas; 102.2 cm x 126.5 cm; National Gallery of Canada; Purchased 1886

This well-known masterpiece by Prince Edward Island native Robert Harris was painted following Harris's honeymoon in Europe, during which he and his wife Bessie visited numerous art galleries. In his autobiography, Harris expressed his debt to artists such as Rembrandt and Vermeer: "These men show us, for once and for all, that there is an art which deals...directly with the spirit of man; an art ever aspiring to the noble, the beautiful and the sublime."

Adapting a compositional format from Netherlandish painting, where light from the upper left illuminates a group of people gathered at a table, Harris depicts an event described to him by his friend Kate Henderson, who reported that she had been "laying down the law" to the school trustees and generally "talking them over." Silhouetted by the golden light, the prim, youthful figure of the teacher (modelled by Bessie) contrasts with the untidy farmers gathered to advise her on matters concerning the school. Like actors in a silent play, the trustees declare their response to her beckoning hand through their facial expressions and body language. From mild hesitation to closed-fisted resistance, the trustees exhibit a symbolic reluctance to change in the face of necessary progress and reform. To show his own support for the struggles of rural teachers, Harris carved his name in the desk by Kate's hand.

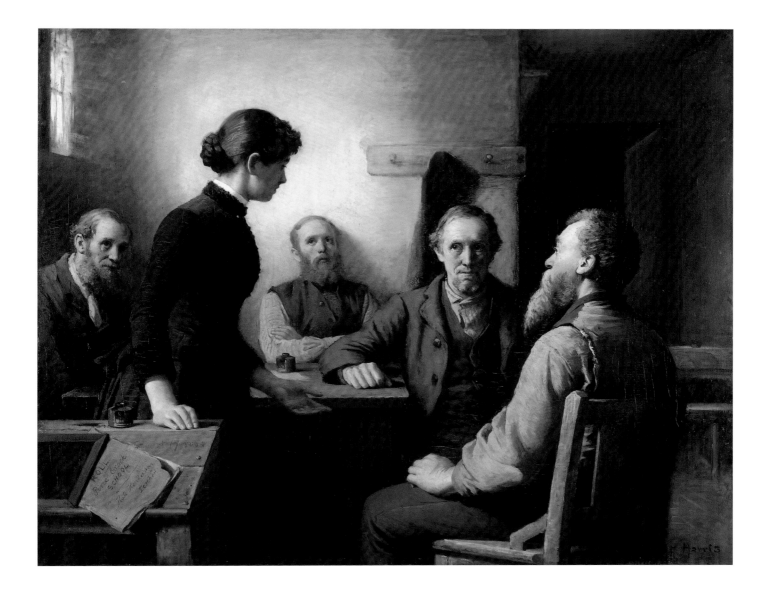

Adrien Hébert (1890–1967)

Le Port de Montréal

1924; oil on canvas; 153.0 cm x 122.5 cm; Musée national des beaux-arts du Québec; 75.289;
Photo by Jean-Guy Kérouac

From a lofty perspective, ships' masts and poles frame our view of the daily operations in the port of Montreal. They create stark linear patterns against the clusters of lifeboats, chimneys and foghorns that occupy the middle ground, where warm sunlight illuminates the white walls of the cabins and the orange-red mass of the smokestacks. The same red draws our attention to the workers carrying their loads across the drawbridge. In the background, grain elevator number 2, built entirely of concrete, circa 1912, towers majestically like an acropolis on the port, its austere geometry and broad, even surfaces providing visual relief from the bustle below.

For artist Adrien Hébert, son of sculptor Louis-Philippe Hébert, the busy port's complex array of lines, shapes and colours was a thing of beauty, a worthy subject for art and a welcome symbol of industrial progress. "Listen to its music," he wrote, "the great symphony created by the loading and unloading of grain, the banging of the steel cables, the noise of the winches and the chatter between tugboats and ocean liners." A contributor to the avant-garde arts publication *Le Nigog* since 1918, Hébert was part of a Montreal artistic elite that battled for the tolerance of current artistic movements. "Having accepted modern life," he said, "it is only logical to embrace modern subjects in art."

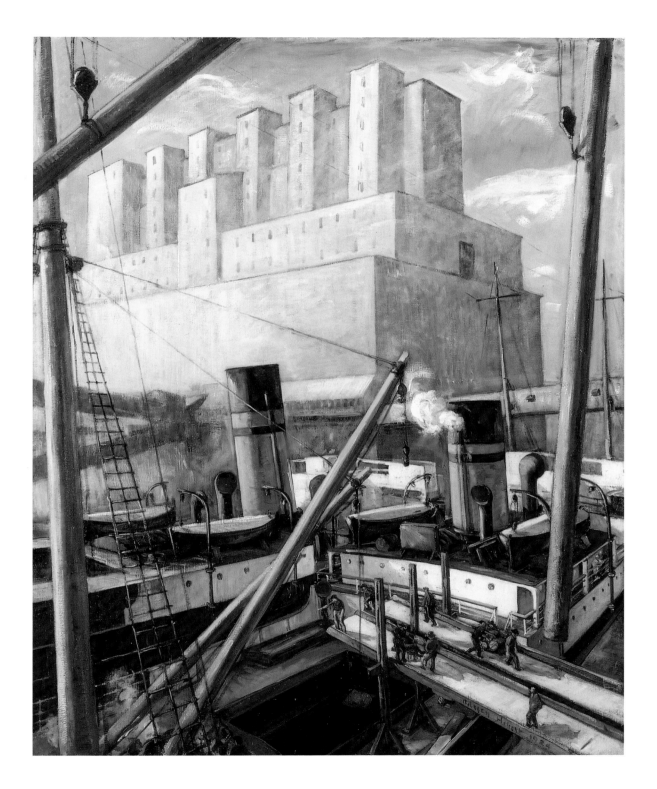

George Heriot (1759–1839)

Lake St. Charles Near Quebec

c. 1801; watercolour over graphite on laid paper; 27.3 cm x 44.5 cm;
National Gallery of Canada; Purchased 1954

As Deputy Postmaster General of British North America from 1799 to 1816, George Heriot travelled widely throughout the Canadas, inspecting postal stations and noting, with sketchbook in hand, the amusements and favourite nature spots of the garrison societies. Benefiting from his education at the Royal Military Academy, Woolwich (where he had been trained by renowned British watercolourist Paul Sandby), Heriot learned to combine accurate description with atmosphere, fusing precise drawing with delicate transparent washes of watercolour.

Heriot described his impressions of Lake St. Charles in his 1807 publication, *Travels through the Canadas*: "On arriving at the vicinity of the lake, the spectator is delighted by the beauty and picturesque wildness of its banks...The lofty hills...in shapes singular and diversified, are overlooked by mountains which exalt beyond them." Our view of the lake in this painting is dominated by the large trees, rendered in soft tones of green and brown, that dwarf the tiny figures in boats silhouetted against the pearly lake. Across the water, the thinly painted mountains rise with the ethereal quality of a mirage, transforming the wilderness into a poetic vision of a magical parkland. Without the title to reassure us of its location, we might think we were travelling with some other Romantic painter in Europe.

Prudence Heward (1896–1947)

Sisters of Rural Quebec

1930; oil on canvas; 157.4 cm x 106.6 cm; Art Gallery of Windsor;
Gift of the Women's Committee, 1962

*I*n Prudence Heward's painting, the figures of two sisters from rural Quebec intersect to create opposing diagonal thrusts that are echoed in their contrasting expressions. The younger Pierrette sits with her hands folded, but her despondent expression is at odds with her bright turquoise apron and violet-pink chair. The older Rollande is slightly defiant, her back pressed firmly into her chair and her dark clothes underscoring the severity of her expression. The starkness of the space defined by repeated window frames and sparse foliage evokes the austerity of life effected by the economic deprivations of the 1930s.

The work is typical of Heward's portrayals of women whose emotional vulnerability and intimation of sadness contrast with a physical impression of strength. In the words of art critic Paul Duval, "[her] painted world is one of sad reflections. Her subjects look out of their frames wondering and a little afraid. They strike one strongly as people living in a world which they cannot quite comprehend."

Heward studied art in Montreal and Paris and, with other Montreal artists such as Edwin Holgate and Lilias Torrance Newton, formed the short-lived Beaver Hall Group (1920–21). Invited to exhibit with the Group of Seven in 1928 and again in 1931, Heward continued to be recognized for her bold and innovative approach to the figure.

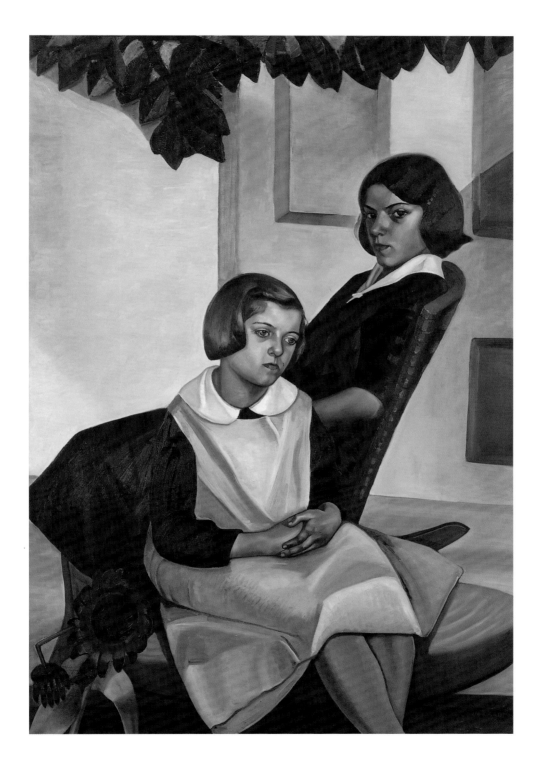

Edwin H. Holgate (1892–1977)

Nude in the Open

1930; oil on canvas; 64.8 cm x 73.6 cm; Art Gallery of Ontario;
Gift from Friends of Canadian Art Fund, 1930; Photo by Larry Ostrom/AGO

Warmed by the afternoon sun, a dark-haired nude woman relaxes on the shores of a crystal-blue lake. The curves of her firmly modelled body are echoed in the smooth, rounded shapes of rocks casting their reflections in the calm waters below. When Edwin Holgate exhibited his nudes in the 1930 Group of Seven exhibition, the art critic for *The Toronto Daily Star* acclaimed: "Holgate sets a new fashion in nudes—away from French decadence to the Laurentians for a background; splendidly painted nudes without cosmetics." Indeed, Holgate showed innovation in presenting a nude in a wilderness setting, free of the subtleties of drapery and the pretenses of mythology often associated with traditional depictions of the subject.

Holgate studied at the Art Association of Montreal with William Brymner and Maurice Cullen before travelling to Paris in 1912, where further training with Russian artist Adolf Milman impressed upon him the importance of fine draughtsmanship and strong colouring. Holgate also admired French artist Paul Cézanne, whose emphasis on solid structure inspired his compositions. In the early 1920s, Holgate was a member of the Beaver Hall Group, and along with such artists as Prudence Heward and Lilias Torrance Newton, he explored a modernist approach to portraits and landscapes, employing the same directness that he had applied to the unclothed figure.

Frances Anne Hopkins (1838–1919)

Canoes Manned by Voyageurs Passing a Waterfall

1869; oil on canvas; 73.7 cm x 152.4 cm; Library and Archives of Canada/C-002771

As the granddaughter of eminent British portraitist Sir William Beechey and the daughter of Arctic explorer Rear Admiral Frederick William Beechey, Frances Anne Hopkins was primed for a career as an artist beyond the conventions of Victorian society. Hopkins arrived in Canada in 1858 with her husband Edward, a Hudson's Bay Company official whose responsibilities included inspecting the company's fur-trading posts, thus affording her unusual subject matter for a woman of her time. In a letter of 1910, she reported, "I have not found Canadians at all anxious hitherto for pictures of their own country."

Hopkins accompanied Edward on at least two trips to Fort William, at the head of Lake Superior, making countless sketches and noting the details of scenery, which would be combined later in studio paintings. With a high degree of realism befitting the tradition of a Victorian narrative, Hopkins records the painted canoe built for transporting officials of the Hudson's Bay Company, the blankets, the luggage, the British flag and the individual faces of the voyageurs; in the centre, she and her bearded husband admire a lily plucked by one of the men. In contrast to this meticulous detailing of objects and people, nature has been depicted in summary fashion, as seen in the loosely painted expanse of rock face and in the fluid reflections in the river.

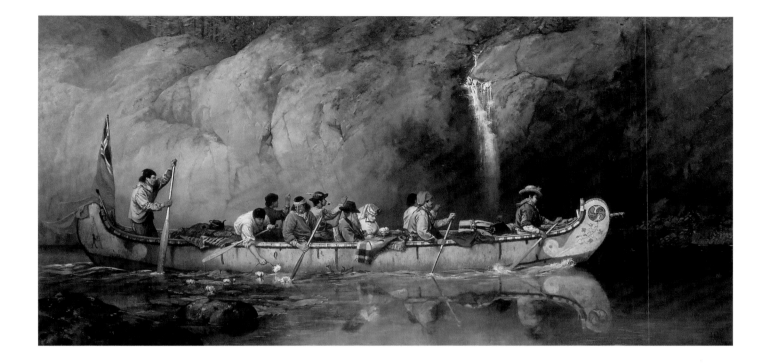

Robert Houle (1947–)

Kanata

1992; acrylic and conte crayon on canvas; 228.7 cm x 732 cm overall;
panels: 228.7 cm x 183.0 cm each; National Gallery of Canada; Purchased 1994

*I*n the 1990s, Robert Houle explored the representation of native peoples in European art, quoting these images in his own work as a critique of colonial attitudes toward the indigenous population. In appropriating Benjamin West's 1770 painting *Death of General Wolfe*, Houle recalled his grandfather's words: "Remember when this country was named, native people were present and native people signed treaties." Indeed, the word "Canada" is derived from the Huron-Iroquois word *kanata*, meaning village or settlement.

Seizing the monumental scale of American abstract expressionism, Houle presents a monochromatic version of West's painting and flanks it with red and blue monochromatic canvases symbolic of the British and French forces. Only the allegorical figure of the Indian seated in the foreground is enhanced by these colours, signifying the involuntary "assimilation" of the native peoples whose lives would be irrevocably changed by the "two founding nations." The Indian, as Houle said, is "in parenthesis...is surrounded."

Houle, who is from the Saulteaux Nation, grew up on the Sandy Bay Indian Reserve northwest of Winnipeg and studied at the University of Manitoba and McGill University. He sees abstraction as a means for native artists to explore the side of their identity central to the "reconstruction of cultural and spiritual values eroded by faceless bureaucracy and atheistic technology."

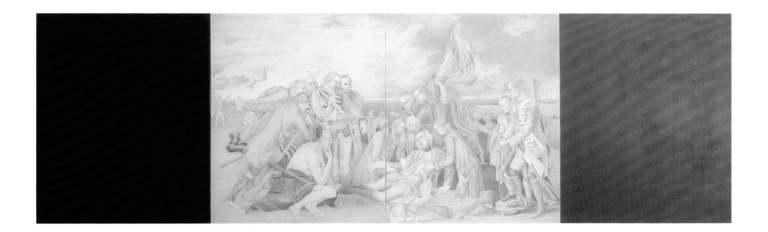

E.J. Hughes (1913–2007)

Logs, Ladysmith Harbour

1949; oil on canvas; 76.2 cm x 101.6 cm; Art Gallery of Ontario;
Gift from the Albert H. Robson Memorial Subscription Fund, 1950; © 2007 Art Gallery of Ontario

With the intricacy of a richly embroidered tapestry, E.J. Hughes presents a singular view of the West Coast landscape, elaborately embellished with the textures, vitality and wondrous patterning of nature. The repeated cylinders of the coarse brown logs cram the harbour and contrast with the perpetual rippling of the rapidly flowing river, attesting to Hughes' rigorous attention to the complexity of nature. In a vista dominated by the lush stands of forest and ominous grey sky, humanity—symbolized by the brightly coloured tugboats, rafts and tiny figures of men—is humbled. Unpretentious and direct about his objectives as an artist, Hughes has said that his intentions were "to make art out of picturesque and popular subjects...in a matter-of-fact way to organize nature as well as possible in the rectangle provided."

Although Hughes was acquainted with the modernist directions of his teachers F.H. Varley and Jock Macdonald in Vancouver, he was more attracted to the art of the past. In particular, he admired the early 20th century French painter Henri Rousseau, sharing with him a disregard for perspective and scale in order to make a picture more interesting. Following a career as a commercial artist and muralist, Hughes worked as a war artist from 1940 to 1946, then returned home to create, in the words of art historian Doris Shadbolt, "a permanent poetry of Canada's Pacific Coast."

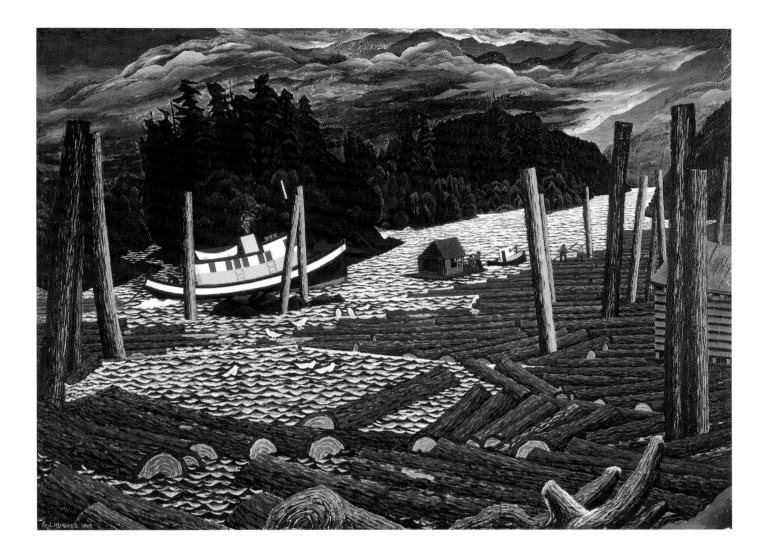

Jack Humphrey (1901–1967)

The Pensive Child (Winnie)

1941; oil on Masonite; 81.5 cm x 61.0 cm; Art Gallery of Hamilton; Gift of Wintario, 1980;
© Humphrey Estate

Winnie rests her chin on her hands and stares with timid expectation. Creating an almost sculptural presence, Jack Humphrey fills the frame with her figure, carefully modelling the features of her face and hair and defining the curving shapes of her rounded shoulders, bent arms and lap. In contrast to the large dominant area of colour established by the green sweater and the dark brown skirt, Winnie's delicate hands and wistful expression evoke the vulnerability and innocence of childhood. "My particular problem," wrote Humphrey, "is to achieve quality which is as universal as it is contemporary while surrounded by a purely regional nourishment."

The "purely regional nourishment" to which Humphrey referred was that of his native Saint John, New Brunswick, a city which had offered him nothing in the form of art education but was the only home to which he could return when the Depression began in the early 1930s. Prior to that, Humphrey had enjoyed a peripatetic education in the United States, France, Italy and Germany, honing his drawing and painting skills. But back on his native soil, trapped by financial misfortune, Humphrey fused the lessons of the academy and modernism and discovered his most enduring subjects in the city's desolate streets and architecture and in the faces marked by hardship, endurance and hope.

Gershon Iskowitz (1921–1988)

Green Highlands No. 5

1977; oil on canvas; 195.6 cm x 228.7 cm; The Montreal Museum of Fine Arts; 1995.30;
Gift of the Gershon Iskowitz Foundation; Collection of the MMFA; Photo by Brian Merrett/MMFA

*E*ngulfed by the scale of this large painting, we find ourselves in a spatial limbo. Are we high in the air, looking down on masses of colour floating in a sea of white space, or are we below, watching free-falling colours and shapes coalesce? The bright greens, oranges and blues dance their own secret language and bring joy to the dreamlike ambiguity of this work.

Although Gershon Iskowitz's ambitions to enrol at the Warsaw Academy were extinguished by the German invasion of Poland in 1939, his urge to create persisted through the atrocities of the Nazi concentration camps of Auschwitz and Buchenwald. There, Iskowitz depicted the horrors and endurance of the people in the camps with a graphic expressionism.

After the war, he studied briefly with Austrian painter Oskar Kokoschka, and in 1949, he immigrated to Canada. Settling in Toronto, he embraced nature as his subject and responded to the brightness of the light and the vividness of the colour in work that abstracted the vitality and essence of the landscape. Of particular importance to the development of his vision was a helicopter trip over Canada's North in 1967. The memories of the land seen through the falling and ascending movements of the helicopter hovering and defying gravity inspired imaginative, intuitive perspectives.

Alexander Young Jackson (1882–1974)

Winter, Charlevoix County

c. 1932–1933; oil on canvas; 63.5 cm x 81.3 cm; Art Gallery of Ontario; Purchased 1933;
Courtesy of the Estate of the Late Dr. Naomi Jackson Groves

In 1909, A.Y. Jackson was working in his hometown, Montreal, as a commercial artist. Recently returned from studies in Paris where he had been attracted to the work of the Impressionists and their manner for capturing the fleeting effects of light in nature, he became excited about "the clean, crisp air and sharp shadows" of his native land. His paintings of sun-filled Quebec landscapes were not appreciated locally, but they did attract the attention of Lawren Harris in Toronto, which ultimately led to Jackson's move there in 1913. Painting with Harris at Georgian Bay in the fall of 1913, and with Tom Thomson and other future Group of Seven artists in Algonquin Park in the fall of 1914, consolidated Jackson's desire "to express, in paint, the spirit of our country."

The war years dispersed the artists. Jackson enlisted in the army in 1915 and, in 1917, received a commission as a war artist from the Canadian War Memorials Fund. He returned to Toronto in 1919 and joined Harris, J.E.H. MacDonald and Frank Johnston on a painting trip to Algoma, reestablishing the prewar artistic camaraderie. These sketching trips and the return of the artists (with the exception of Thomson who died in 1917), to the city led to the first exhibition of the Group of Seven in 1920. While the members of the Group shared common ideals about an approach to Canadian painting, their interests diversified as the decade progressed and as each artist sought out particular areas of the country to paint.

Although he would later sketch in the Rockies and the Arctic, Jackson maintained an attachment to his native province, and in the spring of 1921, when the deep snows still blanketed the fields, he made the first of many trips to the Quebec countryside. In *Winter, Charlevoix County*, we follow a twisting road through the undulating snow-covered farmland on the north shore of the St. Lawrence River. As a horse-drawn sleigh journeys homeward in the pink glow of the sun at the end of the day, telephone poles cast long blue shadows that seem to dance and sway in time to the rhythm of the land.

Alex Janvier (1935–)

The Doggone Weakbacks

1975; acrylic on canvas; 56.0 cm x 71.3 cm; McMichael Canadian Art Collection

A sinuous blue line snakes across the surface of the canvas, and from its underbelly, organic abstract shapes and colour suggest animal life. Other lines descend, flowing into serpentine forms; their narrow heads, at first unnoticed, start to twist and writhe. Although Alex Janvier's title has a political bent and alludes to his criticism of "bureaucratic weakbacks" whose theories never touch the people they are supposed to serve, the work is, at the same time, rooted in his native Dene heritage. In their meandering expansion, the lines evoke the rhythms of the rolling Alberta landscape, and the shapes refer to patterns from traditional hide paintings and quill- and beadwork. As National Gallery of Canada curator Diana Nemiroff has noted, "Janvier's vision is a highly subjective one, recording his personal quest for a spiritual identity."

Janvier studied at the Alberta College of Art in the early 1960s with Illingworth Kerr and Marion Nicoll, whose instruction in automatic painting opened his imagination to an expression of inner worlds in abstract form. He was also attracted to the work of Russian artist Wassily Kandinsky, whose abstract compositions of line and shape sought to encompass spiritual realities. In 1973, Janvier joined with artists such as Daphne Odjig and Norval Morrisseau to form the Professional Native Indian Artists Inc., a group of seven artists who focused on marketing and exhibiting their work.

Janvier
287
75

Frank H. Johnston (1888–1949)

Untitled (Serenity, Lake of the Woods)

1922; oil on canvas; 102.3 cm x 128.4 cm; Collection of the Winnipeg Art Gallery;
Photo by Ernest Mayer/The Winnipeg Art Gallery

*I*n 1921, the year after his first and only participation in a Group of Seven exhibition, Francis Hans (later Franz) Johnston moved to Manitoba for two years to become principal of the Winnipeg School of Art. In the summers, he enjoyed painting at nearby Lake of the Woods, where snowy sunlit clouds dominate the flat prairie terrain, casting their reflections on the peaceful surface of the lake. In the distance is a barely visible puff of smoke, while on the left shore, cottages bask in the late-afternoon sun. Johnston simplifies the forms of nature with a characteristically muted palette, creating a poetic and lyrical effect that distinguishes his work from the images of rugged wilderness usually associated with the Group of Seven.

Johnston's relationship with these artists dated back to 1908, when he met Tom Thomson and J.E.H. MacDonald at the commercial art firm of Grip Limited, in Toronto. In 1915, he was commissioned by the Canadian War Memorials Fund and produced 73 paintings recording the activities of the Royal Air Force in Canada. Although Johnston accompanied the future Group artists on sketching trips to the Algoma region after the war and shared their passion for painting the Canadian landscape—especially the effects of light on ice and snow in the Arctic and the Northwest Territories —he preferred to pursue a path of his own, separate from group affiliations.

Helen Kalvak (1901–1984)

Life in Igloo

1967; stonecut on paper; 96.0 cm x 59.9 cm; Collection of the Winnipeg Art Gallery;
Bequest from The Estate of Arnold O. Brigden; Photo by Ernest Mayer/The Winnipeg Art Gallery

As if endowed with magical x-ray vision, we see both the inside and the outside of an igloo in Helen Kalvak's portrayal of traditional Inuit domestic life. On the outside, a man makes repairs to the wall of the snow house, while on the inside, two women look after the necessities of the home. The mother sits on skin blankets and nurses a child; the other woman attends to the stone lamp, where the delicate jagged edge inside the large white oval represents the flame. Near the wall, a drying rack supports the family's socks and mittens. In this refined graphic distillation of the women's world, the egg-shaped cross section of the igloo suggests the shape of the female uterus.

Kalvak lived on the land on Victoria Island, in the central Arctic. In her early sixties, she moved to Holman, on the island's west coast, where she was encouraged to draw by the resident Roman Catholic priest, who assisted in the founding of the local printmaking co-operative. A prolific artist, Kalvak depicted her memories of camp life, shamanism and legends in over 3,000 drawings, almost 200 of which were made into prints.

Life in Igloo is characteristic of the early approach to printmaking in the community of Holman, where line drawings were traced directly onto stone, then cut and printed in dark colours to produce dynamic silhouetted images.

11 Eskimo Western Arctic 1967 Life in an igloo by Kalvok 19/40

Paul Kane (1810–1871)

Kee-a-kee-ka-sa-coo-way

1852–56; oil on canvas; 45.7 cm x 73.6 cm;
With permission of the Royal Ontario Museum, © ROM

Paul Kane's ambition "to devote whatever talents and proficiency I possess to painting a series of pictures illustrative of the North American Indians and scenery" was fuelled by his admiration for the work of American painter George Catlin, whose mission had likewise been to record Native American people visually. Kane, who had been born in Ireland and had immigrated to Canada in 1819, set out in 1845 on the first of two journeys that would take him across the Canadian prairies, over the Rockies to the Pacific and back again. Despite the hardships of travel, Kane produced more than 500 sketches of the native peoples and their habitats, rituals and landscapes.

In his travel memoirs, *Wanderings of an Artist Among the Indians of North America*, published in 1859, Kane wrote of his arrival at Fort Pitt on the North Saskatchewan River in January 1848 and of his meeting with Kee-a-kee-ka-sa-coo-way, the Cree chief. When he did this oil painting in the studio several years later, Kane elaborated upon his original sketch, which shows the chief with one naked shoulder and a white wolf pelt over the other. While the unwavering gaze and clenched expression resemble the chief's features in the sketch, the additions of the fringed buffalo-skin shirt, feathered hairpin and intricate medicine-pipe stem were a "dressing up" by Kane to comply with Victorian society's image of the "noble savage."

Garry Neill Kennedy (1935–)

An American History Painting
(The Complete List of Pittsburgh Paints
Historic Colour Series)

1989 and ongoing; Left: *An American History Painting (Painting on Canvas)* 1989; latex paint on canvas; 188.0 cm x 121.9 cm; Centre: *An American History Painting*; latex paint on wall; Right (top): *An American History Painting (Painting on Canvas)* 1989; photo cross-section 1991; 76.2 cm x 101.6 cm; Work of Four Decades Exhibition, Nickle Arts Museum, University of Calgary, 2002; Photo by M.N. Hutchison

Garry Neill Kennedy is renowned as the inspired artist and president of the Nova Scotia School of Art and Design, who, during his 23-year tenure there (1967-90), transformed it into an innovative school with an international reputation. Imaginative, critical and analytical in his teaching and administrative duties, Kennedy is similarly inquiring in his art. As a conceptual artist whose practice is primarily rooted in painting, Kennedy states that his work "asks questions about painting—my painting, other artists' painting, contemporary and historic 'high art' painting and 'low art' painting, like painting a sign or a house." Embracing traditional subjects such as history, war, still life, or portraiture, Kennedy reinvents them in a subtle and critical manner.

An American History Painting evolved from Kennedy's interest in a Pittsburgh Paint chart that evoked names and places in American history and an invitation to create a work for an American art magazine that appreciated his integration of language into art. Kennedy's idea was to stack the names of the colours with the shortest word—Gunstock—at the top and the longest—Smokey Mountain Blue—at the bottom. In between, colours such as Texas Star, Bunker Hill and Mayflower Blue reinforced the historic theme. What interested Kennedy was this process of decoding commercial culture and showing how something as banal as house paint, designed to decorate domestic environments, could at the same time be weighted and implicated with the history of America's past. Later, Kennedy extended the work to a wall painting whose height has ranged from 5 to 10 metres, depending on its location. In 2003, Kennedy was named a Member of the Order of Canada for his innovations as an artist and as an administrator, and in 2004 received the Governor General's Award in Visual and Media Arts.

Illingworth Kerr (1905–1989)

Ravenscrag, Ross's Ranch

1930; oil on canvas; 76.8 cm x 92.1 cm; MacKenzie Art Gallery, University of Regina Collection; Gift of Mr. Norman MacKenzie; Photo by Don Hall

On the aptly named Ravenscrag Ranch, a large brown barn with a red roof dominates the land, adding an element of cheer to the open fields and low hills surrounding it. While the landscape remains stark, the palette used by the artist to describe the garden is marked by a symphony of greens, ranging from a blue-green to a yellow-green, that is balanced by the grey of the rocky hills and the passive blue sky.

Having grown up in Lumsden, Saskatchewan, Illingworth Kerr began his arts education by taking correspondence courses in lettering. He moved to Toronto in 1924 to attend the Ontario College of Art, where the instruction—dominated by Group of Seven artists—left him ill-prepared to render the vast prairie spaces. In his unpublished autobiography, *Paint and Circumstance*, however, he acknowledged retaining some good advice. From Arthur Lismer, he remembered to "look for the design elements in nature," and from F.H. Varley, he learned to have "a sense of awe and reverence for one's subjects." Returning home in 1927, Kerr painted in the rolling Qu'Appelle Valley of southern Saskatchewan, basing his canvases on field studies afforded by his travels as a sign painter, harvester and trapper. From 1947 to 1967, he was the influential head of the art department at Calgary's Provincial Institute of Technology and Art (now the Alberta College of Art and Design).

James Kerr-Lawson (1862–1939)

Portrait of Alice and Louise Cummings ("Music, when soft voices die, vibrates in the memory")

c. 1885; oil on canvas; 56.3 cm x 69.0 cm; Art Gallery of Windsor;
Gift of Mr. and Mrs. William N. Tepperman, 1978

In a room shuttered from the afternoon sun, Alice Cummings plays the piano while her sister Louise, who would later become a distinguished mathematician, sings. Taking its title from a poem by Percy Bysshe Shelley, this intimate painting is itself a visual poem of hushed tones evoked by the soft grey colouring and by the women's quiet concentration. A subtle rhythm of line and shape crosses the canvas, moving from the clutter of books and papers on the left to the erratic arrangement of bows and creases of Alice's skirt and finally coming to rest in the harmony of horizontal lines lent by the shutters and by the stripes on Louise's dress.

James Kerr-Lawson was born in Scotland and immigrated to Canada with his parents around 1865. Settling in Hamilton, where the father of the Cummings sisters was once mayor, Kerr-Lawson studied first in Toronto and then in Paris. He was influenced by French realist Jules-Bastien Lepage and by American artist James McNeill Whistler, whose distilled compositions and restrained use of colour he greatly admired. Although his reputation was achieved abroad, Kerr-Lawson returned to Canada between 1884 and 1887 and thereafter maintained his Canadian contacts through friendships with artists, exhibitions and a commission from the Canadian War Memorials Fund for murals, two of which are in the Senate Chambers in Ottawa.

Janet Kigusiuq Uqayuittuq (1926–)

Caribou Meat Covered with Flies

1990; graphite and coloured pencil on wove paper; 57.1 cm x 72.5 cm;
National Gallery of Canada; Purchased 1992

The image of a freshly skinned caribou lying on the tundra continues to be a welcome sight to Janet Kigusiuq Uqayuittuq, who in her youth led a traditional life on the land in the Back River area of Keewatin, where caribou was the primary sustenance. In contrast to earlier drawings that depicted, with fine graphic detail, scenes of everyday camp life and Inuit legends, Kigusiuq Uqayuittuq's work in the 1990s became more colourful and less illustrative of life in a narrative sense. Here, in a large drawing that resembles a collage, the head, hooves and torso of a caribou carcass are juxtaposed like flat abstract shapes. Exercising her distinctive affinity for fine linear detail, Kigusiuq Uqayuittuq meticulously blankets the caribou's head and torso with hundreds of delicately drawn flies, imbuing the natural process of decay with a decorative, almost whimsical beauty. In her desire to fill the drawing, she applies richly layered areas of green and brown to contrast with the redness of the flesh and the brightness of the white paper.

Kigusiuq Uqayuittuq moved to Baker Lake in the early 1960s, and like her famous mother Jessie Oonark and several of her siblings, she embraced the arts as a means of supplementing the family income. Kigusiuq Uqayuittuq sold many drawings that were later translated into prints at the Sanavik Co-operative. With the closing of the print shop in 1990, she began to draw more freely, liberated from the exigencies of the print media.

E 271·PAYD

Roy Kiyooka (1926–1994)

Red Complex (Hoarfrost)

1959–1960; oil and Duco automobile lacquer on hardboard; 182.5 cm x 122.5 cm;
The Estate of Roy Kiyooka; Photo courtesy Catriona Jeffries Gallery

A lacelike pattern of white and off-white lines weaves an intricate screen on the surface of the painting, obscuring our view of the red, blue and green colours beneath, creating an image whose entangled beauty seems to extend beyond the frame. The reference to nature in the title directs us to Roy Kiyooka's inspiration: In the fall of 1959, while walking to the School of Art in Regina, Kiyooka was struck by the contrast in brightness between the hoarfrost on the green trees and the clear blue sky. Distilling this experience into visual form, Kiyooka demonstrated his intuitive response to life and asserted his freedom from any particular style. In a 1991 interview, he said of painting: "It's always a movement towards clarity. Ideally, one wants the utmost complexity along with that clarity."

Born in Saskatchewan of Japanese parents, Kiyooka studied art with Jock Macdonald in Calgary (1946–49), and in 1956, he spent eight months at the art school in San Miguel de Allende, Mexico. There, he experimented with Duco, a quick-drying automobile lacquer, which he used for the bright colours in this painting. In 1959, he attended the Barnett Newman workshop at Emma Lake, Saskatchewan, along with Ronald Bloore and other artists who sought new approaches to abstraction. In the late 1960s, Kiyooka explored poetry, photography and collage.

Dorothy Knowles (1927–)

The River

1967; oil and charcoal on canvas; 142.2 cm x 142.5 cm;
Collection of the Mendel Art Gallery, Saskatoon; Gift of Mr. and Mrs. Harvey S. Smith, 1973;
© Dorothy Knowles

Dorothy Knowles drives her van, a portable studio, across the rolling prairie in search of subjects for her art. Working directly from nature on a large canvas, she has captured the vast expanse of prairie space where the Saskatchewan River meanders through low bush and golden fields. The enormous sky overhead is a vaporous umbrella of clouds stretching to the flat horizon.

Knowles came to art unexpectedly. From 1944 to 1948, she studied biology at the University of Saskatchewan. Then, on a friend's suggestion, she enrolled in the university's summer art course at Emma Lake, where she discovered her artistic talent. Although Knowles continued her training at the university, at Banff and in England, the Emma Lake workshops were her most important inspiration. Particularly encouraging was the 1962 session led by American art critic Clement Greenberg, who wrote: "The problem was how to master the prairie's lack of feature...Knowles was the only landscape painter I came across...whose work tended towards the monumental in an authentic way." Subsequent workshops led by American abstractionists such as Kenneth Noland and Jules Olitski, who soaked their canvases with pigment, prompted Knowles to thin her oil paint, thus making it more translucent, like watercolour. This technique helped Knowles to realize her ambition of integrating charcoal sketches with her painting so that the drawing would show through.

Wanda Koop (1951–)

Part 4 from the Reactor Suite

1985; acrylic on plywood; 243.8 cm x 487.6 cm; National Gallery of Canada; Purchased 1986

Wanda Koop described the *Reactor Suite*, composed of four large panels, as consisting of "the reactor cooling towers, the shadow man and the great blue heron, the nuclear submarine and the two human silhouettes partially submerged in water." The images were created as the result of an extensive sketching trip that Koop made from May to September 1984, when she travelled from northern Manitoba to British Columbia. Later, reviewing the 260 drawings she produced during that four-month period, she discovered that particular groupings evolved. Those in the *Reactor Suite* expressed her views about the vulnerability of humanity and nature in the face of nuclear disaster. With its stark compositional simplicity and monumental scale, which overwhelms the viewer and augments the tone of disaster, Part 4 of the series embodies the evening light and eerie tone of the other panels. Here, two figures rendered faceless in the dying light stand apart in the boundless blue water, reinforcing the mood of ominous loneliness that pervades the suite.

Born in Winnipeg, Koop graduated in fine arts from the University of Manitoba in 1973. Her characteristic practice of working on a large scale is inextricably linked with her environment. "When you live on the prairies," she once said, "you have no limitations. You walk out into a horizon that goes on forever, and you have this tremendous rush of freedom."

Cornelius Krieghoff (1815–1872)

Merrymaking

1860; oil on canvas; 88.9 cm x 121.9 cm; The Beaverbrook Canadian Foundation,
The Beaverbrook Art Gallery, Fredericton, New Brunswick

After peripatetic beginnings that featured his birth in Amsterdam, his upbringing in Germany and a spell in the United States Army fighting in the Seminole War in Florida, Cornelius Krieghoff started his artistic career as a painter of portraits in Boucherville, Quebec. In 1844, he left for Paris, where he registered as a copyist at the Louvre, consolidating his attraction to landscapes and genre scenes, which he would later adapt to a Canadian context. He returned to Canada in 1846 and, in 1854, moved to Quebec City, where the English-speaking merchants and the British garrison families provided a steady market for his idealized scenes of Quebec rural life, local First Nations and popular outing destinations such as Montmorency Falls.

Krieghoff entertains us here with a spectacle of chaotic activity, where the arrivals and departures of winter travellers create mishap and confusion on the veranda and grounds of the Jolifou Inn. In assembling this cast of characters, the artist quoted earlier pictures that featured isolated events such as the overturned sleigh, drunken revellers or people on snowshoes. Ever enterprising, Krieghoff took full advantage of *Merrymaking's* instant celebrity: As was his practice with other successes, such as *Bilking the Toll* (of which he painted close to 30 versions), he proceeded to produce variations on the theme of jovial carousing. None, however, is as elaborate as this one.

William Kurelek (1927–1977)

Green Sunday

1962; oil and graphite on gesso on masonite; 69.2 cm x 74.4 cm x 2.3 cm;
National Gallery of Canada; Gift of Judge and Mrs. Darrell Draper, Willowdale, Ontario, 1987

William Kurelek was born of Ukrainian parents near Whitford, Alberta. As a child, he moved to Manitoba, where memories of the harsh and happy experiences of growing up on a farm would later provide subject matter for his art. In 1949, the year he graduated from the University of Manitoba, the family moved to Ontario, and in defiance of his father's wishes, Kurelek enrolled at the Ontario College of Art in Toronto. Although he was attracted to the work of teachers such as Carl Schaefer, whose rural themes impressed him, Kurelek stayed for only a year. He then travelled to Mexico to see the murals of such artists as Diego Rivera, whose social conscience and devotion to the culture and dignity of ordinary people touched him profoundly. Kurelek, however, was uncertain of his direction. He became deeply troubled, and in 1952, sought psychiatric help in England. By 1957, with the aid of this treatment and his conversion to Catholicism, he had set a new course for his life.

Kurelek returned to Toronto in 1959 and worked as a framer at the Isaacs Gallery. He held his first exhibition in 1960. *Green Sunday* is one of a series of works shown in 1962 under the theme "Memories of Farm and Bush Life." As Kurelek explained, "This is the farm kitchen on a May Sunday morning and combines three occurrences...an annual spring custom of bringing branches of poplar trees into the house to be placed in the corners of the living room...the maid is posing in the traditional Ukrainian costume of the province of Bukovina, where my people come from...the youth with the accordion represents our neighbours' son...I used to be entranced by his playing." Art historian Charles Hill has noted that, for Kurelek, these paintings were "a means of reclaiming an identity and [of] bonding with a community from which he had been alienated."

Despite his popularity as a writer and an illustrator of children's books, which drew on his youthful experiences on the farm, Kurelek's later work became increasingly preoccupied with humanity's spiritual frailty.

Fernand Leduc (1916–)

Solar Strata

1958; oil enamel on canvas; 160.0 cm x 113.9 cm; The Montreal Museum of Fine Arts; Purchase, Horsley and Annie Townsend Bequest; 1995.20; © Fernand Leduc/SODRAC (2007); Photo by Brian Merrett/MMFA

A brilliant choreography of geometric shapes fills the space, juxtaposing primary colours of deep red and bold blue with secondaries of hot orange and medium green. Together, these create a balanced composition that asserts the flatness of the picture plane. The small black square in the centre is countered by the openness of the white areas, while the entire composition is made dynamic by the diagonal orientation of the forms, radiating with their own inner light.

During the time that Fernand Leduc studied at the École des beaux-arts in Montreal (1938–42), modern art was highly derided: "We were told Matisse couldn't paint…Picasso couldn't draw…and then there was a Borduas exhibition…and for all of us, it was a complete revelation." Paul-Émile Borduas' exploration of Surrealist theories and abstraction opened the door to a freedom of expression embraced by Leduc and other young artists who would sign the *Refus global* in 1948. Explaining his passage from 1940s automatism to the geometric abstraction of the 1950s, Leduc said, "I am attracted by order rather than the fluid appearance of form. It's more important to discover order." In 1956, he became the founding president of the Non-Figurative Artists' Association of Montreal and participated in an exhibition at l'Actuelle, the first gallery in Canada dedicated to nonrepresentational art. Leduc's allegiance to pushing and exploring the limits of abstraction has been concentrated and unwavering over the many years of his long career. In 1988, he received Quebec's Prix Paul-Émile Borduas, and in 2007, the Governor General's Award in Visual and Media Arts.

Ozias Leduc (1864–1955)

Boy with Bread

1892–1899; oil on canvas; 50.7 cm x 55.7 cm;
National Gallery of Canada; Purchased 1969; © Estate of Ozias Leduc / SODRAC (2007)

A young boy with a torn shirt and bare feet pauses at his meal to play the harmonica. His relaxed pose, in combination with the modesty of the setting, contributes to a feeling of peacefulness that is enhanced by the subdued palette and enlivened by the rose tones of his shirt and the gold-coloured bowl on the table. "By respectfully exalting the real," wrote Ozias Leduc, "(think for a moment that Nature must be handled gently to extract poetry), this art will necessarily add beauty to the world (think here of the supreme goal of art)." Although grounded in the specificity of the artist's life—Leduc's young brother Ulric was the model—the painting captures a universal moment resonant with the beauty of simple existence and the pleasures of everyday pastimes.

The reverent tranquillity that permeates this painting similarly imbued Leduc's long and prolific career as church decorator for 31 churches in Quebec, Nova Scotia and the eastern United States. For his own pleasure, he painted still lifes, landscapes and portraits, always in search of a beauty that would lead to a greater truth. Leduc was a primary influence on his student Paul-Émile Borduas, who would later lead artists committed to abstraction. "It is the struggle between rebel matter and thought," wrote Leduc. "It is through this struggle that human beings perfect their intelligence and penetrate even further into the order of Nature."

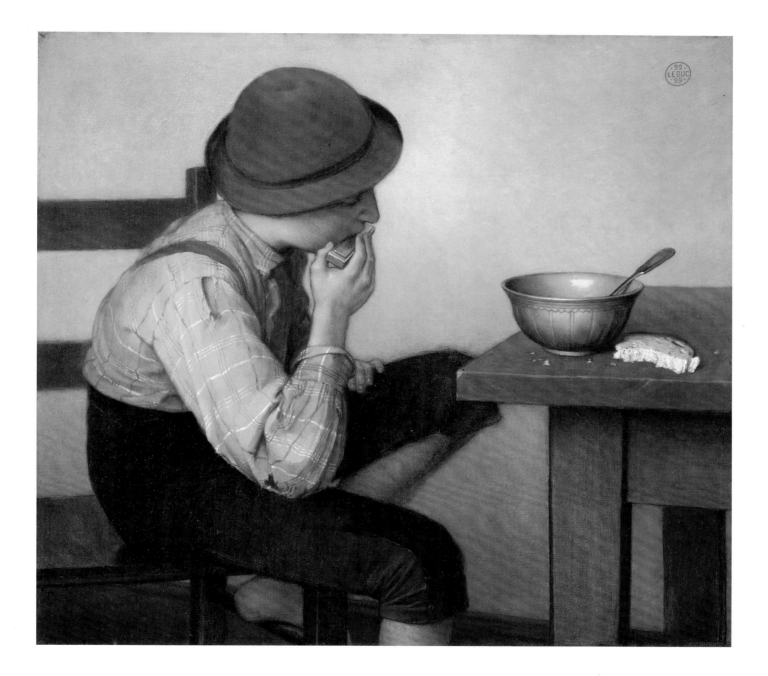

Joseph Légaré (1795–1855)

View of the Fire in the Saint-Jean District of Quebec City, Looking West

1845–1848; oil on canvas; 81.3 cm x 110.5 cm; Musée national des beaux-arts du Québec; 58.470;
Restoration made possible by a contribution from the Amis du Musée du Québec;
Photo by Jean-Guy Kérouac

An apocalyptic vision of orange flames and fiery sparks heats up the black sky in an earthly inferno as fire destroyed more than 1,300 homes in the Saint-Jean Quarter of Quebec City on the night of June 28, 1845. Presenting a panoramic view of the disaster, Joseph Légaré imposes order on chaos, structuring the composition in quadrants created by the intersection of streets in the middle ground. On the ramparts, the fresh green rectangles of grass define a safety zone from which people watch the destruction while heaping their few remaining possessions against the stone walls. In the foreground, at the entrance to Saint-Jean's Gate, hundreds of tiny figures huddle in fear as they attempt to retreat from danger.

While the artistic potential of a scene of natural destruction was certainly not lost on Légaré and his romantic vision as an artist, his social and political conscience was also roused. He was passionate about recording Quebec's history in his art and was active on many committees, including one to seek financial assistance for fire victims. Unlike his famous student Antoine Plamondon, Légaré never studied in Europe but taught himself to paint by copying and restoring paintings brought from France. Among his varied output of religious copies, portraits and genre scenes, his innovative landscape paintings represent his most singular contribution.

Jean-Paul Lemieux (1904–1990)

Summer

1959; oil on canvas; 58.4 cm x 126.4 cm; Collection of Museum London;
Gift of Maclean-Hunter Publishing Co., Ltd., Toronto, 1960

*I*n a vast, deserted field, the lone figure of a young girl dressed in red
and illuminated from behind breaks the horizon line. Against the soft
grey sky and olive-green fields, the colour of her dress seems to
heighten her solitude, accentuating her separateness from her environ-
ment. The flat, even application of paint evokes a feeling of distant other-
worldliness that is echoed in the girl's melancholy expression. "What
fascinates me most is the dimension of time," said Jean-Paul Lemieux. "I
paint because I like to paint. I have no theories. In landscapes and figures,
I try to express the solitude in which we live…I try to recall my inner
memories."

Lemieux studied at the École des beaux-arts in Montreal from 1926 to
1934; during that period, he also spent some time studying art in Paris.
From 1937 to 1965, he taught at the École des beaux-arts in Quebec City.
In the early 1940s, his painting went through a series of changes, as he
explored portraits, still lifes and allegorical subjects. By the mid-1950s, he
began focusing on solitary figures and small groups set against austere
landscapes. Indifferent to his contemporaries' preoccupation with abstrac-
tion, Lemieux looked to 14th-century Italian painting and early Quebec
folk art for his inspiration. "I try to convey a remembrance, the feeling of
generations," he said. "I sometimes see myself as the central figure, but as
a child in the continuity of generations."

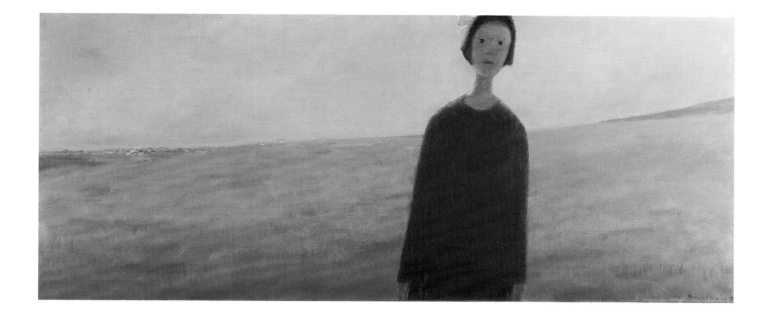

Rita Letendre (1928–)

Combat nordique

1961; oil on canvas; 126.5 cm x 137.0 cm; Musée d'art contemporain de Montréal;
Photo by MACM

With a frenzied energy that plays itself out in the thick applications of paint and in gestural expressiveness, the canvas becomes a battlefield where hot reds challenge cool blues and bright whites struggle against the overwhelming darkness. The feeling of conflict is further accentuated by the forms the colours take—with a jagged sharpness, they assert their identity against the blackness.

Disenchanted with the teaching at the conservative École des beaux-arts in Montreal, Rita Letendre, who is of Abenaki heritage, quit after a year's study and became an associate of Paul-Émile Borduas and the Automatistes, embracing their style of abstraction informed by dreams and the subconscious. In 1950, she appeared with them in the Les Rebelles exhibition and continued to explore gestural abstraction throughout the decade, exhibiting widely and drawing critical acclaim for her expressive use of colour and thick impasto. While witnessing the evolution of the work of such abstract artists as Jean-Paul Mousseau and Fernand Leduc in Montreal, Letendre also looked to New York City, admiring in particular the dramatic black-and-white paintings of Franz Kline. By the early 1960s, critics recognized the rich chaotic tension and agitation we see in *Combat nordique*, prompting one art critic to suggest that the work "seems to have emerged from a witch's cauldron, redolent with powerful images and turbulent paint."

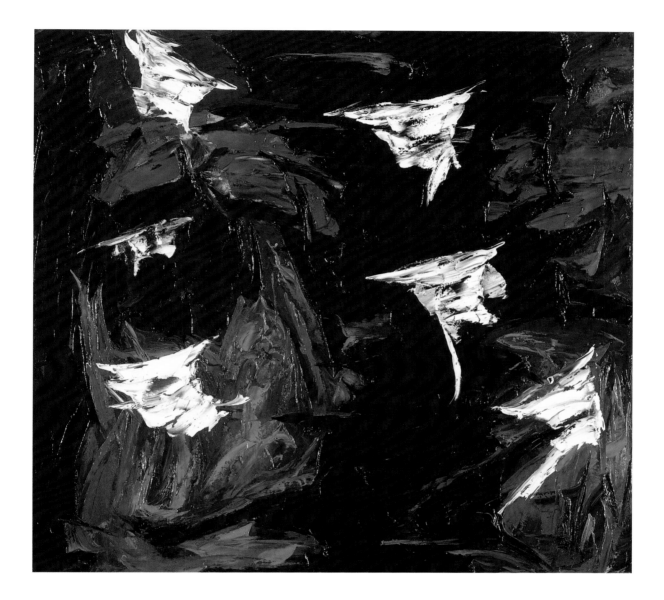

Maud Lewis (1903–1970)

Oxen and Logging Wagon

undated; oil on pulpboard; 26.0 cm x 35.8 cm; Collection of the Art Gallery of Nova Scotia; Gift of Louis Donahoe, Halifax, 1996; 1996.49; Photo by G.N. Hilfiker

A pair of oxen wearing an elaborate harness pulls a sleigh loaded with logs along a winter road whose frozen surface makes travel easier. In the background, a house overlooks the water where a ship is moored. Painting simply and directly with a palette of bright colours, Maud Lewis has dug into her childhood memories to re-create a setting near the port of Yarmouth, Nova Scotia, where her father's business as a blacksmith and harness maker attracted steady customers from the nearby forestry and fishing industries.

Lewis's childhood had been happy, but fragile health (the result of birth defects) and the loss of family support as she grew older left her without an income. Despite the deprivations of daily life and the pain endured from her increasing infirmity—and even after her marriage to Everett Lewis, a miserly fish pedlar—she summoned her creative spirit and looked back on her youthful past for the subjects of her art. When Lewis was painting, she was happy, and she was delighted to make the meagre sums she charged for her art.

In the words of Bernard Riordon, director of the Art Gallery of Nova Scotia, "Maud Lewis…embodies the free spirit of folk artists working outside the mainstream, liberated from preconceived notions about art. By creating work that brings joy and reflects simplicity, she succeeded in illuminating the best of the human spirit."

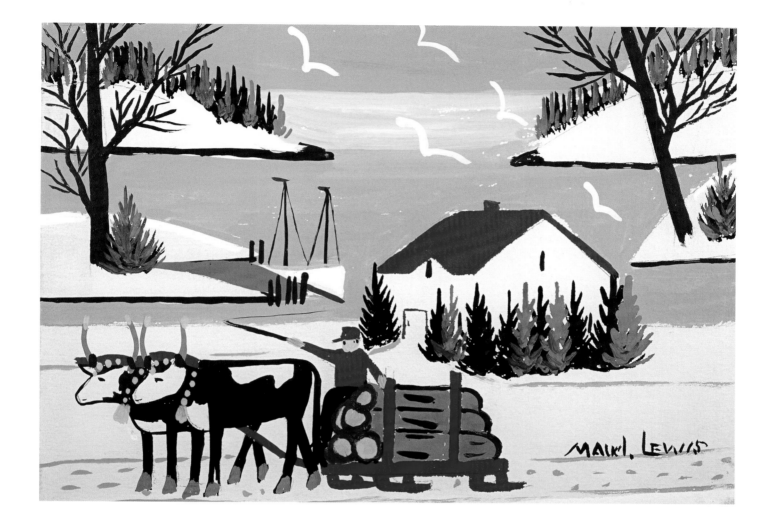

Arthur Lismer (1885–1969)

Bright Land

1938; oil on canvas; 81.1 cm x 101.5 cm; McMichael Canadian Art Collection

Born in Sheffield, England, Arthur Lismer studied at the Sheffield School of Art and at the Académie Royale in Antwerp, Belgium, before immigrating to Toronto in 1911. Finding employment as a graphic artist at Grip Limited, he met Tom Thomson, J.E.H. MacDonald and, eventually, the other artists who, in 1920, would form the Group of Seven. Describing himself as "a newcomer, raw English, full of enthusiasm," Lismer joined the artists on sketching trips to Algonquin Park. He later claimed that these experiences in the Canadian bush were "turning points" in his life. At the same time, Lismer was becoming a passionate and outspoken advocate for art education: During the First World War, he was principal of the Victoria School of Art and Design in Halifax and, in 1919, he returned to Toronto to become vice principal of the Ontario College of Art. In the 1920s and 1930s, like the other members of the Group, Lismer explored the country—Georgian Bay, Algoma, the Rockies— revelling in the contrasts and power of the Canadian landscape.

In *Bright Land*, we stand high on a hilltop in the Killarney region of Ontario where ancient rounded mountains surround a cool, deep lake untouched by settlement and industry. Out of the confusion of rock, low bushes and clusters of trees, a lone pine towers majestically, linking earth and sky. Bathed in the light of a clear blue sky, the rich greens of the conifers contrast with the warm yellows of deciduous trees that announce the last days of summer. An air of serenity permeates the painting, as Lismer captures, in the words of Lawren S. Harris, one of nature's "pristine and shining moods." Writing in the late 1920s, Lismer stated, "The artist's business in any age and in any country is to recall, not the facts and formulae, but the beauty of the experience—to give us pictures of our inarticulate selves, to widen the horizons of our unexpressed thoughts and hopes...and to push aside veils from unseeing eyes."

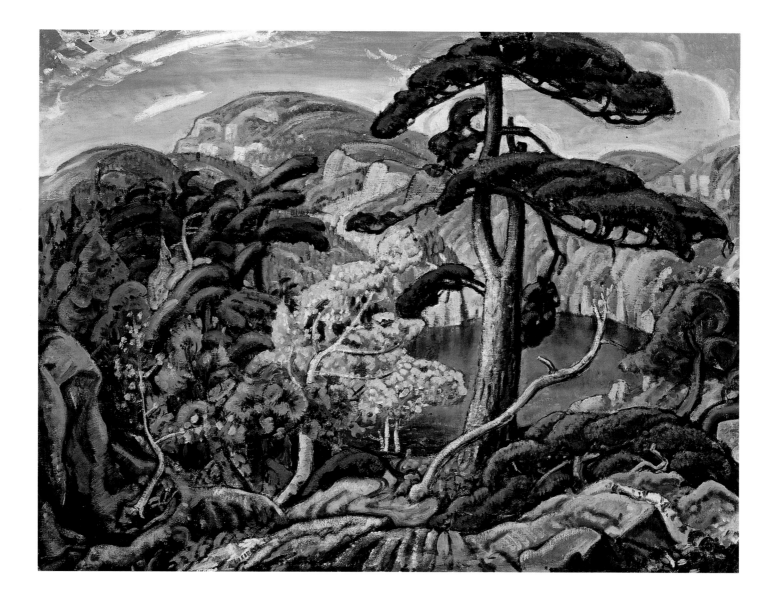

Attila Richard Lukacs (1962–)

Where the Finest Young Men…

1987; oil, tar and enamel on canvas; 427.0 cm x 484.0 cm x 3.2 cm;
National Gallery of Canada; Gift of Ira and Lori Young, West Vancouver, 1990

Working on a heroic scale and using oil paint, tar and enamel, Attila Richard Lukacs evokes the theatrical architecture and dramatic lighting of Italian Baroque painting and combines it with the depiction of a contemporary degenerate society, creating a feeling of dissonance between the style and the content of the image. Far from the military academies, "where the finest young men" enlist for an education to serve their country, the skinheads of North America, England and Germany gather in their own ritualistic communities, secure in their fascist beliefs. Here on the scaffolding, nude booted men assume a variety of positions. Some stare with indifference at the viewer; another directs our attention to the activity below, where men in red aprons and black gloves perform a mysterious ceremony. The group on the right, dominated by the man with the ass's head, lends a satanic tone, suggesting a dark underworld existence.

Lukacs' interest in skinheads as a source for his art is as a voyeur in a marginalized site of male beauty. "What I am trying to do," he said, "is deal with the male nude in the way classical nudes have always been dealt with." Born in Edmonton, Alberta, Lukacs went to Vancouver in 1983 to study at the Emily Carr College of Art and Design. In 1986, he moved to West Berlin, where he attracted international acclaim for his innovative approach to the male nude.

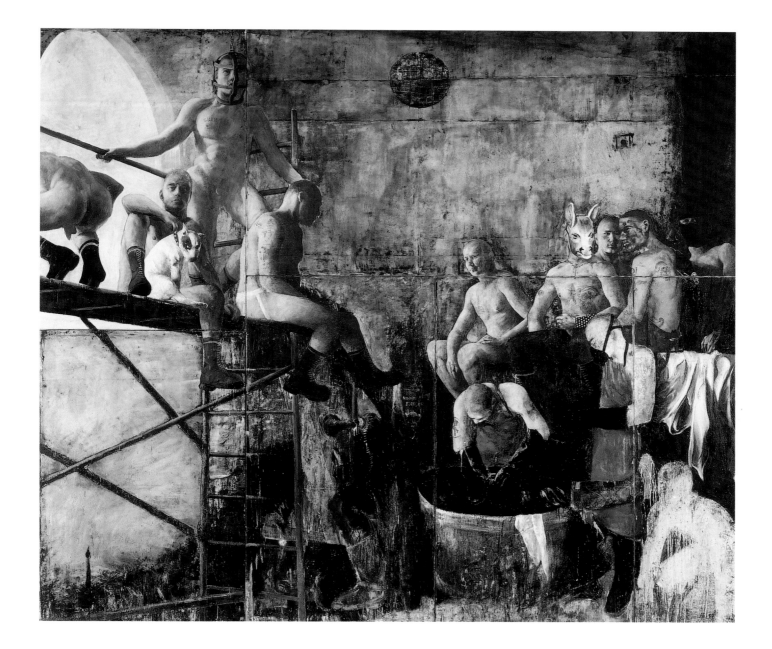

Alexandra Luke (1901–1967)

Symphony

1957; oil on canvas; 246.7 cm x 208.3 cm; The Robert McLaughlin Gallery, Oshawa;
Gift of Mr. and Mrs. E.R.S. McLaughlin, 1972; Photo by VIDA/Saltmarche, 1979

In her statement for the Canadian Abstract Painters Exhibition that she organized in 1952, Alexandra Luke wrote, "For me, colour is a very important instrument to be played like a flute or like a trumpet or like a symphony, controlled intuitively but uninhibited." In this work, a pageant of pinks, reds and yellows is balanced by an array of blues and cool greens. Like a symphony, all the colours play in harmony, eliciting an emotional response that is as large and overwhelming as is the scale of the painting itself.

In 1945, after years as a homemaker and nurse, Luke enrolled at the Banff School of Fine Arts, studying with Jock Macdonald and A.Y. Jackson. Macdonald was particularly influential in her pursuit of abstraction. He introduced Luke to Surrealism, with its dream-inspired imagery, and to new discoveries in science, encouraging her "to create from within, with no relation to natural forms." From 1947 to 1952, Luke studied in the summers with Hans Hofmann in Massachusetts, exploring colour and its relationship to music. As a result of the 1952 exhibition that toured the country, Luke met younger Toronto painters such as Harold Town and William Ronald and joined with them to form Painters Eleven in 1953. "Art is a powerful instrument," she wrote. "It should not stop with already discovered beauty but should continue searching forever."

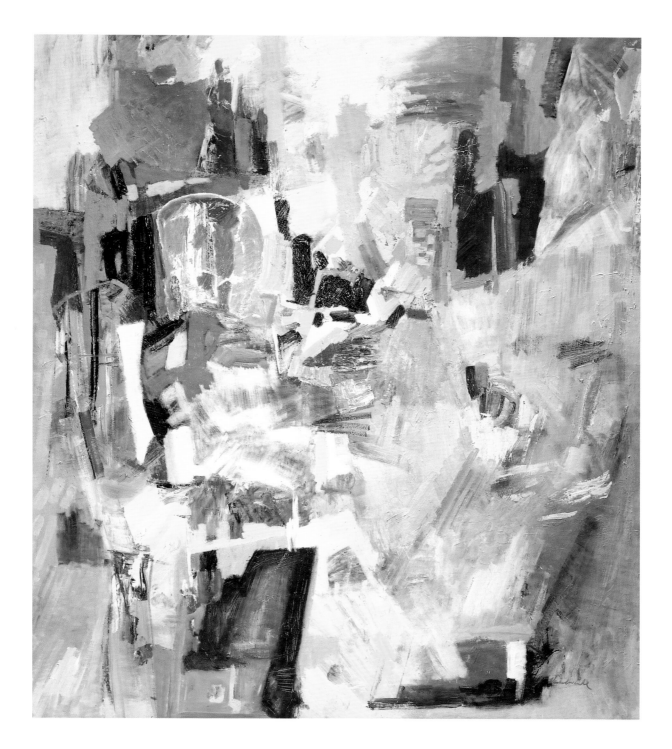

John Lyman (1886–1967)

Portrait of Marcelle

c. 1935; oil on canvas; 60.7 cm x 50.5 cm; Art Gallery of Ontario;
Purchased with assistance from Wintario, 1978; Photo by Larry Ostrom/AGO

After 24 years abroad, John Lyman returned to his native Montreal in 1931 and declared that "the essential qualities of a work of art lie in the relationships of form to form and of colour to colour. From these, the eye…derives its pleasure and all artistic emotion." Lyman's philosophy was rooted in his Paris training and, principally, in the six months spent in the Académie Matisse in 1909, where he learned that painting was an art of sensation and that the combination of colour, line and shape was the carrier of "aesthetic feeling."

In *Portrait of Marcelle*, a woman looks up from her reading with a pursed expression. We are struck by the bold contrasts set up by the dark green of her hat and scarf that is punctuated with a yellow-green colour, repeated in her shirt. In emphasizing the rose-red tones of his subject's skin, Lyman establishes an eccentric play of complementary colours that challenges the equilibrium of the composition.

A vociferous critic of the Group of Seven's domination of the Canadian art scene, the financially independent Lyman opened the Atelier in 1931 and, in 1939, founded the Contemporary Arts Society, an association of young artists committed to free artistic expression and to the cause of international modernism. These advances would later pave the way for the artistic revolution led by Paul-Émile Borduas and the Automatistes.

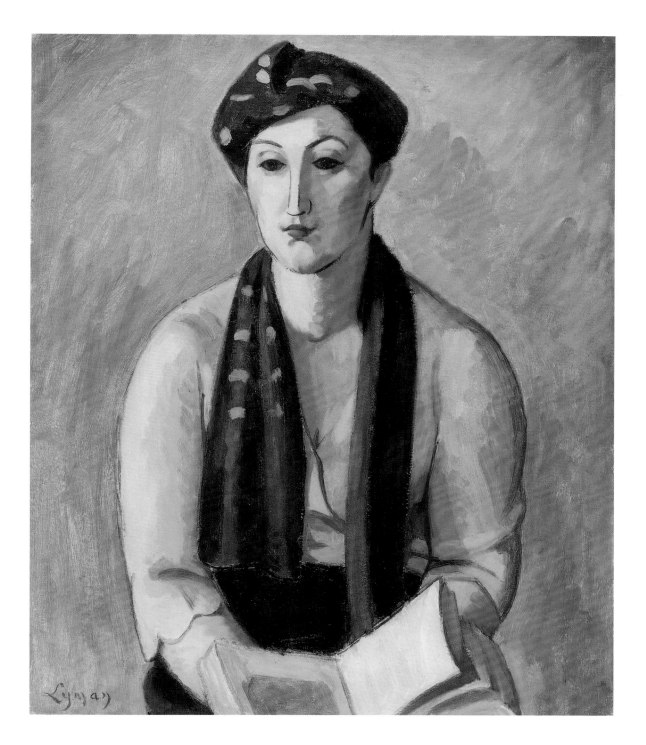

James Edward Hervey MacDonald (1873–1932)

Falls, Montreal River

1920; oil on canvas; 121.9 cm x 153.0 cm; Art Gallery of Ontario; Purchase, 1933;
© 2007 Art Gallery of Ontario; Photo by Larry Ostrom/AGO

In the first decade of the 20th century, the British born J.E.H. MacDonald worked as senior designer at the commercial design company of Grip Limited in Toronto. On weekends, MacDonald and several colleagues from Grip sketched on the outskirts of the city. Following an exhibition of MacDonald's rural landscapes in 1911, Lawren Harris declared that the work "contained intimations of something new in painting in Canada, an indefinable spirit which seemed to express the country more clearly than any painting I had yet seen." This admiration led to a friendship and subsequently to sketching excursions with Harris, MacDonald, and the artists who would later form the Group of Seven. Defending these works in the pre-war years, MacDonald insisted, "It would seem to be a fact that in a new country like ours…courageous experiment is not only legitimate but vital to the development of a living Canadian art."

Falls, Montreal River was exhibited in the first Group of Seven show at the Art Gallery of Toronto in 1920 and is based on sketches that MacDonald made in 1918 and 1919 during the so-called boxcar excursions to Ontario's Algoma region. Equipped with bunks, a stove and a water tank, the boxcar was hauled to chosen destinations by a freight train and then shunted onto a siding from which the artists scouted their painting places.

A.Y. Jackson described MacDonald as "a quiet, unadventurous man who could not swim or paddle, swing an axe or find his way in the bush, [but he was] awed and thrilled by the landscape of Algoma…he loved the big panorama." In *Falls, Montreal River*, an energetic torrent of line and colour cascades before our eyes as the white water of the falls tumbles turquoise in a sinuous path to the swirling blue river below. The dense forest on each side of the river creates a mosaic of colour that all but blocks our view of the sky in the far distance. For MacDonald, the wild magnificence of Algoma, where he sought "to paint the soul of things, the inner feeling rather than the outward form," filled him with "something of the feeling of the early explorers."

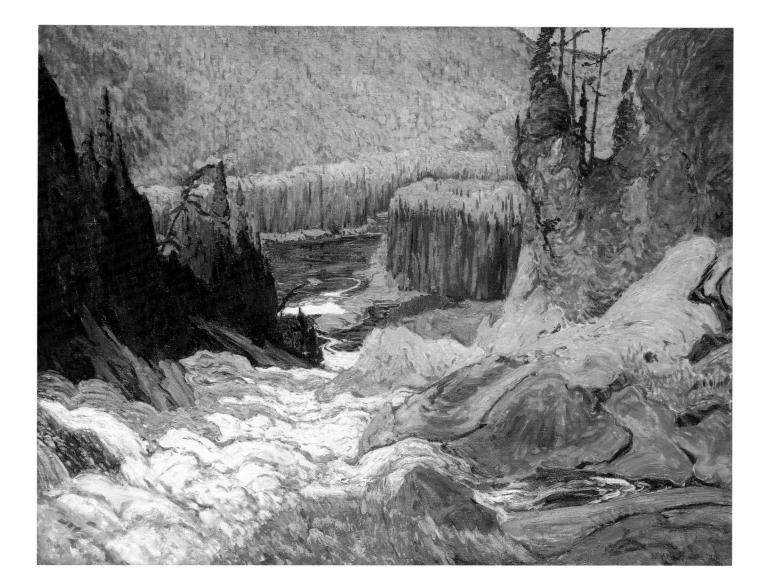

J.W.G. "Jock" Macdonald (1897–1960)

Iridescent Monarch

1957; oil, acrylic resin, Lucite 44 and sand on hardboard; 105.7 cm x 121.8 cm;
Art Gallery of Hamilton; Gift of the Canada Council, 1960

Singular organic shapes juxtaposed by concentrations of thick black lines float across the picture plane, displaying a harmonious arrangement of orange–reds, greens and yellows. Here, Jock Macdonald experiments with new quick-drying paints, which add a shimmering translucency to the colour, enhancing his vision of an inner world informed by scientific discoveries that raised questions about the essence of reality. In his 1940 lecture "Art in Relation to Nature," he said: "Art now reaches the plane where it becomes the expression of ideals and spiritual aspirations. The artist no longer strives to imitate the exact appearance of nature but, rather, to express the spirit therein."

In 1922, the Scottish-born Macdonald graduated in textile design and wood carving from the Edinburgh College of Art. He immigrated to Canada in 1926 to teach at the Vancouver School of Decorative and Applied Arts. There, he met F.H. Varley, under whose guidance he began to paint in oils. Although his early work embodied the study of visible nature, Macdonald was influenced by the writings of Russian artist Wassily Kandinsky and by the teachings of theosophy, and he sought a spiritual expression in his art. After a brief sojourn in Calgary (1946–47), Macdonald moved to Toronto, where, in 1954, he joined Painters Eleven. There, Macdonald's imaginative powers coalesced, and he produced his most significant body of work.

Landon Mackenzie (1954–)

Lost River Series, No. 12

1981; acrylic on canvas; 198.2 cm x 228.3 cm; Art Gallery of Ontario; Purchased 1982;
Photo by Carlo Catenazzi/AGO

*I*n the centre of a dark landscape that seems to extend to infinity, a lone creature pauses to drink from a pool whose waters create a pink effervescent ripple. The imaginary animal finds its own reflection in the deep shadows of the water and hovers close to the fish and colourful red plant life that thrive beneath the surface. The isolation and vulnerability of the animal are enhanced by a mound of white that evokes snow, while a ribbon of blue encloses it protectively from the boundless secrets of the empty landscape.

Landon Mackenzie's Lost River series was inspired by several Yukon river trips she took over three summers in the late 1970s and early 1980s. Her realization of the fragility of the natural environment moved her to create an allegory of powerlessness and lost innocence in the face of ecological destruction, a theme symbolically extended to the alienation of humanity from nature. As Mackenzie observed, "You learn that you're just a very frail human being trying to exist in a much larger ecosystem where you're not the ruler, the grizzly bear is…Living there forced me to address fears."

The Lost River series won first prize in the Third Quebec Biennale of Painting in 1981, launching a career in which Mackenzie continues to map abstract-dream territories, to probe the mystery of the land and to chart the isolation of the individual.

Pegi Nicol MacLeod (1904–1949)

Self-Portrait with Flowers

c. 1935; oil on canvas; 91.4 cm x 68.7 cm; The Robert McLaughlin Gallery, Oshawa

*I*n an unconventional self-portrait, Pegi Nicol MacLeod gives us a fragmented view of her nude torso nearly overwhelmed by the tangled profusion of plants and flowers in her lap. The spirit and energy of this painting, with its eccentric perspective that incorporates her hand large on the left and a foreground writhing with colour and line, are typical of the imaginative exuberance and passion for life that the artist brought to her work. Years later, art critic Graham McInnes commented that owning a painting by Nicol MacLeod was "like smelling daffodils in winter."

Nicol MacLeod studied with Franklin Brownell in Ottawa, followed by a year at Montreal's École des beaux-arts. Her landscape paintings of the late 1920s revealed her admiration for the Group of Seven artists, and she later defined her own voice in spontaneous, loosely brushed and vibrantly coloured images of everyday life. In 1937, she moved to New York City but returned to Canada each summer. Hired in 1944 to portray the activities of the Canadian Women Services, she created a vivid record of the on-and-off-duty reality of the women's war effort. On the occasion of Nicol MacLeod's memorial exhibition in 1949, Vincent Massey, then chair of the board of trustees at the National Gallery of Canada, praised the original style that sprang from "her impulsive nature and…her unreserved love of humanity."

Doris McCarthy (1910–)

Aurora and the Bergs

1996; oil on canvas; 91.4 cm x 121.9 cm; Courtesy of BMO Financial Group Collection;
© Doris McCarthy

Doris McCarthy's lifelong attraction to the landscape as the subject for her art was established in her youthful attraction to nature. Her talents and vision as a young artist drew the attention of Arthur Lismer, on whose recommendation she earned a scholarship to the Ontario College of Art. Following her graduation, she taught with Lismer at the Toronto Art Gallery School, and then, in 1932, embarked on a 40-year career as an influential teacher at Toronto's Central Technical School. During this period, McCarthy travelled widely, exploring Canada and the world—often attracted to places that exuded great solitude and peace. Upon her retirement from teaching in 1972, she made the first of many trips to the Arctic, where views of the majestic giant icebergs created an indelible impression. "To me as a painter," she wrote, "these were riches."

In *Aurora and the Bergs*, a cluster of jagged white peaks, visible above and below the water, are anchored by giant, jewel-coloured forms that swell beneath the green-blue surface. Above, the yellowy-green aurora arcs across the sky, lending a note of magic that captures the wonder and mystery of the Arctic world. In her constant refinement of form, and her desire to express the rhythms of nature and the spirit and essence of a place, McCarthy creates a fantasy world of floating abstractions. "My grasp of the landscape is intellectual. I see it with my eyes and my mind and I respond to it with all of my emotions." In 1986, McCarthy was appointed a Member of the Order of Canada.

Jean McEwen (1923–1999)

Loophole Crossing Blue

1961; oil on canvas; 193 cm x 153 cm; The Montreal Museum of Fine Arts;
© The estate of Jean McEwen; Purchase, Mr. and Mrs. Gérard O. Beaulieu fund; 1962.1342;
Photo by MBAM/MMFA

The first impression of Jean McEwen's *Loophole Crossing Blue* is of a painting that is both ancient and modern, its lapis lazuli surface burnished and eroded by time, revealing the red, brown and gold underpainting. McEwen layered colour, superimposing transparent and opaque paint, varying margins, edges and internal divisions to create dynamic, luminous compositions. Divided by a central axis, the near symmetry of this work suggests two doors, firmly closed upon their secrets. The poetic quality of McEwen's work reflects his own lifelong commitment to writing. He assigned lyrical titles to his paintings, not as literal equivalents but for poetic evocation, obliquely summoning an emotional response. In his book, *Cul de lampe*, McEwen wrote, "A painting is created from rhythm, form, space, light, shade and colour—but it is the feeling, the poetry of the painter that produces the harmony."

Self-taught as an artist, McEwen graduated in pharmacy from the University of Montreal in 1947. In 1951, he went to Paris, where he became enchanted with the light-filled canvases of the Impressionists and encountered Jean-Paul Riopelle and abstract artist Sam Francis, whose harmonious use of colour appealed to his fascination with light in painting. McEwen was acclaimed as an "abstract impressionist," and his painterly approach to colour and the dynamics of space was as innovative as it was unique.

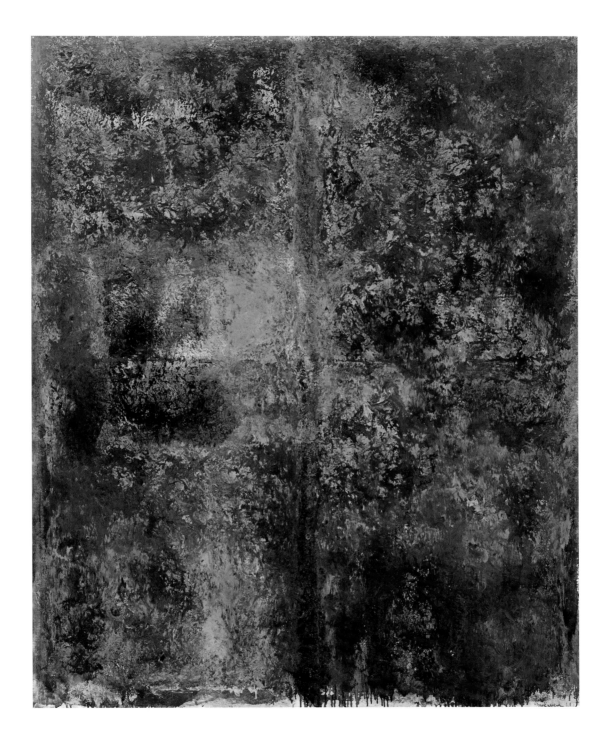

Yvonne McKague Housser (1897–1996)

Cobalt

1931; oil on canvas; 114.8 cm x 140.0 cm; National Gallery of Canada; Purchased 1932

The northern Ontario mining town of Cobalt was in decline when Yvonne McKague Housser visited in the early 1930s, but she was charmed, nevertheless, by the chaotic rhythm of the quickly assembled houses, the narrow staircases and the twisting streets and alleys that wove between the buildings. She wrote: "People sometimes say to me, 'What on earth do you see in those ugly mining towns?' But there is something romantic about a mining shaft against a northern sky…and about the big mountainlike slag heaps." Expressing her pleasure with her subject, she creates a quirky architectural mosaic of yellow, green and red houses, whose angular stockiness contrasts with the willowy telephone poles cutting the horizon line. In the distance, the colours of the palette become grey and more subdued as we approach the deserted mine shafts and accumulations of industrial waste.

McKague Housser was born in Toronto and studied first at the Ontario College of Art and then for a few years in Europe. By the early 1920s, she was teaching at the Ontario College of Art with Arthur Lismer and F.H. Varley. But in her own work, McKague Housser was attracted to the example of Lawren Harris's urban paintings. Although she sketched in Quebec and the Rocky Mountains, her most distinct contribution remains her depictions of the desolate mining regions.

Isabel McLaughlin (1903–2002)

Tree

1935; oil on canvas; 203.5 cm x 92.0 cm; National Gallery of Canada; Purchased 1984

Here, a colossal tree looming up from a bed of weeds and Queen Anne's lace towers against the cool grey sky. Its deeply furrowed bark encases it in a protective armour as its twisted clawlike branches embrace the hostile beauty of early winter. In a review a few years earlier, one art critic praised Isabel McLaughlin as "one of the boldest young woman painters we have...Her compositions are intensely modern in feeling...characterized by real power, together with originality of expression and a fine structure."

The daughter of the president of General Motors Canada, McLaughlin began her studies in Paris (1921–24) and later studied at Toronto's Ontario College of Art under Arthur Lismer, whose expressive use of line had an enduring impact. When Lismer left the college, however, McLaughlin became dissatisfied with its conservative teaching. She and several colleagues then founded their own Art Students' League, named after the New York school. Renting a space near the Art Gallery of Toronto, they invited the city's leading artists, such as Lismer, Lawren Harris and A.Y. Jackson, to give weekly critiques of their work. Later, Jackson wrote of McLaughlin's founding role in the Canadian Group of Painters in 1933: "...reserved, shy of acclaim, paints a naturalist's world...She has been a moving spirit in keeping the Group alive, and we are very much indebted to her."

Gerald McMaster (1953–)

Hunter/Hunted

1990; acrylic and oil pastel on mat board; 96 cm x 116 cm;
Courtesy McMichael Canadian Art Collection; Private Collection; © Gerald McMaster

In a field of dreams, the profiles of dark blue buffalo that resemble native pictographs blanket the surface of the mat board and are obliterated in the centre by the figure of a blue cowboy characteristically capped and a red shaman with buffalo horns. The cowboy is shaded and modelled to evoke three-dimensional form, as in the European tradition, while the shaman is painted flat like the buffalo. Gerald McMaster explained: "The two figures viewed the buffalo quite differently. The buffalo gave the Indian not only its body but its spirit—in the transformation, the man became the buffalo itself...What is stronger here physically? What is stronger here spiritually?"

In the distance, the smooth horizon of the rosy landscape and the large symbolic hailstones speak of the ancestral past, while the splattering of colour in the foreground suggests the spilled blood of buffalo driven to the brink of extinction and the shattered existence of the assimilated First Nations.

A Plains Cree, McMaster was raised on the Red Pheasant Indian Reserve in northwestern Saskatchewan. He studied at the Institute of American Indian Art, in Santa Fe, New Mexico; the Minneapolis College of Art and Design; Carleton University, in Ottawa; and the University of Amsterdam. He continues to explore issues of identity for native peoples as both an artist and a writer.

Helen McNicoll (1879–1915)

The Apple Gatherer

c. 1911; oil on canvas; 106.8 cm x 92.2 cm; Art Gallery of Hamilton;
Gift of G.C. Mutch, Esq., in memory of his mother, Annie Elizabeth Mutch, 1957;
Photo by Robert McNair

The hot, flickering sunshine virtually radiates from this canvas, where the apple gatherer, silently absorbed in her task, stands juxtaposed against a fluttering pattern of leaves rendered with blunt, energetic strokes loaded with blues and greens. Below, long, spiky strokes describe the green-grey fields that give way in the distance to a shimmering yellow expanse. The apple gatherer herself is a symphony of colour as the deep mauve shadows in her clothing play against the unshaded patches oflight filtering through the trees. When this work was exhibited in Montreal in 1911, Helen McNicoll attracted critical acclaim. *The Gazette* praised its "quality of open-air sunshine disarming all thoughts of labour in the studio."

Born into a wealthy Toronto family, McNicoll studied with William Brymner at the Art Association of Montreal from 1899 to 1902, then spent two years at the Slade School of Art in London, England, where figure studies were complemented by an exploration of the gestural, light-filled expression of British Impressionism. In 1905, she left for St. Ives, Cornwall, to study with Algernon Talmage, who advocated painting *en plein air* and, in the summer, held classes in a nearby orchard. Deaf since childhood, McNicoll pictured a hushed, luminous world of women and children quietly engaged in the labours and leisure of everyday life.

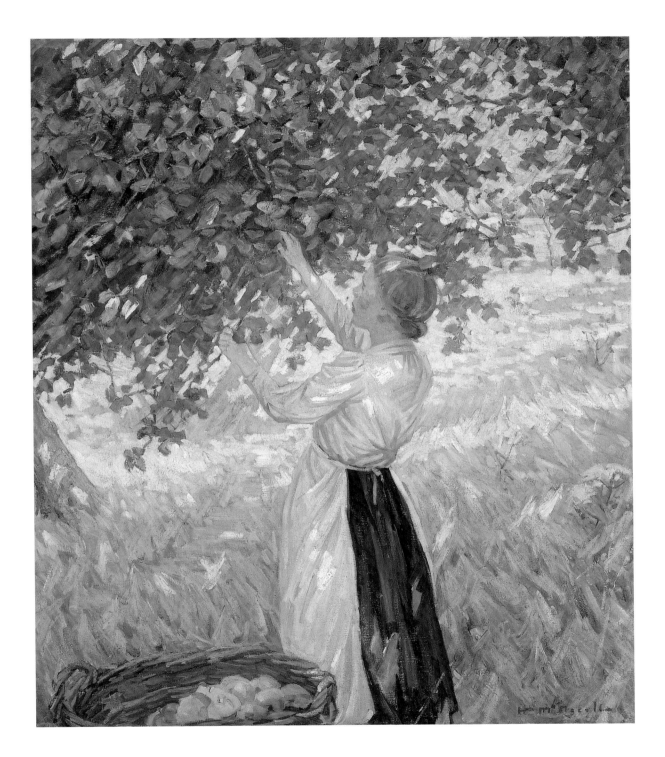

David Milne (1882–1953)

Waterlilies and Sunday Paper

1928; oil on canvas; 51.5 cm x 61.6 cm;
Hart House Permanent Collection, University of Toronto; Photo by Thomas Moore

Born in Paisley, Ontario, David Milne began his study of art by correspondence. In 1903, he moved to New York City to work as a commercial illustrator and studied at the Art Students League, where he received instruction from teachers such as Robert Henri and William Chase, who were renowned for their loosely brushed, highly coloured scenes of everyday urban life. Of central importance to Milne in his decision to become a painter were the exhibitions of modern European art at Alfred Stieglitz's gallery "291." Reflecting later on the work he saw there, Milne wrote: "In those little rooms under the skylights, we met Cézanne, Van Gogh, Gauguin, Picasso, Brancusi. For the first time, we saw courage and imagination bare, not sweetened by sentiment and smothered in technical skill."

In 1917, Milne joined the Canadian Army, and in May 1919, he received a commission from the Canadian War Memorials Fund to record the aftermath of the war in Europe. He returned to the United States in late 1919, where he continued to live until the spring of 1929, when he moved back to Canada. Camping near Temagami, a mining village northwest of North Bay, Ontario, he often worked in a deserted prospector's cabin, arranging the local flowers and other objects as subjects for his paintings.

In *Waterlilies and Sunday Paper*, Milne uses delicate lines and an almost transparent paint to depict a bowl and a jar of white-petalled water lilies that create a starlike pattern against the grid of the Sunday newspaper opened to the comics. On the right, a bottle with flowering branches offers a tighter concentration of line and colour and extends the play of lightness and translucency in the depiction of the water-filled glass containers. "Do you like flowers?" wrote Milne. "So do I, but I never paint them. I didn't even see the hepaticas. I saw, instead, an arrangement of the lines, spaces, hues, values and relations that I habitually use."

Guido Molinari (1933–2004)

Rhythmic Mutation No. 9

1965; acrylic on canvas; 203.2 cm x 152.4 cm;
National Gallery of Canada; Purchased 1975; © Estate of Guido Molinari/SODRAC (2007)

In *Rhythmic Mutation No. 9*, we are confronted with a large work where a dynamic series of vertical coloured stripes vibrate one against the other, holding tight to the flatness of the canvas, so there is no illusion of volume or depth nor is there a traditional figure-ground relationship. Hot and cold colours of uncommon temperatures keep each other in check and invite the viewer to discover the constantly changing relationships. In a 1977 interview, Guido Molinari said, "I'm trying to communicate the power, the potential of colour, of colour sequence, of colour energy and specifically the possibility of the viewer to become aware that he is the operator."

Molinari, who was educated at the École des beaux-arts in Montreal and influenced by the advances made by Paul-Émile Borduas in the realm of abstraction, sought an alternative to the "automatist credo." Following on the heels of the first Plasticiens, who focused on a rational geometric approach to abstraction, Molinari went further, seeking a more radical purification of the elements of art and a hard-edge form of expression. Inspired in this area by the achievements of European artists such as Piet Mondrian, Kasimir Malevich and Wassily Kandinsky and aware of the innovations of American artist Barnett Newman, Molinari sought to purge his art of all figuration, as he said in 1955, "to destroy volume by using the plane."

James Wilson Morrice (1865–1924)

Café el Pasaje, Havana

c. 1915–1919; oil on canvas; 65.8 cm x 67.5 cm; National Gallery of Canada;
Gift of G. Blair Laing, Toronto, 1989

James Wilson Morrice was born into a wealthy Montreal family, and although he trained as a lawyer, he decided, with the support of his family, to become a painter. In 1889, Morrice left for Paris and enrolled at the Académie Julian, where he befriended a large circle of artists keen on exploring the modernist trends that developed after Impressionism. Of particular importance was his admiration for Anglo-American artist James McNeill Whistler, whose art-for-art's-sake aesthetic and penchant for simplified form and subtle colour harmonies appealed to Morrice's poetic sensibility.

Morrice's meeting in 1909 with French artist Henri Matisse served as an introduction to the brilliantly coloured palette and loose brushwork of the Fauves, whose example he synthesized in landscapes and in scenes of people at their amusement or in repose. In his constant and extensive travels throughout Europe, North Africa and, later, the Caribbean, Morrice distilled the essence of the life around him in his art. In the shaded coolness of the nearly deserted *Café el Pasaje, Havana*, a man sitting at a table looks out to the street. Several pedestrians animate the flat patches of hot yellow sidewalk, and behind them, rows of trees block the brilliant azure sky. Inside, the soft, quiet music of form unfolds as the circular rhythms of the tables and window grillwork play against the rectangular patterns of the windows and architecture. A man alone and at his leisure, whether on a street or a beach or sitting in a café, was frequently the artist himself, who, despite his many friendships and an affable personality, remained an outsider wherever he went. Morrice knew international success during his lifetime, an achievement that was of singular importance to many artists in Canada, such as Maurice Cullen and the Group of Seven. Following Morrice's death in 1924, Matisse recalled him in a letter to a friend as an "artist with a sensitive eye, who with a moving tenderness took delight in rendering landscapes in closely related values…On a personal level, he was a real gentleman, a great companion, brimming with liveliness and wit."

Norval Morrisseau (1932–)

Artist's Wife and Daughter

1975; acrylic on Masonite; 101.6 cm x 81.3 cm; McMichael Canadian Art Collection

Norval Morrisseau was born on the Sand Point Indian Reserve near Thunder Bay, Ontario, and learned of the legends and sacred rituals of his Anishnaabe (Ojibwa) heritage from his shaman grandfather. To recover his native identity, which was denied in residential schooling, he embarked on a study of ancient rock paintings in northern Ontario, 17th-century Anishnaabe Midewiwin shamans' scrolls and 19th-century Anishnaabe beadwork, distinguished by its bright colour and strong linear composition.

In portraying his daughter and former wife, Morrisseau fused the composition frequently used in European painting to depict the Christ child and Mary with a style inspired by his Anishnaabe roots. In a manner characteristic of the period between 1966 and 1975, Morrisseau explores the native and Christian dichotomies, which reflects his circumstance of being caught between two cultures and belief systems. Here, he revitalizes native artistic traditions through a dynamic and innovative approach to colour and design, bridging the native past with the present. Following the success of his first solo exhibition in 1962, Morrisseau was acclaimed the leader of the Anishnaabe, or Woodland School, and his career was launched. In 1979, he stated: "My art speaks and will continue to speak, transcending barriers of nationality, of language and of other forces that may be divisive, fortifying the greatness of the spirit that has always been the foundation of the Great Ojibwa."

Jean-Paul Mousseau (1927–1991)

Untitled

1947; ink and watercolour on paper; 22.2 cm x 30.2 cm; La Collection Lavalin du Musée d'art
contemporain de Montréal; © Estate of Jean-Paul Mousseau/SODRAC (2007);
Photo by Richard-Max Tremblay

In a shallow, dreamlike space, golden light radiates from the centre of the composition, creating a tranquil luminosity that contrasts with the energy of the thin, spiky black lines, which block the brightness with their strange presence. In 1944, 17-year-old Jean-Paul Mousseau befriended the Automatistes associated with Paul-Émile Borduas and became captivated by the Surrealist theories circulating among the Montreal avant-garde of an art inspired by dreams and the subconscious. Mousseau signed the manifesto *Refus global* in 1948, supporting its demand for freedom of expression and for a new social and political order in the Church-dominated society of Quebec.

In a 1967 interview, Mousseau said, "For me, art is the expression of a certain awareness...of conscious or unconscious needs...art should be expressed in all that surrounds us, in all that we touch and in all materials." Mousseau's commitment to an art that was socially engaged led him to produce art outside the frame, when he exercised his talents as a set and costume designer for theatre and dance and as an interior decorator for discotheques. Maintaining his painterly preoccupations with colour and light, he used glass and electric light to create suspended sculptures, and in 1966, he employed ceramic tiles for public spaces such as the murals in the Peel Street station of the Montreal Métro.

Louis Muhlstock (1904–2001)

William O'Brien Unemployed

c. 1935; charcoal and brown chalk on buff wove paper; 68 cm x 51 cm irregular;
National Gallery of Canada; Purchased 1974

*L*ouis Muhlstock explored the city streets of Depression-era Montreal in his time off from the family's fruit-importing business and observed the assemblies of hungry, unemployed men. Among them, William O'Brien caught the eye of the artist — he sat apart, disinterested in the droning chatter. In Muhlstock's work, O'Brien leans forward with his arms crossed, huddled in a large overcoat, his haggard face revealing the endurance and despair of a man who has fallen on hard times. Muhlstock tenderly describes every crease, line and shadow with rich black charcoal, capturing the composure of a man enveloped in his own despondency. It was essential for Muhlstock that individuals be depicted "with the greatest respect for humankind."

Muhlstock emigrated with his family from Poland to Canada in 1911 and studied at the Art Association of Montreal and at the École des beaux-arts. He travelled to Paris in 1928 and studied the figure with Louis-François Biloul. Returning home in 1931, he focused on the poor and the destitute with a graphic compassion which frequently elicits a comparison of his work to that of German artist Käthe Kollwitz, whose art he greatly admired. Praising Muhlstock for his sympathetic objectivity, art critic Robert Ayre wrote, "He simply makes drawings of the suffering, the despised and the rejected and lets them speak for themselves."

Kathleen Munn (1887–1974)

Composition

1928; oil on canvas; 51.0 cm x 60.5 cm; Collection of the Art Gallery of Alberta;
Purchased in 1983; Photo by Eleanor Lazare

Recalling the pastoral subjects of her earlier canvases, Kathleen Munn creates a dynamic rhythmic pattern of a horse and cows in a field, simplifying and flattening the forms of nature and unifying figure and ground with the colourful faceting of Cubism, which reflects the cadence of staccato music.

Munn's devotion to international modernism began in 1912, when she left her native Toronto to study at the Art Students League in New York City. By 1920, her style had evolved from the loose colourful brushwork of Impressionism to the more hard-edge geometric fragmentation of natural form that had developed from her study of the works of French artist Paul Cézanne.

Munn embraced both an intellectual and a spiritual approach to art. Her notebooks reveal that she read extensively about colour theory, Cubism and the relationships between colour and music and that she was attracted to theosophy and various Eastern religions. Like her colleague and admirer Lawren Harris, Munn sought a formal order in art that would convey spiritual truths. As an "invited contributor," she submitted *Composition* to the 1928 Group of Seven exhibition, after which it was purchased by Bertram Brooker, an artist who praised the work for its "musicality." While most Toronto art critics were uncertain about her pioneering innovations, one recognized that she was "one of the ablest...of women painters and one of the most advanced."

Lilias Torrance Newton (1896–1980)

Self-Portrait

c. 1929; oil on canvas; 61.5 cm x 76.6 cm; National Gallery of Canada; Purchased 1930

*L*ilias Torrance Newton looks at us with a penetrating gaze and with the intelligence that she would bring to her career as one of Canada's greatest portrait painters. Delving for psychological disclosure and employing a characteristically vibrant palette, Newton creates a strong sculptural presence with a minimum of means. Warm reds, golds and flesh tones focus our attention on her striking demeanour and boldly striped dress. The curves of her head and shoulders, echoed in the chair, soften the angularity of the composition, whose symphony of contrasts evokes the complexity of her own sensitive and determined personality.

In the early 1920s, Newton associated with like-minded modernists such as Prudence Heward and Edwin Holgate, forming the short-lived Beaver Hall Group. In 1923, she studied in Paris, where she received an honourable mention for a portrait of a woman at the Paris Salon, the large government-juried exhibition. When Newton returned to Montreal, her career continued to flourish, and commissions from influential individuals such as Eric Brown, then director of the National Gallery of Canada, and Vincent Massey, an avid patron of the arts, led to numerous other commissions from businesspeople and government officials. In 1957, she was distinguished as the first Canadian to paint portraits of the current British sovereigns.

John O'Brien (1831–1891)

HMS Galatea in a Heavy Sea

1888; oil on linen; 43.4 cm x 71.6 cm; 1955.5; Collection of the Art Gallery of Nova Scotia;
Gift of Alice Egan Hagen, Halifax, Nova Scotia, 1955

An 1853 edition of *The Morning Chronicle* announced "to the merchants and shipmasters of Halifax that [John O'Brien] can give most accurate portraits (in oils) of their respective vessels, of all classes and on the most reasonable terms." Launching his career in the "golden age" of Nova Scotia shipbuilding, which saw the province supply thousands of ships for immigration, war and trade, O'Brien found ready patronage with commercial and naval shipowners alike.

Largely self-taught, he learned to draw by copying engravings from contemporary journals, illustrated fiction and accounts of travel at sea and by studying instruction booklets on painting at the local Mechanics' Institute. His early work can be appreciated for its technical accuracy in the details of masts and rigging. But after 1857—and a year's study in England with a follower of the Romantic J.M.W. Turner—O'Brien's documentary powers were complemented and enriched by a more painterly sensitivity to light and atmosphere.

Toward the end of his career, O'Brien did double and triple portraits of ships, chronicling major events in their histories. The *HMS Galatea in a Heavy Sea* is the second work in a triptych that begins with the ship at sunrise in Halifax harbour, its sails filled with a gentle wind as it meanders among smaller craft. In this piece, the *Galatea* endures the trials of dark, turbulent waters, and in the third painting, it survives a raging cyclone.

Lucius O'Brien (1832–1899)

Sunrise on the Saguenay, Cape Trinity

1880; oil on canvas; 90 cm x 127 cm; National Gallery of Canada;
Royal Canadian Academy of Arts diploma work, deposited by the artist, Toronto, 1880

In the stillness of the misty morning light, the imposing silhouette of Cape Trinity asserts its craggy presence and casts a long shadow across the silent waters of Quebec's Saguenay River. Bathed in the silvery pink glow of the rising sun, humanity begins to stir. Smoke rises from a boat in the distance, and closer to shore, small figures greet the day. Despite the development of logging along the river, Lucius O'Brien deliberately offers us a romantic view that focuses on its leisurely exploration by pleasure boats. Only in the foreground does a discrete pile of logs and scrubby bushes remind us of the intrusion of industry.

O'Brien's emphasis on the effects of light to create a poetic and picturesque view of nature reflects his admiration for American luminist painter Albert Bierstadt. Peaceful and orderly, O'Brien's vision also embodies the gentlemanly comportment of the artist himself, who retired from his job as a surveyor and businessman at the age of 40 to pursue his love of painting.

O'Brien was the preeminent painter in Ontario in the 1870s and 1880s, and his work was praised for its "marked individuality…feeling and genius far above the average." In 1874, he became vice president of the Ontario Society of Artists and, in 1880, was appointed the first president of the Royal Canadian Academy of Arts.

Daphne Odjig (1919–)

Tribute to the Great Chiefs of the Past

1975; acrylic on canvas; 101.8 cm x 81.0 cm; McMichael Canadian Art Collection

From a swirling array of lines and shapes, the Great Chiefs of the past emerge like phantoms in a fire, their identities dimmed by time but their spirits undaunted and ever present. The undulating curves that engulf them suggest tree roots and water, while the conelike protrusions arching and curving at the top evoke feather headdresses and tusks, alluding to the integration of native spiritual beliefs with nature.

Daphne Odjig was born on the Wikwemikong Indian Reserve on Manitoulin Island and is of Odawa, Pottawatomi and English heritage. Encouraged to draw at home, Odjig later moved to Toronto and began to study European art. In the early 1960s, when native people across the country were lobbying for political rights, Odjig began to combine native pictographs and Northwest Coast art with 20th-century European styles, developing an innovative technique that she later employed to depict native legends from her childhood. In 1974, she opened the first Canadian gallery dedicated to native art, in Winnipeg, and in 1973, she joined with Alex Janvier and others to form the short-lived Professional Native Indian Artists Inc., a group of seven native artists who embraced modernism as a means to express national identities. "My aspiration," said Odjig, "is to excel as an artist in my own individual right, rather than to be accepted *because* I am Indian." In 1987, Odjig was appointed a Member of the Order of Canada, and in 2007, she received the Governor General's Award in Visual and Media Arts.

Jessie Oonark (1906–1985)

Woman

1970; colour stonecut and stencil on wove Japan paper; 78.5 cm x 54.4 cm;
image: 62.2 cm x 40.2 cm irregular; Printed by Thomas Mannik (1948–);
National Gallery of Canada; Courtesy Public Trustee for the Northwest Territories;
The Estate of Jessie Oonark; Gift of Dorothy M. Stillwell, M.D., 1986

Jessie Oonark grew up in camps along the Back River, about 200 kilometres northwest of the community of Baker Lake in the Northwest Territories. Following the death of her husband in the early 1950s, she suffered increasing hardship. In 1958, Oonark and one of her children were rescued from near starvation and flown to Baker Lake, where she was able to get work scraping and sewing skins for the Hudson's Bay Company. Intrigued by children's art at the local school, Oonark made her first drawings at the invitation of Dr. Andrew Macpherson, a biologist with the Canadian Wildlife Service who provided paper and coloured pencils and paid for her work as a small relief from her poverty.

By 1961, the federal government had established an arts-and-crafts program at Baker Lake, and with the arrival of artists Jack and Sheila Butler in 1969, the Sanavik Co-operative was established. Oonark's *Woman* graced the cover of the first catalogue of prints, published in 1970. With a sureness of hand, an acute perception and a flair for design gleaned from years of cutting caribou skins and sewing clothes for her family, Oonark created an iconic image of womanhood. The figure's broad shoulders and large hooded amautiq assert her role as mother, while her serene gaze and the even symmetry of the brightly coloured clothing allude to strength and stability. The attention to the parka's shape and embellishments reflects Oonark's fascination with design and her adept synthesis of Back River and Baker Lake patterns.

Oonark drew and sewed ceaselessly. From 1970 to 1985, she published more than 105 prints and produced scores of highly esteemed wall hangings. The largest, commissioned by the National Arts Centre in Ottawa, was cut and handstitched in her tiny Baker Lake bungalow and viewed in its entirety by Oonark only after it was hung. "What shines through," recalled Jack Butler, "is a tremendous human being with a great command of the artistic language given to her by her culture and developed by herself."

Woman Feb 1970 Otnark, Manik

Parr (1893–1969)

Bear Hunt

date unknown; felt-tip ink pen on paper; 50.8 cm x 65.8 cm (sheet); Art Gallery of Ontario;
Gift of the Klamer Family, 1978; Photo by Carlo Catenazzi/AGO;
Reproduced with the permission of Dorset Fine Arts

Parr, the old hunter, as he was frequently called, fills the space of the paper with the objects of his quest: the large, bulky bodies of the bears and the angry twisted head and gnashing teeth of the wounded one. The dogs, employed to tire and annoy the dangerous carnivores, are partners in the chase, while the small birds act as pert spectators. Parr's style of drawing is simple and direct, reminiscent of the descriptive pictographs found on ancient rock art as well as the emphatic spontaneity of children's drawing. The small arrow shape to the left of the hunter's leg is Parr's signature, placed without heed to Western conventions.

At the age of 68, after a life of moving between camps, Parr suffered frostbite so severe as to require the partial amputation of one foot. His mobility compromised, he was forced to settle in Cape Dorset, where subsidized housing and medical facilities were available. Like many fellow Inuit who were exploring alternative means of economic self-sufficiency, Parr was introduced to drawing by Terry Ryan, manager of the West Baffin Eskimo Co-operative, a printmaking endeavour that encouraged Inuit to draw as a source for print imagery. Offered paper and pencil and, later, coloured pencils and felt-tip pen, Parr embarked in his forthright manner to express his nostalgia for a passing way of life, producing more than 2,000 drawings in his eight-year career as an artist.

Paul Peel (1860–1892)

The Little Shepherdess

1892; oil on canvas; 160.6 cm x 114.0 cm; Art Gallery of Ontario;
Bequest of John Paris Bickell, 1952; © 2007 Art Gallery of Ontario

At the foot of a grassy hill, a little shepherdess abandons her flock, crook and clothing and stops to take timid delight in refreshing herself in the quiet waters of a pond. The shadowy green of the meadow provides a perfect foil for her rosy flesh tones, while a nearby outcrop of irises alludes to her youthfulness and the springtime of her life. Painted in the last year of his short life, this work is a testimony to Paul Peel's acclaim as a painter of sentimental studies of children and young nudes who were often portrayed in an exotic or arcadian setting that tempered the blatant nudity with a narrative context acceptable to Victorian taste.

Born in London, Ontario, Peel studied at the Pennsylvania Academy of Fine Arts under Thomas Eakins, who promoted the study of anatomy as well as painting from the nude model. Peel later spent five years in the Paris ateliers of Jean-Léon Gérôme and Benjamin Constant and came to master the effects of light and shadow and the representation of flesh tones and material textures in a highly finished manner. Although he did not receive high prices for his work in Canada before his death, he was much appreciated in Europe and won a bronze medal at the Paris Salon of 1890 for his painting *After the Bath*, making him one of the first Canadian artists to gain international recognition in his lifetime.

Alfred Pellan (1906–1988)

On the Beach

1945; oil on canvas; 207.7 cm x 167.6 cm; National Gallery of Canada; Purchased 1961;
© Estate of Alfred Pellan / SODRAC (2007)

As the first recipient of the government of Quebec's fine-arts scholarship, Alfred Pellan travelled to Paris in 1926 and remained there until the Second World War forced him back to Canada in 1940. A Montreal exhibition of his European work, which revealed his admiration for the 20th-century masters Picasso and Matisse, rocked the Quebec art world. For artists in Quebec on the verge of exploring Cubism and Surrealism, Pellan's work was a liberating example. "Because of [Pellan]," said one art critic, "we are rushing to recover the half-century by which we have fallen behind."

More than two metres in height, *On the Beach* overwhelms the viewer with the monumental head of a Minotaur dreamily gazing at women sunbathing against brick walls that suggest an urban beach. Reflecting on Picasso's work of the early 1930s, which showed the mythological beast frolicking with nude women, Pellan presents the Minotaur with naturalistic contours, while the women are twisted and compressed in their shallow Cubist space. Pellan, already acclaimed for his murals, creates a mosaic-like surface, animating the organic shapes with a geometric patterning of textures and lines that transports us to a world of fantasy. In 1948, in opposition to the Automatistes, Pellan and his circle of artists formed the Prisme d'yeux, calling for an art "liberated from all contingencies of time and place, from restrictive ideologies."

Christiane Pflug (1936–1972)

Kitchen Door with Ursula

1966; oil on canvas; 164.8 cm x 193.2 cm; Collection of the Winnipeg Art Gallery;
Purchased with the assistance of the Women's Committee and the Winnipeg Foundation; Photo
by Ernest Mayer/The Winnipeg Art Gallery

Through the open kitchen door of Christiane Pflug's Woodlawn Avenue apartment in Toronto, our view is dominated by a winter scene of snow-covered roofs and lawns, with skyscrapers in the distance. This depiction of winter is curiously contradicted by the reflection in the windowpanes of the door of a lightly dressed child, with a background of green trees and shrubs. While this reference to different seasons mirrors the passage of time it took the artist to render the details of this large work, the simultaneous representation of spring and winter may have been an allusion to the cycles of nature, from birth to death and rebirth. As Pflug said, "I would like to reach a certain clarity which does not exist in life. But nature is complicated and changes all the time. One can only reach a small segment, and it takes such a long time."

Pflug was born in Berlin, and in 1953, she moved to Paris to study fashion design. There, she married Michael Pflug, who encouraged her to paint. In 1959, they immigrated to Canada, where she produced paintings of their children, possessions and immediate environs. The gridlike structures that preoccupied Pflug—embodied here by the kitchen cabinetry, door, balcony and architecture and in other works by birdcages—served as both structural refuges and prisons, whose confines Pflug ultimately escaped through suicide in 1972.

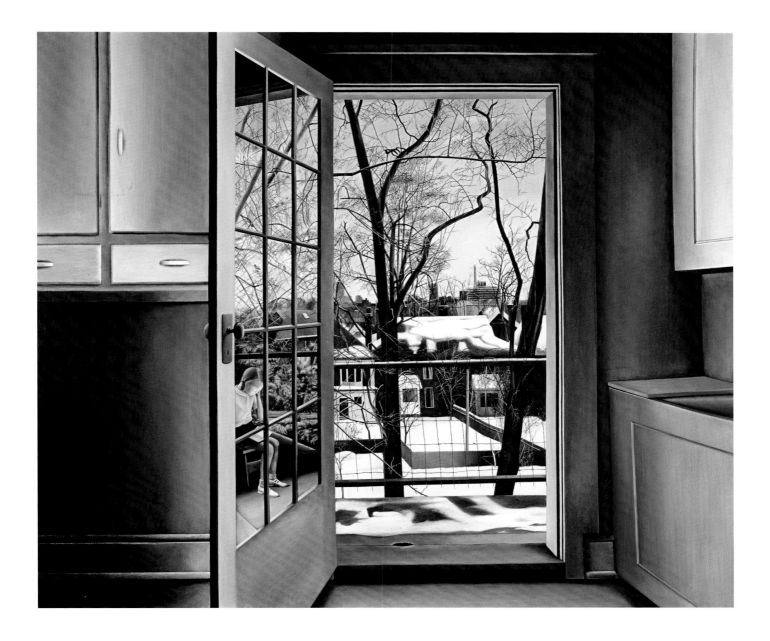

Walter J. Phillips (1884–1963)

York Boat on Lake Winnipeg

1930; colour woodcut on Japan paper; 29.6 cm x 38.7 cm; block: 26.1 cm x 35.0 cm;
National Gallery of Canada; Purchased 1930

As a resident of Winnipeg for over 28 years, the British-born W.J. Phillips made frequent sketching excursions to the nearby lakes. There, he conjured up the journeys made by the York boats used by the Hudson's Bay Company in the 19th century to transport heavy cargo. "It was easy to imagine…the brigades of York boats coming around the bend," he wrote. "They say you could hear the crews singing before the boats came in sight." In his usual fashion when working directly from nature, Phillips made quick pencil sketches of the windswept lake and distant island and then, in his studio, composed a watercolour as a model for the colour woodcut.

Here, sweeping black lines define the churning waters of Lake Winnipeg, where a strong wind fills the square sail, whose cheerful colour is echoed in the sailors' bright caps and the boat's red rim. In this work, Phillips reveals his debt to the Japanese woodcuts that had been popular since the 19th century with artists who admired their unusual points of view, the flattened space and the expressive use of line juxtaposed with a delicate colour. Phillips had made his first successful colour woodcut in 1917, but it was only after a trip to England in 1924 and a meeting with the Japanese master Yoshijiro Urushibara that he discovered a technique which would establish his reputation as Canada's foremost colour-woodcut artist between the wars.

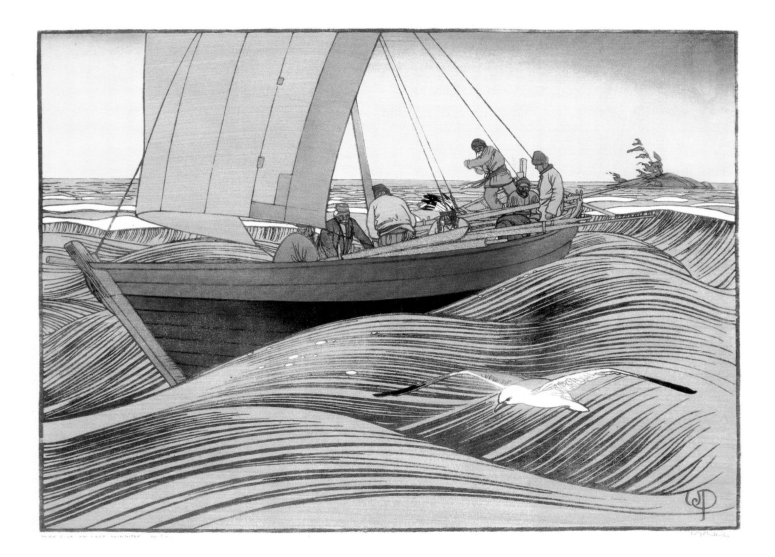

Antoine Plamondon (1804–1895)

Soeur Saint-Alphonse

1841; oil on canvas; 90.6 cm x 72.0 cm; National Gallery of Canada; Purchased 1937

*T*he former Marie-Louise-Émilie Pelletier, dressed in the habit of an Augustinian nun, smiles and gazes from the canvas with gentle reserve. Bathed in a light that illuminates her delicate features and casts a halolike aura behind her, she sits framed by her long black veil and starched white wimple. Their triangular shapes lend an air of stable tranquillity to the portrait. In contrast to the austerity of her dress, the radiant flesh tones and the red of her chair, book and lips add an element of warmth and a contained sensuality.

Inspired by the 18th-century French portrait tradition that depicted nuns set against a neutral background, Antoine Plamondon created a composition whose underlying geometry and highly refined realism reflected his neoclassical training in France more than a decade earlier. His skill in constructing the illusion of material texture, illustrated by the thinness of the muslin veil, the crisp wimple and the sheer linen covering the hands, conveys a realism that is as restrained as it is palpable.

Plamondon, then Quebec's most eminent portraitist, was commissioned by Soeur Saint-Alphonse's father, a prosperous Quebec merchant, to paint this work two years after she had taken her final vows. It would have been hung in the home as a cherished reminder of someone who would never again cross the familial threshold.

Jane Ash Poitras (1951–)

A Sacred Prayer for a Sacred Island

1991; oil paint, collages of photographs, photocopies and printed papers, blackboard acrylic, wax crayon, eagle feather and five-dollar bill on canvas; 187.3 cm x 437.5 cm overall; left panel: 187.3 cm x 116.0 cm framed; centre panel: 187.0 cm x 166.0 cm framed; right panel: 187.0 cm x 115.5 cm framed; National Gallery of Canada; Purchased 1995; © Jane Ash Poitras, 1984

Employing the triptych format of early Christian art, Jane Ash Poitras assembles images that reflect the multifaceted nature of aboriginal experience, history and spirituality. In the centre, a large tipi decorated with ancient native pictographs is flanked by expressive drawings of shamans. Above, a collage of photographs of sweat lodges and sun dancers is linked to images of the hunt and refers to the integration of native spirituality with nature. In the side panels, Poitras combines photographs of Western thinkers she admires with aboriginal symbols and drawings. While words such as "Manifest Destiny" and maps of the globe allude to the abuse of power in the history of colonization, the preponderance of aboriginal imagery establishes a balance in a world that has lost touch with its spiritual roots. As Poitras stated, "Only through spiritual renewal can we find out who we really are, be empowered to achieve our potential and acquire the wisdom to eliminate the influences that bring tragedy upon us and destroy us."

Born in Fort Chipewyan, Alberta, and raised as a Catholic by her adopted German mother, Poitras began to recover her Cree heritage and language as an adolescent. In her studies at the University of Alberta and at Columbia University in New York, she cultivated a visual language that combines images and words to express the complexity of personal and collective histories.

Napachie Pootoogook (1938–)

My New Accordion

1989; lithograph; 112.4 cm x 79.9 cm; Cape Dorset 1989, no. 23;
Printed by Pitseolak Niviaqsi (1947–); Canadian Museum of Civilization, image #S99-40;
Reproduced with the permission of Dorset Fine Arts

As the daughter of Pitseolak Ashoona, Napachie Pootoogook was heir to both her mother's artistic talent and her optimistic spirit, despite the dangers and hardships endured in her life on the land. In the early 1960s, Napachie and her family moved to Cape Dorset, where she and her mother were each introduced to drawing by James Houston, the founder of a printmaking co-operative. Napachie's early drawings depict images of birds and scenes of everyday northern life on the land, while her later work reflects Inuit culture in transition, in which the old ways are juxtaposed with the new.

Married to printer Eegyvudluk Pootoogook, Napachie was one of the first artists to experiment with lithography when it was introduced in Cape Dorset in the early 1970s. In this planographic process, the artist draws directly on the printing plate with a lithographic crayon that allows the rendering of fine detail and subtle tonal transitions. In *My New Accordion*, the beauty of the delicate drawing and the attention to the visual description of the clothing and background are complemented by the expression of pleasure on the face of Napachie.

Her pride is also conveyed in the use of colour, notably in the accordion, where the rainbow hues sweep across the expanding instrument like the joyous swell of the music itself.

My New Accordion Lithograph WELL INK 14 Povulat 1488 Pisaula

Christopher Pratt (1935–)

Deer Lake: Junction Brook Memorial

1999; oil on canvas; 114.5 cm x 305.0 cm; National Gallery of Canada; © Christopher Pratt;
Gift of David and Margaret Marshall, Toronto, 1999

A long, thin rail separates us from the churning waters illuminated by a seemingly infinite series of Palladian windows, whose soft colours and graceful shape suggest a palace or a church rather than an electrical power station. While meticulously rendered institutional architecture has long been a subject of Christopher Pratt's art, the buildings are usually fabricated from his imagination. This work, however, is an exception and was inspired by Pratt's view of a power station near his home in his native Newfoundland. Pratt recalled that he was attracted to the contrast between "the immense power of the water and then…a kind of revulsion at its entrapment, imprisonment behind dams." An element of sadness pervades the painting, with its dark palette and impenetrable sky, and finds its reflection in the word "memorial" of the title. "Junction Brook" is the euphemistic term for the dried-up riverbed, formerly a major confluence of rivers. Pratt wrote: "The forces of nature become the implements of art: the powerhouse…becomes a secular cathedral…the light comes from the inside out; the windows, their brilliance and variety speak of the achievements of man, not the glory of God…As a painter, all I could celebrate was light."

Pratt studied at the Glasgow School of Art (1957–58) and at Mount Allison University, Sackville, New Brunswick (1959–61), before returning to Newfoundland, where he continues to live.

Mary Pratt (1935–)

Eggs in Egg Crate

1975; oil on Masonite; 50.5 cm x 60.5 cm;
From the Collection of Memorial University of Newfoundland at The Rooms Provincial Art Gallery

*L*ight fills the rectangles and hollow cavities of an open carton wherein lie three broken eggs, their delicate shells paper-thin and brittle against the thick pressed cardboard of the container. Haphazardly placed in their gridlike box, the shells harbour the transparent whites and deep yellow remnants of life. Mary Pratt paints meticulously, almost reverently, with seemingly invisible brush strokes, capturing the fragile beauty and chromatic harmonies of everyday life. Although the egg is a powerful metaphor for life, death and regeneration, Pratt insisted: "The reality comes first, and the symbol comes after...I see these things, and suddenly, they become symbolic of life."

Born in Fredericton, New Brunswick, Pratt graduated in 1961 from Mount Allison University in Sackville, where she studied with Alex Colville and Lawren P. Harris. Moving to Newfoundland with her husband, artist Christopher Pratt, she strove to balance the responsibilities of a family with her desire to paint, inspired by the transforming but fleeting effects of light on food and on the other objects of her domestic environment. Initially, she attempted to paint quickly in order to capture the ephemeral effects of light, but she later embraced photography, sketching with the aid of 35mm slides to preserve the fugitive play of light on transparent jellies, glistening fish reflected in tinfoil and, later, nudes and landscapes.

Pudlo Pudlat (1916–1992)

Sea Creatures

1976; acrylic paint, coloured pencil, black felt pen on wove paper (watermark:
"BFK RIVES FRANCE"); 49.5 cm x 56.1 cm; National Gallery of Canada;
Gift of Dorothy M. Stillwell, M.D., 1987; Reproduced with the permission of Dorset Fine Arts

Beneath the blue waters, a large fish carries Sedna, the Inuit goddess of the sea. Both goddess and fish are embellished by a rhythmic repetition of squares echoed in the line of windows of the airplane flying overhead, signalling a blending of old spiritual and new physical realities that characterizes the art of Pudlo Pudlat. In applying the transparent acrylic wash to describe the water, Pudlo combines spatial perspectives, showing the water both as a transparent medium and as a surface, where the kayaker and dog watch creatures and whales frolic on the horizon of the Arctic sea. Pudlo's creative merging of traditional and modern iconography reflects his optimistic and sometimes humorous view of Inuit culture in transition.

Born at a camp some 350 kilometres east of Cape Dorset, Pudlo lived as a hunter along the southwest coast of Baffin Island, where he endured many hardships in his struggle to support his family. He began to draw around 1960, while living at Kiaktuuq, near Cape Dorset. In his prolific 30-year career, during which he produced almost 4,500 drawings, his art was served by the liveliness of his imagination, a talent for drawing and an eye for colour. "Artists draw what they think…and what they have seen also," he said. "But sometimes, they draw something from their imagination, something that doesn't exist anywhere in the world."

Andrew Qappik (1964–)

With Open Mind

1992; lithograph; 40 cm x 49 cm; Printed by the artist;
Canadian Museum of Civilization, image #S2000-2375

As part of a younger generation of Inuit artists who grew up in settled communities with access to modern telecommunications, Andrew Qappik admired the drawings in Marvel comic books. Before he finished high school, Qappik began working in the print shop at Pangnirtung, Baffin Island. Qappik's work, like that of other Pangnirtung artists, reflects the legacy of the earlier contact with whalers as well as an enduring fascination with the spirit world.

Qappik gives traditional beliefs modern form in this delicately drawn and sensitively shaded lithograph, setting the transformation of the shaman in a realistic Arctic landscape. With their cheerful, almost human smiles, walrus-faced creatures lounge on an ice floe and portray the shaman's ability to adopt many guises. The walrus in the background waves its whalelike lower body, while the one in the foreground balances on its human arm. Strangest of all, the large, rounded body casts the shadow of a miniature dog team, reminding us of the shaman's mysterious magic.

"Our heritage includes shamanism," explains Qappik. "A shaman would have a champion animal which he or she would become...like the walrus is feared by the killer whale. Today, the transformation occurs in humans with an open mind. You can know so much more of others' way of life today, and learning this...this knowledge becomes part of you."

"With Open Mind" Lithograph 34/45 Andrew Karpik Pangnirtung 92'

George Agnew Reid (1860–1947)

Call to Dinner

1886–1887; oil on canvas; 121.6 cm x 179.8 cm; McMaster University Collection;
Gift of Moulton College, Toronto; Donated to Moulton College by
Mr. and Mrs. John H. L. Patterson, Mr. Robert Lawrence Patterson,
Mr. J. F. W. Ross and the artist; Photo by Isaac Applebaum

In the brilliant noonday sun, the artist's sister Susan stands at the edge of the family farm and calls the workers to dinner. The hot light beats down on her hat and upraised arm, casting her face and neck into shadow and bestowing a sculptural monumentality to her figure that spans the height of the large canvas. The blue-green colour of her dress offers a chromatic synthesis of the summer-green fields that extend to the horizon, and the tranquil blue sky overhead. In 1888, a Toronto critic praised George Agnew Reid's work for its "boldness and truth and a thorough acquaintance with anatomy, the laws of perspective and the rules of composition."

Born on a farm in Wingham, Ontario, Reid began his art studies in 1878 at the Central Ontario School of Art and Design in Toronto. There, he met Robert Harris, who promoted the lessons of French academic training. Reid's desire to study the nude model led him to Philadelphia, where he spent three years with American realist Thomas Eakins, who insisted on a thorough grounding in anatomy and life drawing. Despite the heavy influence of the French academic tradition on artists of his generation, Reid, who would soon become Canada's foremost genre painter, applied this training to Canadian subjects. Many years later, he stressed how essential it was that "the Canadian brush…have for its ultimate end the expression of Canadian life, sentiments and characteristics."

Reid travelled to Paris in 1888 to study at the Académies Julian and Colarossi, continuing his examination of the nude model and perfecting his attention to the effects of atmosphere and light on the figure. When he returned to Canada in 1889, he embarked on a series of large-genre pictures inspired by his experiences growing up in rural Ontario.

In the late 1890s, Reid's passion for Canadian subjects evolved from scenes of everyday life to historical paintings and murals, through which he could express his commitment to public art and education on a grander scale. In 1912, Reid was appointed the first principal of the Ontario College of Art, where he presided until his retirement in 1929.

Mary Hiester Reid (1854–1921)

Chrysanthemums, A Japanese Arrangement

c. 1895; oil on canvas; 45.7 cm x 61.0 cm; Art Gallery of Ontario;
Gift of Friends of Mary Hiester Reid, 1923; © Art Gallery of Ontario;
Photo by Carlo Catenazzi/AGO

*P*raised for "diligence and sincerity" in her study of nature, Mary Hiester Reid is best known for her small, intimate paintings of flowers and interiors, which reflect her appreciation of the play of light on colours and textures in nature.

Here, the feathery delicacy of the pink and yellow chrysanthemums contrasts with the cool blues and greys of the smooth, round ceramic vase and the Japanese print in the background. The inclusion of a Japanese print demonstrates Reid's awareness of the importance of these works to late-19th-century artists, and her use of an asymmetrical composition is an adoption of some of the principles of Japanese design. But her realist approach to the subject reflects her academic training under Thomas Eakins at the Pennsylvania Academy of Fine Arts (1883–85). It was there that the artist, who was born in the United States, met Canadian painter George Agnew Reid, whom she married in 1886.

Reid's use of words such as "harmony" and "study" in titles of other flower pictures indicates her awareness of the art-for-art's-sake aesthetic of Anglo-American painter James McNeill Whistler. After her death, a Toronto art critic's appreciation characterized Reid in this way: "She was not only a painter of flowers, but their poet...she showed a wonderful felicity of arrangement and facility of execution."

Peter Rindisbacher (1806–1834)

Indians Returning from War

1825; watercolour, pen and ink; 25.8 cm x 21.3 cm; Library and Archives of Canada/C-114471

When Swiss-born Peter Rindisbacher took his first art lessons with a Bern miniaturist in the summer of 1818, he had no idea that he would become the first European artist to record prairie and Indian life west of the Great Lakes. In 1821, he immigrated to Canada with his parents, arriving at York Factory, a Hudson's Bay Company post on the west coast of Hudson Bay. His first sketches tell of the arduous sea voyage, the hazardous navigation of ships and the aboriginal groups they encountered in their perilous journey to the Red River Colony. In this rare depiction of the interior of a Plains Indian tipi, a warrior dressed in a buffalo hide brandishes an enemy scalp and carries a rifle acquired by trade with the settlers. A young warrior in the foreground, standing with his back to us, wears a Plains Indian buffalo robe characteristically decorated with a sunburst design. The other objects in the tipi, however, are Woodland Indian and confirm the ethnographic mixing prevalent in the Red River area.

An expert draughtsman with a keen eye for detail, Rindisbacher produced hundreds of colourful works, many of which were commissioned by Hudson's Bay officers. As accurate depictions of the daily rituals, hardships and violence experienced by both the native peoples and the settlers, they have proved valuable to historians and ethnologists.

Indians Returning from War

Jean-Paul Riopelle (1923–2002)

Pavane

1954; oil on canvas; 300.0 cm x 550.2 cm overall; National Gallery of Canada; Purchased 1963;
© Estate of Jean-Paul Riopelle/SODRAC (2007)

Although Jean-Paul Riopelle had moved to Paris in 1946, he was an integral part of the artistic revolution that took place in Montreal in the late 1940s. He designed the cover for the 1948 manifesto *Refus global* with a gestural allover linear patterning that characterized his work at the time.

Pavane is considered Riopelle's masterpiece from the 1950s. An immense work spread over three large panels, it envelops the viewer in a swirling, awe-inspiring array of colour. The elongated triangular shape of the artist's palette knife swoops across the canvas with a dizzying energy, creating featherlike patterns of flickering light. From left to right, areas of brilliance and darkness and of warm and cool colours swirl and dip across the canvas with musical rhythms, evoking the flamboyant Spanish dance of the title. "My purpose is not abstraction," said Riopelle, "it's moving towards a free gesture; it's trying to understand what is nature, starting not with the destruction of nature but with the world."

Riopelle studied at Montreal's École des beaux-arts and with Paul-Émile Borduas at the École du meuble, where he came into contact with Surrealist theories of automatism that encouraged a spontaneous expression of the subconscious in art. Recognized abroad by the late 1940s, Riopelle had achieved international success by the 1950s and continued to paint almost until his death in 2002.

Rick Rivet (1949–)

Whaler Mask

1999; acrylic on canvas; 139 cm x 140 cm;
Indian Art Centre, Department of Indian Affairs and Northern Development, Canada; Photo by
Janet Dwyer

From the dark waters of the sea, a large greenish mask emerges, its form evoking the ancient masks of the Dorsets, the people who inhabited Arctic coastal regions from about 500 B.C. to 1500 A.D. The mask seems animated, its small eyes peering out and its mouth a curious spiral whose archetypal shape suggests the continuity of time and ancestral secrets. The areas of bright red, yellow and turquoise contrast with the enigmatic shadows of the sea world and lend a material beauty to this dreamlike realm. "In my art," said Rick Rivet, "I seek poetic expression—a visual language which uses the visible universe as a metaphor for the invisible, a communication between the world and the spirit, a mystical relationship."

Working spontaneously and intuitively, Rivet reveals otherworldly imagery that reflects his identity as a native artist. He remains committed to "the idea of 'bearing witness' to the strong spiritual content within the artistic traditions of aboriginal peoples in Canada and worldwide…These ancient artistic traditions, with their basis rooted in shamanic ideology and belief, have survived despite the devastating effects of colonialism."

Rivet, a Métis, was born in Aklavik, Northwest Territories, and later moved to Inuvik. He studied at the Universities of Alberta, Victoria and Saskatchewan. "Art," he said, "is a journey of the human spirit through the space/matter/time continuum."

W. Goodridge Roberts (1904–1974)

Marian

1946; oil on canvas; 97.0 cm x 72.4 cm; Art Gallery of Ontario; Purchase, 1946;
© 2007 Art Gallery of Ontario; Photo by Brigdens/AGO

With a solemn monumentality, Marian Roberts sits in a simple ladder-back chair, setting a tone of austerity that is echoed in her masklike expression. Contrasting with her sombre clothing and the boldly painted grey background, the light from the left lends a sculptural quality to her head, creating an area of brightness that continues in her hands and softly falling scarf. Tension and a feeling of sadness pervade the painting, perhaps because this was one of the last portraits Goodridge Roberts did of his first wife before their separation later that year.

The child of a literary family, Roberts enrolled at the École des beaux-arts in Montreal in 1923. Disliking its staid academic approach, however, he left for New York City to study at the Art Students League (1926–28), where teachers such as Max Weber introduced him to new ways of structuring space and to a daring palette inspired by Cubism and Fauvism. The city's galleries and museums offered him a glimpse of the work of the Post-Impressionists and the art of Paul Cézanne. "For the first time," wrote Roberts, "I saw painting that moved me." Following his term as the first artist in residence at Queen's University at Kingston (1933–36), Roberts returned to Montreal, where he continued to paint landscapes, still lifes and nudes with his characteristic directness and imaginative use of colour.

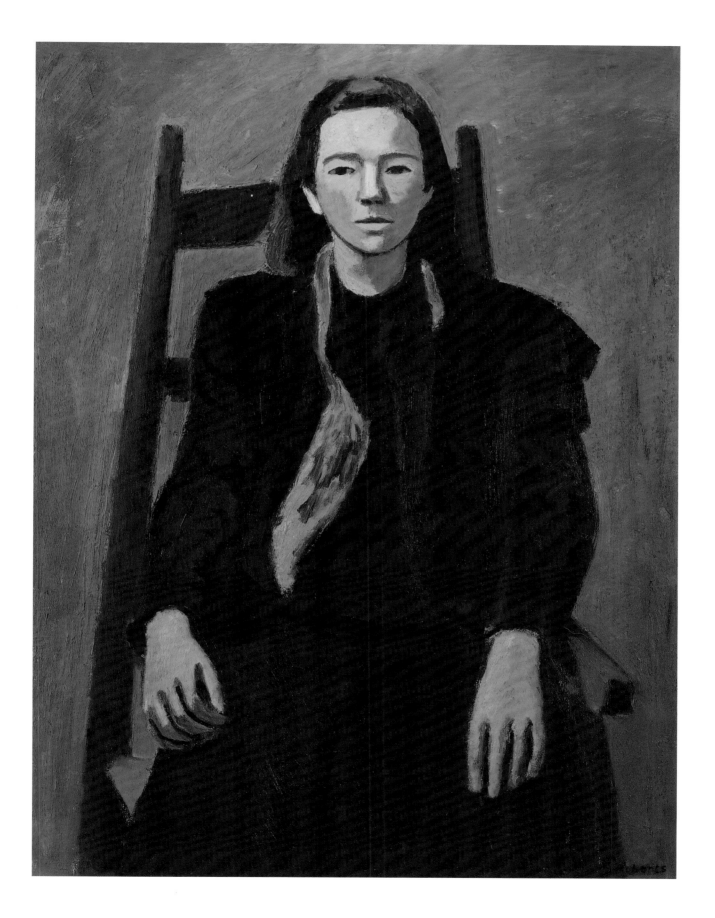

William Ronald (1926–1998)

J'accuse

1956; oil on canvas; 152.4 cm x 175.9 cm;
The Robert McLaughlin Gallery, Oshawa; Purchase, 1971; Photo by Thomas Moore

"Jazz, the crash of bombs, the racing of civilization [all] have a definite effect on painters," said William Ronald in 1952. Here, a bold red shape created by energetically applied oil paint dominates the middle of the canvas, which is divided by an area of thick white paint above and a largely grey area, where rich blacks press against the red. The striking juxtaposition of colours combines with the powerful brushwork to form a strong central image whose newness confronts us with the feelings of uncertainty or aggression echoed in the painting's title.

Ronald studied with Jock Macdonald at the Ontario College of Art in 1952, then briefly in New York City with German abstractionist Hans Hofmann. In 1953, Ronald organized Abstracts at Home, an exhibition at the Robert Simpson department store by artists who would subsequently form Painters Eleven. But as Jack Bush recalled, "Bill Ronald got fed up with Toronto completely. He hated it here. He was a furious and angry young man in those days—and what a painter!" In 1955, Ronald moved to New York City, where his work attracted critical appreciation: "His pictures have an insistent honesty, a refusal to cover up confusion and a compelling painterliness." By 1957, Ronald was being represented by the successful Samuel Kootz Gallery, which promoted abstract art.

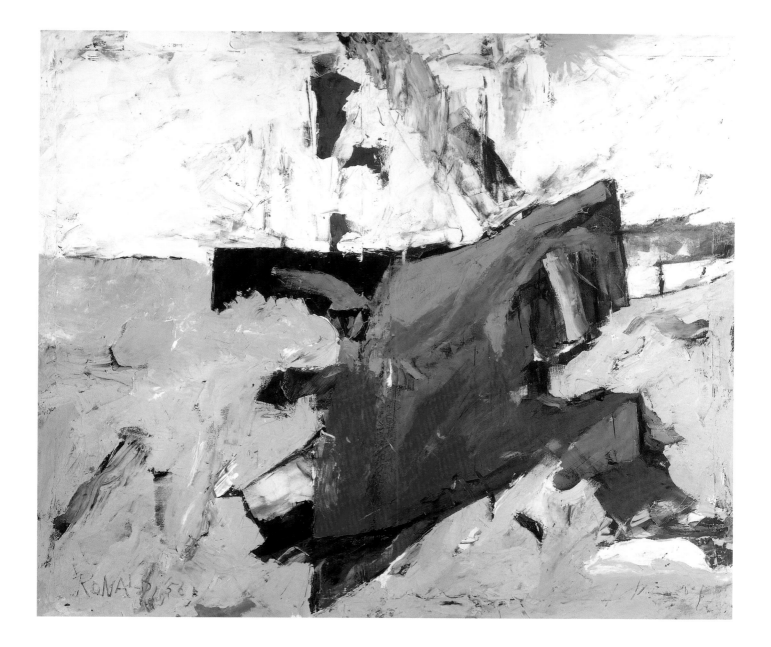

Fred Ross (1927–)

A Delancey Encampment

1985; casein tempera on canvas; 274.3 cm x 213.4 cm; Saint John Arts Centre

Under the protective canopy of a solitary tree, a solemn troop of soldiers, women, and children pose with theatrical stillness, frozen in time, communicating silently through body language and facial expression. In responding to the commission to celebrate the 200th anniversary of the city of Saint John, New Brunswick, Fred Ross depicted the arrival of a group of Loyalist settlers led by a member of the Delancey's Brigade. Ross used actual citizens in historic dress as models, and integrated them in a composition that reflects his admiration for the structure of Italian Renaissance religious paintings. Here, for example, the mother, flanked by young children, resembles a Madonna in "sacred conversation" with the kneeling soldier, who poses like a saint. And rather than a "last supper," Ross presents a "first supper" of newcomers, where the young family in the foreground suggests the cycle of life and the promise of future generations. At the same time, Ross's palette of subdued and bright colours, his distillation of detail, and the careful orchestration of the geometric shapes that weave through the figures announce a thoroughly modern sensibility.

A native of Saint John, Ross is celebrated as a painter of murals, canvases of haunting individuals and small groups, as well as meticulously rendered, still-life works. In the mid-1940s, Ross studied with Ted Campbell at the Saint John Vocational School. He later travelled to Mexico where he met the renowned Mexican artist Diego Rivera, who counselled him about the importance of painting stories from Canadian history on a large scale. In 2002, Ross was appointed a Member of the Order of Canada for his achievements as an artist and for his generosity as a teacher and citizen of Saint John.

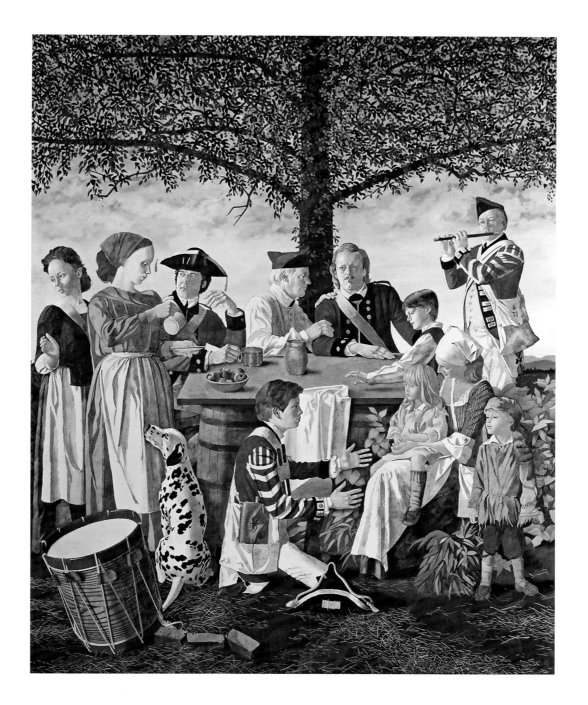

Running Rabbit (1833–1911)

Buffalo Robe

1909; buffalo skin; 170 cm x 190 cm; With permission of the Royal Ontario Museum, © ROM

When artist Edmund Morris (1871–1913) travelled across Canada in the first decade of the 20th century to paint portraits of native people, he met Blackfoot chief Running Rabbit on a reserve east of Calgary. Between 1908 and 1910, Morris commissioned eight Blackfoot and Sarcee chiefs to paint their histories on buffalo hides, the traditional robes used by warriors to summarize visually their war exploits, horses or enemies captured and brave deeds. Here, on the large surface of the buffalo hide, Running Rabbit used the porous part of a buffalo bone as a tool to draw images inspired by "picture writing," a pictographic tradition practised by Plains Indians. Women are easily recognized as skirted, while the triangular bodies of men feature either a single leg in profile or a pair of striding legs. Running Rabbit worked within a conventional artistic language where figures were clearly drawn and arranged systematically for tabulation, and included symbols to represent scalpings or the capture of enemies. He distinguished the players in his chronicles with different colours: Cree were painted in red, Crow in yellow and Blackfoot in blue or black. At Morris's request, Running Rabbit drew red lines around the various groupings to separate the stories that unfolded over a period of time. These events were highly valued within the native community as signs of bravery and were depicted with respect.

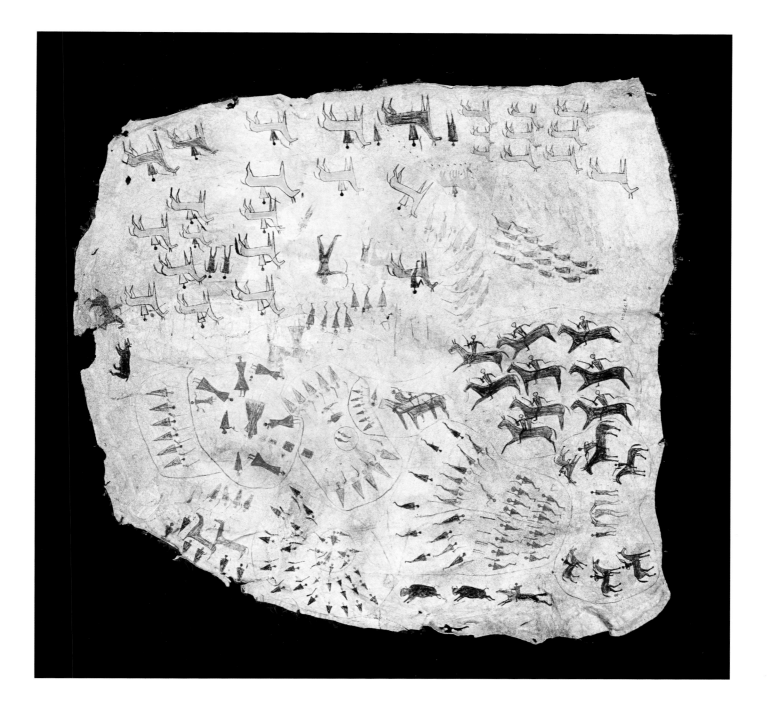

Allen Sapp (Kiskayetum) (1929–)

The Pow-Wow

1987; acrylic on canvas; 101.6 cm x 152.4 cm; Collection of the MacKenzie Art Gallery;
Purchased in memory of Mari Stewart; Reproduced with permission from the artist;
Photo by Don Hall

Beneath a ring of branches, people come together for a summer powwow, a colourful First Nations social gathering. In the foreground, figures painted in primary colours direct our gaze to the procession of dancers dressed in ceremonial beadwork clothing, whose red, yellow, black and white colours symbolize the four cardinal directions and honour the four races of the Earth. The beadwork patterns are similar to those of Allen Sapp, himself a powwow dancer. To the right, men in white hats stand in a circle and beat on the drum, and in the distance, the tipis stand like tall spectators on the circle's edge. Although Sapp is renowned for his depictions of the cultural activities and daily life of the Northern Plains Cree, Métis artist Bob Boyer insists that "[Sapp's] work is marked by his 'spiritual reverence' for the world and is not merely an illustration of the world around him."

Sapp was born on the Red Pheasant Indian Reserve near North Battleford, Saskatchewan, and began to make portraits of friends and family in the 1950s. Adopting the conventions of Western art gleaned in his youth from magazines and calendars and profiting from a short period of study with Saskatoon painter Wynona Mulcaster, Sapp expressed his Cree heritage as "he who knows it," fulfilling the meaning of his native name, Kiskayetum. In 1987, Sapp was made an Officer of the Order of Canada.

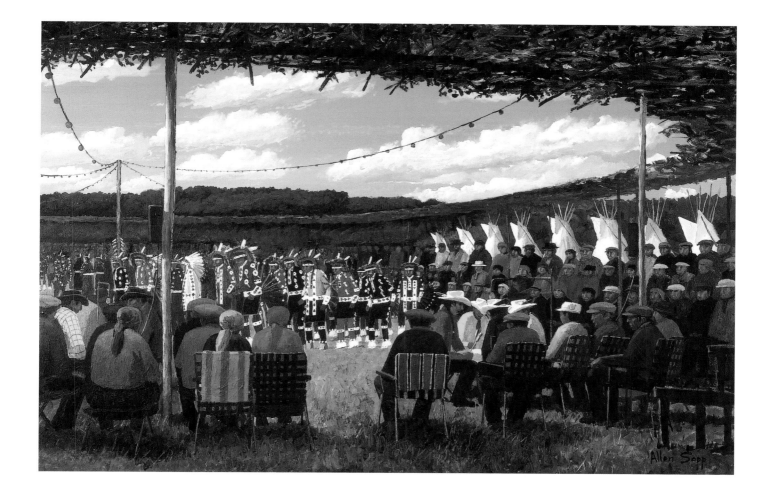

Anne Savage (1896–1971)

The Plough

c. 1930; oil on canvas; 76.4 cm x 102.3 cm; The Montreal Museum of Fine Arts;
Gift of Arthur B. Gill; 1970.1652; Photo by Brian Merrett/MMFA

Here, a close-up view of a plough cuts a strong diagonal across the canvas and provides a window onto an undulating landscape, where a sea of green grass wafts as smooth as silk. The contours of the ploughed fields rise and fall with a steady rhythm until they meet the shining green sky, which is tempered by a wispy sliver of purple cloud.

Through the poetic use of colour and line, Anne Savage evokes her feelings of joy in capturing the splendour of the Quebec countryside along the shores of the Lower St. Lawrence. "The backcountry was always perfectly beautiful," she said. "And it's wonderful the way the land rolls away in great sweeping folds. The forms, they run in long laps right up from the sea. Field after field. It was like a patchwork quilt."

Savage studied with William Brymner and Maurice Cullen at the Art Association of Montreal, and in 1920, she joined the Beaver Hall Group, where she developed a long and close friendship with A.Y. Jackson. Occupied as a teacher for most of her career, she continued to travel the country widely on sketching excursions. Although Savage was influenced by members of the Group of Seven and exhibited with them, her sense of colour and design was a departure from theirs and was marked by a lyrical and passionate response to the land.

Carl Schaefer (1903–1995)

Ontario Farmhouse

1934; oil on canvas; 106.5 cm x 124.7 cm; National Gallery of Canada;
Gift of Floyd S. Chalmers, Toronto, 1969; © Paul Schaefer

Carl Schaefer left his grandfather's farm and the place of his birth in Hanover, Ontario, in 1921 to study at the Ontario College of Art in Toronto. Through his teachers J.E.H. MacDonald and Arthur Lismer, the young student met A.Y. Jackson and Lawren Harris, whose paintings of Toronto houses he admired. During the Depression in the early 1930s, however, jobs for artists were scarce, and with a family to support, Schaefer was forced to return to his grandfather's farm.

"There is one thing every painter must do," wrote Schaefer, "and this is know his environment…and achieve a proper balance between the technical means and the emotional expression." True to his word, Schaefer embarked on a series of paintings depicting the rural homes and fields of Hanover in a style that evoked the dramatic and uneasy tensions of the 1930s and 1940s. In *Ontario Farmhouse*, a neighbour's home commands a view of the surrounding fields, while a dramatic sky is animated by a diagonal sweep of clouds that contrasts with the stable geometry of the house. To suggest the cycles of nature and regeneration, Schaefer juxtaposes green plants with harvested and unharvested hay, and to the right, a barren tree foretells the cold sleep of winter that will, in turn, give way to spring. Subject to the perpetual transformations of nature, humanity—which is symbolized by the house and the lone chair—endures.

Tony Scherman (1950–)

Macbeth's Mother

1994; encaustic on canvas; 183 cm x 152 cm;
Courtesy of La Serre Art Contemporain/Barbara Farber; Photo by Victor Arnolds

When viewing this work, one hovers in limbo between the awareness of the sensuous surface of the canvas, given luminosity and texture by the oil and encaustic, and the monumental presence of illusion, as the detail of a woman's face assaults us with its huge scale and quivering emotion. In a series of paintings inspired by characters from literature and Greek mythology, Tony Scherman rejuvenates the art of portraiture by combining the "close-up," born from the advances of modern photography and cinema, with the ancient technique of encaustic to present a timeless expression of emotion. While the practice of mixing paint with hot wax can be perilous, the technique appeals to Scherman for its enduring qualities. "I know that my paintings are going to live longer than I will," he explained. "That gives me a sense of satisfaction."

Here, Scherman has fabricated the character of Macbeth's mother, with a soul as tortured and fearful as that of her ambitious and treacherous son. Her wide eyes watch silently as her thin lips speak of woe and resignation. By omitting a setting, the artist portrays the essence of the individual, exposing the surface of memory and experience.

Scherman was born in Toronto and moved to London, England, as a child. He graduated from the Royal College of Art in 1974 and returned to Toronto two years later.

Charlotte Schreiber (1834–1922)

The Croppy Boy
(The Confessions of an Irish Patriot)

1879; oil on canvas; 91.6 cm x 76.2 cm; National Gallery of Canada;
Royal Canadian Academy of Arts diploma work, deposited by the artist, Toronto, 1880

It is not surprising that Charlotte Schreiber, an artist who had already exhibited paintings at the Royal Academy in London at the age of 21 and had illustrated the poems of Chaucer, Spenser and E.B. Browning, would again turn to literature as an inspiration for her work.

Here, her source is a ballad popular during the Irish rebellion of the 1790s, in which the Croppy Boy, so named for his close-cut hair, kneels to confess his sins before going into battle. With exacting realism, Schreiber faithfully captures the boy's unwitting and tragic encounter with the British soldier disguised as a Catholic priest.

Employing academic skills recognized by the Royal Canadian Academy of Arts, which invited her to become a charter member in 1880, Schreiber portrays a moment that is as taut with emotion as it is striking in its verisimilitude. Its poignancy is further enhanced by the contrast of the worn clothes and tired dusty shoes of the boy beside the brass-buttoned coat and magnificent black riding boots of the soldier. Given the players' mutual hostility, the red of their jackets lends an ironic visual unity to the picture. We might wonder whether Schreiber's sympathies are not reflected in her use of light, with the young patriot situated on the bright side of the canvas and the soldier set against an impenetrable shadow.

John Scott (1950–)

Second Strike

1981; oil stick, graphite, and Varsol on paper; 244 cm x 244 cm;
National Gallery of Canada; Purchased 1982

Against a background of dark, lifeless mountains, charred and smouldering from the first strike by a cruise missile, a second missile—innocently white—flies low to the ground searching for its next target. Using Varsol-saturated paper that binds with the rich black oil stick, John Scott evokes the greasy messiness of the mechanics' garage, and at the same time creates a powerful statement about anger, fear and doom: a warning to humanity to find a better way to deal with global conflicts that threaten all life on the planet. The imposing scale—over two metres high and wide—is in itself an act of protest and commensurate with the serious threats of annihilation inherent in these sinister weapons. Reinforcing the ominous tone of the drawing, angry words plug the sky, alluding to the impact of the second strike on the already devastated earth.

In his expressive drawings, installations and transformed found objects —such as his celebrated Trans-Am Apocalypse car with the Book of Revelation scratched with a nail all over its black surface—Scott addresses the fear of nuclear holocaust and environmental destruction. Growing up in the 1950s in Windsor, Ontario, in the shadow of Detroit, then the Mecca of the American car industry and a city marked for nuclear eradication during the Cold War, Scott was quickly acclimatized to the abuse of technology and the threats of world war. "Blood is the lubricant of the modern industrial world," he said. Scott studied at the University of Toronto and the Ontario College of Art between 1972 and 1976. In 2000, he received the Governor General's Award in Visual and Media Arts.

Marian Scott (1906–1993)

Stairway

c. 1940; oil on canvas; 74.3 cm x 50.7 cm; The Montreal Museum of Fine Arts;
Purchase, A. Sidney Dawes Fund; 1942.749; © Estate of Marian Scott;
Photo by Christine Guest/MMFA

In the interior of a modern building, our eye is drawn to the bright red dress of a woman descending a spiral staircase. Below, a man in more subdued colours completes his journey and focuses our attention on a couple embracing and another figure turning a corner. The curving forms of these anonymous individuals lend an organic softness to the severity of the architecture, which is composed of a series of angles, lines and rectangular shapes. Painted around 1940, *Stairway* embodies Marian Scott's intention to create works of art that would reflect humanity's ability to establish a rational environment, an optimistic stance in the face of the impending chaos of war.

As a founding member of the Contemporary Arts Society in Montreal in 1939, Scott and her colleagues were frustrated by the nationalism and domination of landscape painting trumpeted by the Group of Seven. They sought new subjects for Canadian art, desiring, as Scott explained, to explore "the cutting edge…to try to add something new to tradition." Her inquiries into more international influences were nurtured by travels throughout Europe, by a short study in London at the Slade School of Art and, later, by the example of American Precisionists such as Charles Sheeler, whose exacting and geometrically simplified depictions of modern architecture furthered her exploration of urban subjects.

Jack Shadbolt (1909–1998)

Transformations No. 5

1976; acrylic, latex commercial paint, black ink, pastel and charcoal on illustration board;
152.7 cm x 305.1 cm overall; panel: 152.7 cm x 101.7 cm each; National Gallery of Canada;
Gift of Carol M. Jutte, Vancouver, 1995; © Estate of Jack Shadbolt

Central to Jack Shadbolt's long and prolific career as an artist was his preoccupation with the cycles of nature, as both a metaphor and a symbol of human experience. In *Transformations No. 5*, Shadbolt converts the ethereal and diminutive butterfly into a monumental study of the cycle of life. "I saw the butterfly," he wrote in 1988, "as a powerful symbol of the natural and spiritual will to survive through change and transformation—a symbol all the more potent in contrast with the fragile and ephemeral beauty of its subject." With characteristic vigour, Shadbolt draws colossal butterfly shapes whose dizzying array of colours and patterns reverberates with vitality, blossoming forth in the young butterfly on the left, coming to exuberant maturity in the centre and, in the last, withering in the inevitable decline toward death. "I find the butterfly a tremendously erotic image," he said. "The cocoon is almost phallic, this tight-wrapped bar with the life inside it and the capacity for expanding and opening. Then suddenly, the flowering stage, the very unfolding is almost a sexual image in itself." For Shadbolt, the image of the butterfly was redolent with memories of chasing butterflies as a child, and it reflected his interest in the writings of novelist Vladimir Nabokov: "Reading Nabokov, with [his] superbly literate obsession with butterflies, stepped up my rumination about their enigmatic and symbolic overtones from blind enclosure to rapturous unfolding into release and flight."

Shadbolt was born in England and settled in Victoria, British Columbia, in 1912. In the late 1920s, he met Emily Carr, to whom he would pay homage in a series of works inspired by her view of West Coast forests. His studies at New York's Art Students League in the early 1930s and late 1940s consolidated his attraction to abstraction as well as to Surrealist-inspired automatism that would sustain his lifelong desire "to reconcile nature with abstraction and deliberation with intuition." He worked as a war artist and taught at the Vancouver School of Art, retiring in 1966 as one of its most influential and admired teachers.

Arthur Shilling (1941–1986)

Self-Portrait

c. 1975; oil on hardboard; 86.7 cm x 63.6 cm; McMichael Canadian Art Collection;
Purchase, 1975; © Estate of Arthur Shilling

Within a dazzling mosaic of colour, Arthur Shilling's gaze is still and unwavering, a centre of calm amidst the swiftly painted brush strokes that define his hair, shoulders and background. In contrast to many of his native contemporaries, who looked to ancestral art forms and legends as the subjects for their art, Shilling painted the people, particularly children and elders, from his birthplace on the Rama Indian Reserve, near Orillia, Ontario. In his 1986 posthumous publication *The Ojibway Dream*, Shilling wrote, "I try to reveal their spiritual soul, the quietness that makes us different, that no other nation or people have."

Shilling was born of Anishnaabe (Ojibwa) parents and was sent to a residential school in Brantford, Ontario, where he developed his drawing skills and later earned a scholarship to study at the Ontario College of Art. He sold his paintings rapidly in Toronto and achieved national acclaim following a solo exhibition in Ottawa in 1967, but health problems spurred his return to the reserve, where he resumed portrait painting in an innovative and expressive style. Although praised by a critic in *The Globe and Mail* as "a thoroughly independent spirit who happens to be Indian," Shilling insisted: "The Indian spirit, the Indian eye, is still free, uncontaminated. And that's what I am trying to maintain. My primary brush is Ojibway... My Indianness is deep within me."

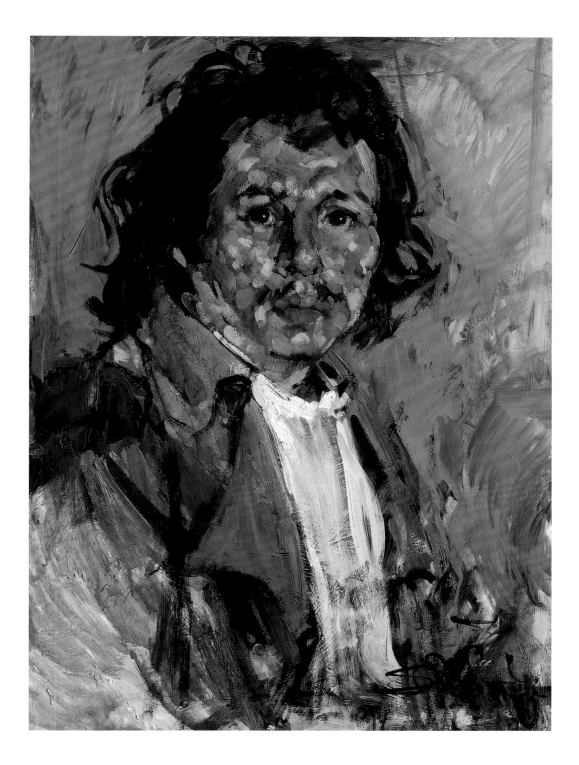

Gordon Smith (1919–)

WP 14

2002; acrylic on canvas; 172.5 cm x 212.5 cm; Equinox Gallery, Vancouver

In 2002, Vancouver artist Gordon Smith did a series of large winter landscape paintings focused on the pond in his garden, where tightly framed, upside down views of skies, looming trees, tangled branches, and leaves reflected the shimmering patterns of nature. Here in *WP 14*, the cool blue-white of the pond is divided by three wet, black trunks that descend from the golden brown grasses above. Like a stained-glass window, the pond is a mosaic of colour and line, where an intricate weave of branches and fallen leaves vibrate with energy and life. The dramatic close-cropping of the pond and shore suggests the zooming-in action of a camera (which the artist sometimes uses), and implies our close proximity to the subject. Hovering between the illusion of nature and the reality of the painted surface, the powerful brushwork, thick and thin, tight and loose, discloses Smith's acute understanding of the complex beauty and rhythms of nature. Interviewed in the 1960s while working in a predominantly abstract idiom, he made a statement that still holds true today: "Painting to me is an intuitive thing…My feeling and themes are always derived from nature, largely from the sea, the forest, the rocks, the trees, the natural things around."

Smith was born in England, moved to Canada in 1933, and first studied art with L.L. FitzGerald in Winnipeg. Later, he studied at the Vancouver School of Art, and after the war, with Jack Shadbolt and B.C Binning. From 1956 to 1982, he taught in the Department of Fine Art at the University of British Columbia. In 1996, Smith was appointed a Member of the Order of Canada for his achievements as an artist and his generous contributions as an educator.

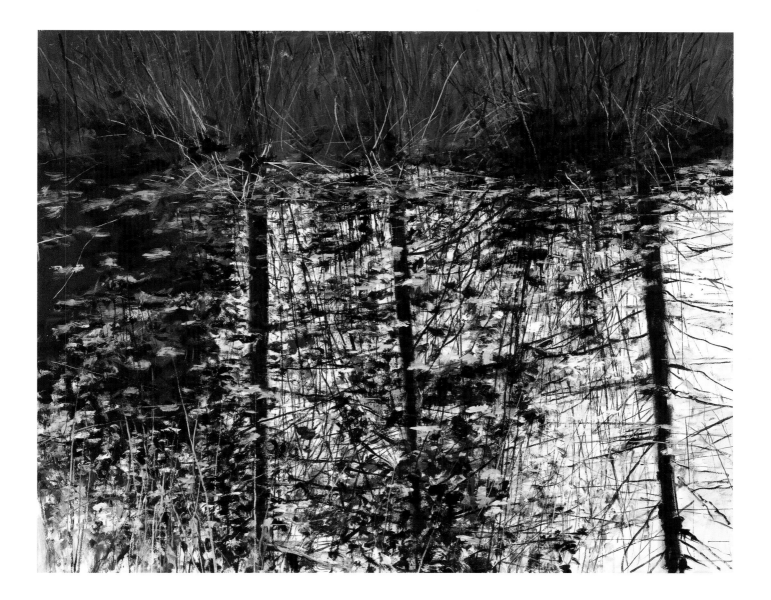

Jori Smith (1907–2005)

Sister of Vitaline

1952; oil on cardboard; 60.3 cm x 47.7 cm;
The Musée d'art contemporain de Montréal Collection; Gift of Dr. Max Stern;
Photo by Richard-Max Tremblay

The sister of Vitaline sits solemnly in the shadow of a large, colourful vase of flowers, whose ebullience is contrasted with her look of subdued concentration. Light falls softly on the child's rounded face, illuminating her white dress against the darkness that engulfs her. Painted with a spontaneity that echoes the freshness of the bouquet and the youthfulness of the subject, the loose brushwork and bold drawing animate the surface, revealing a vitality of spirit that reflects the artist's own.

After four years of traditional academic training at the École des beaux-arts in Montreal (1925–29), Jori Smith studied briefly with Randolph Hewton at the Art Association of Montreal and then privately with Edwin Holgate. Like Holgate, A.Y. Jackson and other artists, Smith was attracted to Quebec's Charlevoix region, where she was captivated by the rolling countryside and the character and kindness of the rural inhabitants. As did her friend Jean-Paul Lemieux, who pursued an anti-academic approach to the figure, Smith embraced a style inspired by European modernism as a means of evoking the personalities of these hardworking folk. She was particularly attracted to children as subjects, revealing in their demeanours —especially in the portraits of the 1930s—a gravity beyond their years. In 1939, Smith joined the Contemporary Arts Society, affirming her passion for a dynamic expression that she joyfully pursued into her nineties.

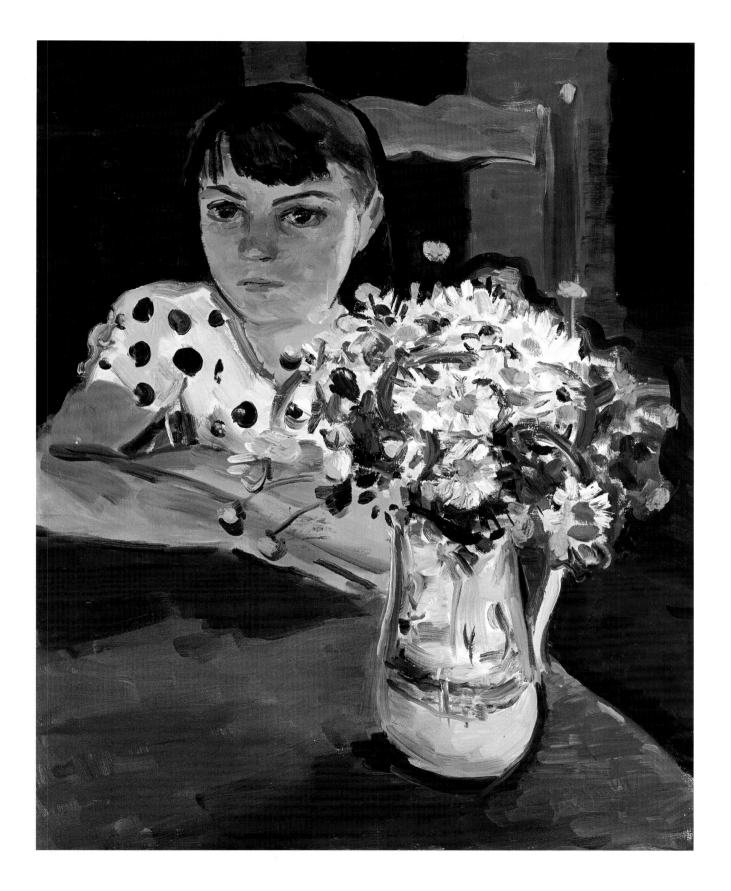

Michael Snow (1929–)

Clothed Woman (In Memory of My Father)

1963; oil and lucite on canvas; 152.0 cm x 386.2 cm; National Gallery of Canada; Purchased 1966;
© Michael Snow

*B*etween 1961 and 1967, Michael Snow produced almost 200 works using the silhouetted image of a walking woman, a cut-out figure that became a tool and a model for exploring relationships between figure and ground and for questioning the essence of visual experience. The "walking woman" was transformed in seemingly endless combinations and permutations, in two and three dimensions, cropped, painted, abstracted, sculpted, photographed and installed in public places, culminating in 11 stainless-steel sculptures for Expo 67. In *Clothed Woman (In Memory of My Father)*, seven silhouettes of the walking woman are made visible through contrasting warm and cool colours that selectively reveal different parts of her profile. These silhouettes suggest, like the sequential frames of a film, motion forward and the passing of time. The reference to his father in the title derives from the fact that Snow completed the painting on the day his father died in February 1963.

Painter, sculptor, printmaker, photographer, musician, and internationally celebrated for his innovative experimental films, Snow is a multidiscipline artist who has declared, "My paintings are done by a filmmaker, sculpture by a musician, films by a painter, music by a filmmaker, paintings by a sculptor…Also many of my paintings have been done by a painter… There is a tendency towards purity in all of these media as separate endeavours." Snow was born in Toronto and studied at the Ontario College of Art (1948-52). Attracted to the New York art scene in the 1950s and 1960s, he particularly admired Willem de Kooning's expressive portrayals of women that combined painting and collage. The recipient of countless awards, Snow was appointed an Officer of the Order of Canada in 1981.

Jeffrey Spalding (1951–)

Night Fall

1984; oil on canvas; 198 cm x 395 cm; National Gallery of Canada; Purchased 1985

The immense scale of this painting, which is almost four metres wide, engulfs the viewer and evokes the monumentality and threatening magnificence of one of the world's greatest natural wonders. The impenetrable silver-black mass of water cascades over the Niagara escarpment with tremendous force, issuing a grey mist that rises to obliterate the ebony sky. Along the curved rim of the eroded rock, an effervescent green defines the point of no return. Shrouded in the mystery of darkness, Jeffrey Spalding's *Night Fall* banishes the image of honeymoons and dreams and embraces the grave side of our imagination—disturbing and even nightmarish.

Spalding emigrated with his family from Scotland to Canada as a child. Following studies at Ohio State University and the Nova Scotia College of Art and Design, in Halifax, he pursued a conceptual approach to art, exploring colour theory and painting processes. In the late 1970s, his metaphoric paintings of domestic interiors were imbued with a psychological ambiguity that he extended to his paintings of nature. Here, he questions the relationship between culture and nature. Are the Falls a symbol of prodigious nature, unknowable, mighty, romantic and sublime? Or does the darkness of the image cast nature as endangered and ecologically vulnerable? While a single meaning will probably elude us, the hauntingly beautiful materiality of this painting endures.

Françoise Sullivan (1925–)

Tondo VIII

1980; acrylic and cord on canvas; 287 cm x 298 cm; Musée national des beaux-arts du Québec; 84.13; © SODART 2007; Photo by Pierre Charrier

Françoise Sullivan studied painting in Montreal at the École des beaux-arts. In the early 1940s, she became associated with Paul-Émile Borduas and other artists who would sign the 1948 *Refus global*, marking her opposition to academic tradition and a lifelong dedication to art forms inspired by the subconscious and inner emotion. Sullivan trained in dance in New York City with Franziska Boas. Later, her career as a dancer and choreographer permeated her explorations of visual art with a love of dynamic movement and circular form.

In the decades that followed, Sullivan produced metal sculptures, photography, collage and dance performances, and in the early 1980s, she returned to painting, intuitively coming upon the idea of cutting the canvas in a round shape, or tondo. In this first work in the tondo series, Sullivan threw the paint on the canvas, allowing the deep blue and green colours to gather and dry in the creases of the previously folded fabric, thus creating mysterious traces of her actions and expressing, as in dance, the artist's "own inner impulses and dynamisms." While the shape of the canvas and the allover painted surface allude to the world of myth and memory, evoking a cosmic symbolism of ritualistic circles and planets, the linearity of the knotted cord that falls to the floor grounds us in the material reality of the present. In her recent abstract work, Sullivan continues to assert the vital relevance of painting. In 2001, Sullivan was appointed a Member of the Order of Canada for her diverse contributions to Canadian art.

Marc-Aurèle de Foy Suzor-Coté (1869–1937)

Winter Landscape

1909; oil on canvas; 72.2 cm x 94.4 cm; National Gallery of Canada;
Gift of Arthur S. Hardy, Ottawa, 1943

Born in Arthabaska, in Quebec's Eastern Townships, Marc-Aurèle de Foy Suzor-Coté began his artistic career as a church decorator with Joseph-Thomas Rousseau in St-Hyacinthe. From 1891 to 1894, he made the first of many trips to Paris, where he learned a traditional academic approach to the figure at the École des beaux-arts, and from 1897 to 1901, he studied at the Académies Colarossi and Julian. The influence of French landscape painter Henri Harpignies was central to sensitizing his eye to the fleeting effects of light in winter landscapes. Although Suzor-Coté continued to travel extensively between Canada and different parts of Europe until 1912, he had, by 1907, resettled in his native village and had begun to paint the rural inhabitants and rolling landscape near the Nicolet and Gosselin Rivers, working in the style of the Impressionists, whose colourful, loosely brushed landscapes he had admired abroad. "Learn to see the beautiful in what surrounds you," he said, "and that should also be good for your soul."

In *Winter Landscape*, nature's most forbidding season is made inviting by the brilliant sunshine and azure-blue stream that snakes a sinewy path through fields of snow. The reflections of pinkish rocks along the shore cast dappled reflections in the water, enhancing the feeling of warmth already lent by the brightness of the day. Suzor-Coté's use of a palette knife to compress the thick texture of the oil paint makes us aware of the flatness of the canvas surface, while still achieving an illusion of depth. Inspired by the example of Norwegian artist Fritz Thaulow, whose paintings of snow-bordered rivers he had seen in Europe, Suzor-Coté continued to explore this theme in over 20 canvases that celebrate the changing harmonies of light as winter's ice and snow submit to the sun's radiance.

At the time of his death in 1937, a *Montreal Daily Star* critic wrote: "He was one of the most brilliant colourists North America has known, and his autumn scenes glowed with light, while as a painter of snow and the refractions of light in ice he was unequalled."

Gerald Tailfeathers (1925–1975)

Procession of the Holy Woman, Blood Sundance

1960; tempera on paper; 36.6 cm x 48.5 cm;
Collection of Glenbow Museum, Calgary, Canada; 60.45.5

On the sunlit plains, the Holy Women solemnly circle the ground on which the sacred dance pole and lodge will be constructed for the midsummer ceremonies of the Blackfoot Nation. The leader, shrouded in a red blanket—perhaps an allusion to the Blood tribe—carries a pole with sacred medicine bundles and is followed by a masked woman and three others gazing sombrely toward the ground. While the open landscape and distant tipis suggest the nomadic life of the past, the prominent display of the striped Hudson's Bay blankets denotes the impact of trade with the Europeans.

Bridging the artistic traditions of his native ancestors, who had painted on clothing, tipis and shields for personal and ritualistic use within tribal life, Gerald Tailfeathers learned a European style of painting and employed it to depict traditional native life. Born on the Standoff Blood Reserve in southern Alberta, Tailfeathers grew up listening to the elders' recollections of war, buffalo hunting and sacred ceremonies. His artistic talents were evident in his youth, and at the age of 16, Tailfeathers won a scholarship to the Banff School of Fine Arts, where he studied with Walter J. Phillips, H.G. Glyde and Charles Comfort. He was also influenced by 20th-century southern Plains painters and romantic depictions of the "Wild West" by American artist Charles Russell.

Joe Talirunili (1893–1976)

Hunters Who Went Adrift

1965; stonecut; 63.5 cm x 79.0 cm; Canadian Museum of Civilization, image #S99-10071

In Joe Talirunili's *Hunters Who Went Adrift*, the jagged edges of the stone on which the image was cut lend their shape to the print in a manner typical of stonecuts printed in Puvirnituq. Here, however, the island shape of the stone has special resonance due to a tragic episode in Talirunili's childhood, in which a group of families from his community was stranded on an ice pan. Talirunili's inscription tells us: "Families who went adrift used skins to make umiak [a large skin boat] and kayak [a single-person vessel], using rocks and materials of the land as fish weir, using Inuit methods of survival." The makeshift boats could barely contain their passengers, however, and most drowned in the frigid waters. Talirunili, then a babe in his mother's amautiq, never tired of retelling the tale through numerous prints and countless carvings of people in improvised boats. As was common in Puvirnituq, Talirunili often carved the print stone himself, and here, he presents a visual lexicon of the seasonal modes of transportation, shelter and animals pursued during his many years as a hunter.

Talirunili settled in Puvirnituq in the late 1950s and was one of the first Inuit artists to become involved in the printmaking co-operative that released its first edition in 1962. Despite an old bullet wound in his right arm, Talirunili was a prolific sculptor and published more than 70 stonecuts.

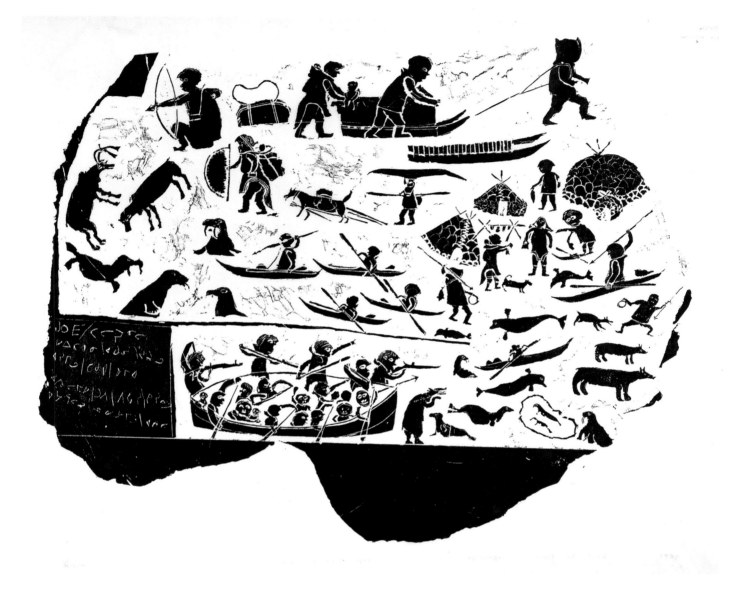

Takao Tanabe (1926–)

The Land #6

1974; acrylic wash on canvas; 84.0 cm x 142.5 cm; Collection of the Vancouver Art Gallery, Permanent Collection Fund VAG 74.40; Photo by Trevor Mills/Vancouver Art Gallery

In *The Land #6*, a ribbon of green earth lies tranquilly beneath the wide expanse of blue sky stretching beyond the frame to infinity, prompting feelings of peacefulness and eternity in the viewer. Far from the depiction of rugged Canadian landscapes popularized by the Group of Seven artists, Takao Tanabe focuses on the space and light of the prairies to create a visual poetry of silence and calm, an echo of the artist's own inner serenity.

Tanabe was born of Japanese parents in Prince Rupert, British Columbia, and began his studies at the Winnipeg School of Art (1946–49) after spending the war years in an internment camp. In 1951, he travelled to New York City, where he worked with Hans Hofmann and was introduced to abstract expressionists Philip Guston and Franz Kline. By the mid-1950s, Tanabe was producing abstract paintings of what he called "interior places." From 1959 to 1961, he studied art in Japan, learning calligraphy and the Japanese ink-wash technique of *sumi-e.* In the series of paintings called The Land, created in the early 1970s, geographical forms are reduced to their essentials and colour, and the brush strokes become increasingly refined. To achieve what art historian Nancy Dillow has called "a larger and metaphysical experience of space," Tanabe applied a thin black wash over the paintings' surfaces, which flattened the space, rendering it more cerebral and less optical. In 1999, Tanabe was named a Member of the Order of Canada for his singular contributions to Canadian Art.

David Thauberger (1948–)

Dance Hall

1980; acrylic and glitter on canvas; 114.9 cm x 172.7 cm;
Collection of the Mendel Art Gallery, Saskatoon; © David Thauberger

The yellow doors and window frames of Memorial Hall are luminous against the blue and red brick façade, where a lone poppy hangs beneath the sign. In contrast to the strict formality of the architecture, the dance hall is a place of dreams and romance, alluded to here in the artist's use of glitter, which lightly covers the surface of the painting like a dusting of magic. While the image is rooted in the local environment of Saskatchewan native David Thauberger, it is, at the same time, anonymous in the context of North American architecture. Like a vernacular icon, the image is static and mysterious.

In 1971, Thauberger graduated from the University of Saskatchewan, where he had studied with David Gilhooly, whose humorous ceramics of food and animals inspired his own study in ceramics at universities in California and Montana. The experience in California was seminal. "This was the first time I had seen so much contemporary art in my life," he said. Of particular influence were American pop artists such as Claes Oldenburg and Jim Dine and Californians William Wiley and Wayne Thiebaud, whose imaginative responses to the subjects of daily life catapulted Thauberger into painting. The candour of Saskatchewan folk art further consolidated his appreciation of local subjects rendered with a pristine geometry animated by lively colour and decorative surfaces.

Tom Thomson (1877–1917)

The Jack Pine

1916-1917; oil on canvas; 127.9 cm x 139.8 cm; National Gallery of Canada

Until 1913, Tom Thomson was employed as a graphic artist at Grip Limited in Toronto, where he befriended J.E.H. MacDonald and, later, other artists who would form the Group of Seven in 1920. Thomson made his first sketching trip to Algonquin Park in the summer of 1912, and then, with his compelling enthusiasm, encouraged the other artists to join him. Largely self-taught, Thomson painted nature spontaneously, combining his skills as a graphic artist with a bold sense of colour, to produce daringly simple but extremely powerful compositions. As A.Y. Jackson explained, "Not knowing all the conventional definitions of beauty, [Thomson] found it all beautiful...You are struck by the slightness of the motif that induced the painting...He gave us the fleeting moment, the mood, the haunting memory of things he felt."

The Jack Pine was painted in his "shack" behind the Studio Building in Toronto from a sketch made during an excursion to Little Cauchon Lake, in northeastern Algonquin Park, in the spring of 1916. Here, the lone tree outlined in red, stands majestically silhouetted against the setting sun. The rhythmic application of green, purple and pink enlivened with areas of yellow, in bold horizontal brush strokes, asserts the peacefulness of the sky, which is mirrored in the calm waters of the lake. In the distance, solemn blue hills form rounded shapes that are echoed in the organic tracery of the tree's green foliage, thus unifying the composition. The artistic promise of works such as this one was abruptly severed with Thomson's mysterious drowning in Canoe Lake in July 1917. The Group of Seven artists felt his loss deeply. As Jackson wrote, "Without Tom, the north country seems a desolation of bush and rock. He was the guide, the interpreter, and we the guests, partaking of his hospitality so generously given."

Joanne Tod (1953–)

The Time of Our Lives/Having Fun?

1984; oil on canvas; 199 cm x 199 cm each; National Gallery of Canada; Purchased 1985;
© Joanne Tod

*I*n *The Time of Our Lives/Having Fun?*, shrewd, colourful realism combines with large scale to produce paintings whose sensuous magnetism momentarily camouflages the critical edge of the contrasts between the "high" world of classical ballet and the "low" entertainment of popular culture. On the left, a ballet dancer en pointe enacts a prettified ritual of romantic pursuit. Smiling gleefully, she raises her arms in helpless delight as the male dancer effortlessly reels her in on a pink satin ribbon, gesturing with bravado. On the right, the toned brown body of the solitary night-club dancer turns away from us, facing her audience, assertively swinging her hips to the music. The proximity of the smiling blonde-haired woman elegantly attired in black contrasts strikingly with the dancer, while the mostly male onlookers display mixed reactions, from amusement to indifference.

Inspired by mass-media advertising, Joanne Tod presents a modern allegory questioning ideas of hierarchy, racism and consumerism in contemporary society. As she has said, "I want to acknowledge through my work that power relationships are interesting to examine but not necessarily to emulate...It is my intention to offer logical, though sometimes unorthodox, possibilities to the viewer as a critical analysis of the issues which affect society." A Montreal native, Tod graduated from the Ontario College of Art in 1974.

Robert Clow Todd (c. 1809–1866)

The Ice Cone, Montmorency Falls, Québec

c. 1840–1850; oil on canvas; 51.2 cm x 67.9 cm; Art Gallery of Ontario;
Purchase with the assistance of the Government of Canada through the Cultural Property
Export and Import Act, 1987; © 2007 Art Gallery of Ontario; Photo by Carlo Catenazzi/AGO

When the cold winter temperatures had frozen the rivers and brought snow to cover the ice cone of Montmorency Falls near Quebec City, those with leisure time flocked to the site to enjoy the play afforded by winter. Since the late 18th century, the Montmorency sugarloaf had been a favourite subject for artists, who were captivated as much by its pristine beauty as by the demand of the British garrison class for paintings depicting popular excursion spots.

This work is typical of the many versions of the subject by Robert Todd, an Englishman who immigrated to Canada in 1834. Serving as a backdrop to an array of seasonal activities, the path to the ice cone is sprinkled with assorted sleighs, dogs and groups of chatting spectators. The barren white foreground is dominated by the dark profile of a team of horses pulling an elegant sleigh driven by a man sitting on a lion's skin. Behind them, other sleighs wait, and to the left, one with prancing horses carries visitors closer to the frozen falls, where miniature figures frolic.

The attention to minute detail, the subtle tonal transitions and the overall precision with which this work was painted all attest to Todd's penchant for careful observation and to the meticulousness characteristic of his training as a decorative artist and sign painter. Research has shown that Todd painted backgrounds first, adding figures pertinent to the commission later.

Claude Tousignant (1932–)

Gong-88

1967; acrylic on canvas; Diam.: 223.5 cm; Art Gallery of Ontario;
Gift of the McLean Foundation, 1968; © Claude Tousignant, 2000

As early as 1959, Claude Tousignant was clear about his intentions: "What I want to do is to objectify painting, to bring it to its source, there where only painting remains...there where painting is only feeling." His journey toward a simplification of form with an emphasis on the dynamics of colour began when he studied with Gordon Webber at the School of Design in Montreal from 1948 to 1952. It continued throughout the 1950s, as he followed in the footsteps of the first Plasticiens, who sought a rational geometric approach to abstraction. By then, Tousignant was producing canvases of radical simplicity, sometimes with just two colours, flatly painted and divided by hard, clean edges.

In 1962, the work of American artist Barnett Newman convinced Tousignant of his mission to create art with a minimum of means. While the shape of the circle began to appear in his compositions of the early 1960s, only in 1965 did the painting itself become circular in format. Tousignant then embarked on a series of works resembling targets, composed of several concentric bands of colour resonating with optical dynamism. In *Gong-88*, we are dazzled by the optical vibrations of hot and cold colours that create a feeling of chromatic spinning, expanding and contracting much like the sounds of a gong reverberating from the centre with repetitions of varying intensities.

Harold Town (1924–1990)

Seaburst

1958; autographic print on paper; 59.9 cm x 48.5 cm; National Gallery of Canada no. 36163;
Gift of the Estate of Harold Barling Town, Toronto, 1991

In 1953, Harold Town joined with 10 other painters from his hometown of Toronto to organize the first exhibition of Painters Eleven, an expression of solidarity in support of abstract art by artists determined to fight Toronto's isolation from international modernism. In the same year, Town won worldwide acclaim for his innovative "single autographic prints," a series of monoprints (single and unique images) overprinted with a variety of colours and enhanced by collage, a technique that thematically and metaphorically would thread through his entire oeuvre.

In *Seaburst*, iridescent blues, greens and browns create an ethereal atmosphere where bold black shapes fan out from a wheel-like configuration at the top of the image. Other shapes scatter and descend, drawing our attention to the uneven edges of the limestone block from which the print was made. In keeping with the many hundreds of other single autographic prints produced by Town between 1953 and 1959, the image of *Sea Burst* evolved more from the process of its making than from a preconceived drawing or idea. Working intuitively, Town pressed flat materials such as pieces of paper or cardboard, felt, or even feathers onto the stone, allowing the compositions to take form.

Versatile and multi-talented, Town produced work that ranged from elegant drawings to boldly coloured abstract work, often employing an audacious use of collage. Throughout his diverse production of paintings, sculptures, portraits, murals, collages and illustrations, there was no linear progression or evolution but, rather, a constant fluctuation between subjects and media, as he pushed the limits of every theme and technique he confronted. Outspoken on a wide range of topics from sports to politics and art, Town was also a writer. "I paint to defy death," said Town.

Frederick H. Varley (1881–1969)

Vera

1931; oil on canvas; 61.0 cm x 50.6 cm; National Gallery of Canada;
Vincent Massey Bequest, 1968; © Estate of Kathleen G. McKay

Fred Varley, a native of Sheffield, England, studied at the Sheffield School of Art and in Antwerp, Belgium, before immigrating to Canada in 1912. Through Arthur Lismer, he found work at the commercial art companies of Grip Limited and later, Rous and Mann, where he met Tom Thomson and the artists who would subsequently form the Group of Seven. While he was excited by his first sketching trip to Algonquin Park with Thomson, Lismer and A.Y. Jackson, Varley did not immediately embrace landscape painting with the zeal of the others. In fact, he was more fixed on establishing his career as a portraitist. Following his time as a war artist in the First World War, he returned to Toronto and secured commissions from Vincent Massey and other members of the Toronto art establishment. Only during Varley's 10-year sojourn in Vancouver, where he moved in 1926 to accept a teaching position, did the magnificent coastal vistas inspire an exploration of landscape painting.

Although Varley's Vancouver years were fraught with financial difficulties, they were also a time of joy and artistic growth. His friendships with artist Jock Macdonald and photographer John Vanderpant deepened his interest in spiritual theories of creativity whose seeds had been sown earlier in Toronto through his contact with Lawren Harris. In the portrait *Vera*, Varley explores theories of colour associated with his interests in Eastern mysticism and his beliefs about the symbolic function of colour. Vera gazes from the canvas with a dreamy expression and a gentle smile, which are enhanced by the animated brushwork and imaginative use of colour. The blue-mauve palette on the left side gives way on the right to one that is darker and greener. In Varley's world, green and blue evoked spirituality, and pale violet, beauty. In using these colours to portray Vera, Varley expressed his feelings for his former student, and who was now an intimate and spiritual comrade. In 1936, he wrote, "The artist's job is to unlock fetters and release spirit, to tear to pieces and re-create so forcefully that...the imagination of the onlooker is awakened and completes within himself the work of art."

Zacharie Vincent (1815–1886)

Zacharie Vincent and His Son Cyprien

c. 1851; oil on canvas; 48.5 cm x 41.2 cm; Musée national des beaux-arts du Québec; 47.156;
Photo by Patrick Altman

Born in a Huron village near Loretteville, now Wendake, Quebec, Zacharie Vincent —also called Telari-o-lin (Huron for unmixed or undivided)— claimed to be the last pureblooded Huron. Here, he appears stern and stoic. Wearing an orange shirt decorated with trade silver and a wampum across his chest, he is accompanied by his young son Cyprien, who is dressed in complementary green. Both carry traditional native weapons—a tomahawk and a bow and arrow. Vincent is known to have painted about 12 self-portraits that document his ageing appearance. Among the earliest of these portraits, this one is distinguished by the simplicity of Vincent's dress and by the fact that it is the only work which includes Cyprien, the eldest of his four children. Although Vincent painted other scenes of traditional Huron life, such as camping, canoeing and snowshoe making, the self-portraits are by far his strongest work and were perhaps a way for him to perpetuate the image of his race in the face of the Huron's assimilation by European culture.

The occasion of having his portrait painted in 1838 by eminent Quebec artist Antoine Plamondon is believed to have inspired Vincent to take up the brush himself. His celebrity as the subject of Plamondon's prizewinning portrait was furthered two years later with the publication of the poem *The Last Huron* by the renowned Quebec poet François-Xavier Garneau.

Peter von Tiesenhausen (1959–)

Bow

1995; acrylic and oil on charred plywood; 56.5 cm x 90 cm;
Osler, Hoskin and Harcourt Collection; Courtesy of the artist

Peter von Tiesenhausen's decision to make a woven willow fence to keep his young sons from wandering into the forest on his Alberta farm led quite unpredictably to his weaving a 5.2-metre willow boat on his land, and in 1993, to *Ship*, which measures 33.5 metres. This was a seminal piece—regarded as both a sculpture and a drawing in nature, it liberated his approach to drawing and gave birth to a complex series of works in which the boat is constantly transformed by different materials and locations, and is sometimes burnt and charred as part of its journey in the life cycle. "Nature dictates the limitations and peculiarities of the materials. Wind and weather change the look and feel and even the meaning of the objects."

Von Tiesenhausen's works are made in collaboration with nature, weaving, for example, large pods and floating vessels to be hung from trees on his land, or elsewhere. In *Bow*, vibrant red and black lines describe the pointed fore-end of a boat, its vertical rib-branches radiating skyward as in *Ship*. Rich in symbolism, the colours evoke life and death, and the boat, unable to float in reality, invites a journey of the imagination. Over the surface of charred plywood, the application of blue paint suggests vitality, water and sky, and the horizontal line, the creation of deep space with the prospects of unknown destinations. Small scale in contrast to much of von Tiesenhausen's work, *Bow* nevertheless incorporates reference to the artist's most essential tools, the four basic elements: earth, air, fire and water.

Painter, sculptor, draughtsman and performance artist, von Tiesenhausen studied at the Alberta College of Art (1979-81), and has exhibited widely, nationally and internationally.

Horatio Walker (1858–1938)

Ploughing, the First Gleam at Dawn

1900; oil on canvas; 153.0 cm x 193.4 cm; Musée national des beaux-arts du Québec; 34.530; Conservation treatment by the Centre de conservation Québec; Photo by Patrick Altman

Horatio Walker's glorification of the hardships of agricultural life is made even more dramatic by the size of this painting, whose large scale overwhelms the viewer. We observe this scene as from a low vantage point, with the fields elevated above us and the yoke of oxen advancing like a dark primeval force as the young herdsman raises his stick. Behind, the farmer bends low to direct the plough. Creating an almost religious aura, the rising sun casts beautiful slivers of light on the heaving sides of the animals and along the curving back and legs of the boy. Silhouetted against the brightening sky, his open hand and commanding gesture are both ethereal and powerful in their masterful authority over nature.

At the turn of the 20th century, Walker was on his way to becoming the most celebrated Canadian-born painter of the time, and his work was well represented in American museum collections. Although he spent his winters in New York City, he summered on Île d'Orléans, east of Quebec City, where he continued to be enchanted by the daily rituals of the agricultural community. There, as he said, he tried "to paint the poetry, the easy joys and the hard daily work of rural life." His love for this subject was fuelled by the example of 19th-century French painter Jean-François Millet, whose sympathetic renderings of peasant life Walker greatly admired.

Esther Warkov (1941–)

Untitled (The Doll's Room)

1980–1981; oil on canvas; 183.3 cm x 198.5 cm; Collection of the Winnipeg Art Gallery;
Anonymous gift; Photo by Ernest Mayer/The Winnipeg Art Gallery

In *The Doll's Room*, the doll, animals and nature are rendered with a crisp realism that belies the dreamlike gathering. The doll herself is the giant hostess, while domestic, wild and exotic animals assemble in close proximity, staring out at us with indifference. Spatial incongruities abound in the juxtaposition of a deep background landscape, which also reappears through the open cupboards that harbour yet more animals. The three canvases provide an image that is simultaneously unified and divided, destabilizing the perception of space where the doll and sheep advance into our space. The red-brown palette, brightened by golden tones and off-whites, suggests an inner world through which the colours of external reality cannot penetrate.

"What I am really trying to do," explained Esther Warkov, "is create an interesting fantasy world of human emotions, which is something a lot of the Surrealists did, like Max Ernst, but a more gentle, human sort of thing." To devise her paintings, Warkov borrows from old books and magazines, presenting personal and collective "half-forgotten memories," perhaps alluding in *The Doll's Room* to lost innocence and an idyllic time when humanity lived in harmony with nature.

A native of Winnipeg, Warkov studied under Ivan Eyre at the University of Manitoba from 1958 to 1961 and, since then, has exhibited widely both nationally and internationally.

Homer Watson (1855–1936)

Before the Storm

1887; oil on canvas; 61.4 cm x 91.5 cm; Art Gallery of Windsor;
Memorial Bequest of Mr. and Mrs. G. Hudson Strickland, 1982, 1990

As purple-grey storm clouds roll forward and throw ominous shadows across the lush green land, three stray cows wander along a sun-bleached road, oblivious to the menacing skies overhead. In the left corner, a stick by the side of the road adds an element of suspense and suggests the quick departure of the cowherd. Homer Watson took pride in this work, as he wrote in a letter, "Have finished up that white road and dark sky affair, and it is my best so far."

A native of Doon, a village near Kitchener, Ontario, Watson was largely self-taught. In 1874, he studied briefly with John A. Fraser in Toronto and, in 1876, travelled to New York City. There, he admired the work of American artist George Inness, whose landscape paintings combined an attention to detail with a romantic feeling. Returning to Canada, Watson garnered instant fame in 1878 when his painting *The Pioneer Mill* was purchased as a gift for Queen Victoria. When Oscar Wilde visited Toronto in 1882, he dubbed Watson "the Canadian Constable"—a compliment that led Watson to spend three years in England in the late 1880s studying Britain's painters. This awareness would later compromise his originality. When Watson returned to Doon, however, he recognized that his homeland offered "ample material to fix, in some degree, the infinite beauties that emanate from the mysteries of land and sky."

Joyce Wieland (1931–1998)

Time Machine Series

1961; oil on canvas; 203.2 cm x 269.9 cm; Art Gallery of Ontario;
Gift from the McLean Foundation, 1966

I n Joyce Wieland's *Time Machine Series*, a large oval shape with a dark green centre—intensely red in its upper half, and more thinly painted in the lower half, floats in a vast blue-green sea. Multi-coloured organic shapes spiral out from its edges, and inside, small round shapes circle around the green centre. The image is ambiguous: Is this a giant view of a microscopic entity or an imaginary planet with mysterious growths? In light of the artist's comment that these thinly painted works which literally stained the canvas were "sex poetry," we begin to read the oval as an egg or a womb, and the perimeter shapes as swimming spermatozoa trying to infiltrate. The small circles within, like the stops on a clock or circling moons, chronicle the female cycle linking the woman's body and menstrual cycles to the time machine of the title. Although the joyous colour and large scale of this painting suggest a celebration of human reproduction, the artist was in fact lamenting her own infertility. While Wieland's exploration of pure abstraction was relatively short-lived, her forthright approach to male and female sexuality—along with her passionate nationalism and concern for the environment—endured throughout her career.

By the mid-1960s, while living in New York City, the multi-talented Wieland, already renowned as a painter, sculptor, printmaker and filmmaker, turned her hand to quilting, creating iconic works that commented on Canadian history and politics. In 1983, Wieland was made an Officer of the Order of Canada for her singular contribution to Canadian art.

Shirley Wiitasalo (1949–)

Park

1992; oil on canvas; 203.2 cm x 152.4 cm x 3.4 cm; National Gallery of Canada no. 37988;
Purchased 1995

*L*ike an urban Jack Pine, a loosely brushed solitary tree anchored by a crisply painted yellow square, stands silhouetted against a yellow-green sky, conjuring notions of acid rain rather than the pristine wilderness. The blurred, almost out-of-focus trees in the background combine with the yellow parking-space lines that seem to zoom into the painted space, and evoke a feeling of life and time rushing by. Soon, the tree, so prominent in daylight, will be cast into the darkness of night, and technology, in the form of the street lamp, will assume the limelight. While juxtapositions of nature and culture have pervaded the work of Toronto painter Shirley Wiitasalo for almost three decades, the manner in which she brings these dichotomies to the fore is ever-changing. According to the artist, the tree with its curious bent top inspired the inclusion of the street lamp not actually present in reality. The relationship between nature and technology is further explored in the background, where the post of the street lamp provides a trunk for the shadowy tree. While Wiitasalo makes us aware of the surface of the canvas by contrasting the confident gestural drawing with areas of diluted colour, she also convinces us of the illusion of nature holding tight on the edge of the modern world.

Wiitasalo studied at the Ontario College of Art and has exhibited widely nationally and internationally since the early 1970s. As a painter loyal to the medium through the difficult years of its declared death by critics, she has explored a wide variety of subject matter, frequently focusing on nature, but also on imagery from advertising and television.

Lawrence Paul Yuxweluptun (1957–)

Scorched Earth, Clear-Cut Logging on Native Sovereign Land, Shaman Coming to Fix

1991; acrylic on canvas; 195.6 cm x 275.0 cm; National Gallery of Canada; Purchased 1993

*I*n the foreground of a surreal wasteland, a red shaman with a desperate expression stands alongside severed logs and brandishes the image of an angry spirit to protest the annihilation of the land behind him. The shaman's grief pervades the painting. A masklike form on the beach emits tears, and in the distance, a blue figure riding the dinosaur's tail gazes at the sun, weeping in sympathy. Borrowing the shapes and curving lines of traditional West Coast art, Lawrence Paul Yuxweluptun uses acidic colour and distortion to create a landscape estranged and alienated from nature. The thin flatness of the forms evokes the dripping clocks of Salvador Dali's *The Persistence of Memory* and alludes to the artist's lament for a time past, before the exploitation of the land by industry.

"I am concerned with the colonial mentality that is directly responsible for the killing of wolves, buffalo [and] whales," said Yuxweluptun. "How do you paint a land claim?…Is it necessary to totally butcher all of this land?…All the money in the bank cannot buy or magically bring back a dead biosystem…Painting is a form of political activism, a way to exercise my inherent right, my right to authority, my freedom." Yuxweluptun was born in Kamloops, British Columbia, of parents whose ancestors were Okanagan and Coast Salish hunters and whose political advocacy was inspirational.

Tim Zuck (1947–)

Yukon

1994; oil on wood panel; 53 cm x 79 cm; McMichael Canadian Art Collection; Purchase, 1995

In Tim Zuck's paintings of figures, still lifes and landscapes, the subjects hover with a material reality, exuding a calm indifference to the chaos of life. They are typically centred in the middle of the canvas and meticulously rendered, their small formats affording a quiet majesty that transcends the ordinariness of their subject. In *Yukon*, Zuck distils the real-life experience of observing a floatplane land on the cool grey northern waters, posing its elegant red geometry against the open water and distant hills. The splashdown is hushed and controlled, causing a horizontal wave that is echoed in the thrust of the wings. Zuck's process is equally methodical: He took about 200 photographs of the airplane, realizing that time and weather would forbid a careful study of the moment.

Despite his devotion to the physical world, Zuck, a native of Erie, Pennsylvania, remains an abstract artist, focused on the formal qualities of objects. "I see life as extremely tenuous, though we all make believe that it's solid and reliable," he said. "I see art, along with humour and philosophy, as a window through which we can suddenly view the world in a different way. It questions the structures, it throws us for a loop, it challenges us, it provides no answer, and I like that."

Zuck studied at the Nova Scotia College of Art and Design, Halifax (1971) and at the California Institute of the Arts, in Valencia.

Glossary
Selected Art Terms and Movements

The artists cited below are *examples only* and do not represent an all-inclusive list of artists associated with the particular styles, groups or movements.

ABSTRACT EXPRESSIONISM: A manner of painting associated with abstract artists who worked in New York City in the 1940s and 1950s that explores gestural and geometric abstraction to express feelings, ideas and inner realities. These artists were also influenced by Surrealist theories of automatism and by the writings of Freud and his followers, both of which led to a visual expression of the subconscious. See: Bush, Luke, Ronald, Town

ABSTRACTION: A term that has several meanings depending on the degree to which the representation of an object is distanced from nature. It can be art that minimizes—abstracts, reduces, takes away— a reflection of the world as we see it, and it can also be art which is nonobjective, that is, art which has no relationship to objects in nature. It consists of a visual language that focuses on the elements of art (colour, line, shape and texture) for its expressive message.

ACADEMY: A term derived from Plato's Academy in Athens which came to be applied to art schools in 16th-century Italy—and, later, in France and throughout the rest of Europe—that provided art training based on the classical art of Greece and Rome. This training emphasized the methodical study of the human figure, from the plaster cast to the live model, nude and draped. State academies also upheld a hierarchy of subjects in art, esteeming historical, biblical and mythological subjects over portraits, landscapes, still lifes and genre paintings (scenes of everyday life). In Paris in 1795, the École des beaux-arts was established as the leader of official art schools, and it upheld the traditions of the earlier Académie royale de peinture et de sculpture, founded in 1648. The private academies, such as Julian and Colarossi, that were frequented by Canadian artists in the 19th century were informal art schools where students had access to models and benefited from the twice weekly criticism by resident senior artists.

AUTOMATISTES: A group of Montreal abstract artists active from the early 1940s to the early 1950s that was led by Paul-Émile Borduas. They subscribed to Surrealist theories of automatism, which led the artist to work "automatically," inspired by dreams and the subconscious. In 1948, they published their manifesto, *Refus global* (*Total Refusal*), a call for freedom of expression during the oppressive Church-dominated Duplessis regime. See: Barbeau, Borduas, Ferron, Leduc, Riopelle, Sullivan

BAROQUE: From the Italian *baròcco,* meaning irregular, a term generally used to describe a style of art that developed in Italy in the 17th century. In painting, it is usually characterized by extravagant gesture, dramatic lighting and a calculated theatricality designed to involve the emotions of the beholder. In sculpture and architecture, elaborate form is often balanced and symmetrical.

BEAVER HALL GROUP: A short-lived (1920–21) predominantly female group of artists who shared studio space on Beaver Square in Montreal. They were encouraged by A.Y. Jackson, who saw their aims as similar to those of the Group of Seven, and their works were included in many of the Group's shows, although, in fact, their strength was in figurative painting, particularly by the women artists. See: Coonan, Heward, Holgate, Newton, Savage

CANADIAN GROUP OF PAINTERS: The success and exclusive membership of the Group of Seven led to complaints by artists and the press that the larger Canadian art scene was not being recognized. After the opening of the last Group of Seven exhibition in 1931, A.Y. Jackson proposed that the Group of Seven should expand. Two years later, a wide representation of artists from across the country collaborated to form the first exhibition of the Canadian Group of Painters. Despite its acknowledgment of modern trends and of subjects other than landscape, this new group continued to bear the imprint of the Group of Seven. It disbanded in 1945. See: Brooker, Comfort, Humphrey, McKague Housser, McLaughlin, Schaefer

CLASSICISM: A term used in broad and diverse ways to refer to art influenced by the principles of design found in the art of ancient Greece and Rome, consisting generally of elegance, balance and restraint. Classicism can also refer to qualities of harmony and simplicity and can be applied to art completely independent of antique influences.

COLLAGE: From the French *coller,* meaning to glue or to paste, collage was first embraced by Georges Braque and Pablo Picasso in 1909 as a method by which real objects and assorted pieces of paper or materials were affixed to the surface of their Cubist artworks. See: Town

CONCEPTUAL ART: A type of art in which the idea or concept behind the work is more important than the work's visual aesthetics. It developed in the 1960s in the United States as a reaction against the excessive commercialization of the art world and was inspired by the innovations of French artist Marcel Duchamp, who in 1913 presented his "readymades"—mass-produced objects selected arbitrarily and displayed as art—declaring that if the artist deemed it art, then it was, by virtue of his decision.

CONTEMPORARY ARTS SOCIETY: Founded by John Lyman in 1939 as a means for bringing together young Montreal artists opposed to the conservatism in Canadian art and committed to modernist trends inspired by early-20th-century French painting. Members also objected to the domination of the Group of Seven. In 1938, Lyman wrote, "The real Canadian scene is in the consciousness of Canadian painters, whatever the object of their thought." See: Lyman, Pellan, Roberts, M. Scott

CUBISM: A revolutionary style of painting initiated by Georges Braque and Pablo Picasso, working together around 1908, in which they abandoned the traditional one-point perspective and rendered the three-dimensional forms of nature through a system of geometric shapes and planes that brought together different points of view simultaneously, thus creating a fragmented vision of nature. The term was first used in the press by French critic Louis Vauxcelles to describe a 1908 painting by Braque. See: Munn, Pellan, Town

DADA: From the French word for hobbyhorse, this was an anarchistic movement born from the despondency and disillusionment of European artists following the First World War. It was founded in Zurich in 1915 by a group of artists and writers who championed an irrational and nihilistic approach to art fuelled by accident and chance. Their aim was to shock and disturb. See: Curnoe

DIPTYCH: A picture comprising two parts featured side by side and sometimes hinged together. See: Tod

EXPRESSIONISM: A term used to describe the distortion or exaggeration of naturalistic form for the purposes of subjective, emotional expression. In a general sense, it can be used to identify the art of any period when the forms of nature have been disturbingly caricatured or overstated. It can also refer to the German movement that occurred from about 1905 to 1930, when artists used violent colours and aggressive

shapes to reflect the fear and anxiety resulting from political upheaval and social unrest. Expressionism was censored by the Nazis in 1933. See: Breeze

FAUVISM: A term meaning "wild beasts," assigned by French critic Louis Vauxcelles to describe works exhibited in Paris at the 1905 Salon d'automne, which featured paintings composed of a daring non-naturalistic use of colour and bold brushwork. Henri Matisse, its foremost proponent, insisted, "The chief aim of colour should be to serve expression as well as possible." As a movement, it was short-lived but influential, especially for the German expressionists.

GENRE PAINTING: An art-historical idiom used to describe works that feature scenes from everyday life, especially domestic subjects. See: Krieghoff, Kurelek

GROUP OF SEVEN: A group of Toronto-based artists who were devoted to the Canadian wilderness as their primary subject and who saw in it an expression of national spirit and identity. The members held their first exhibition at the Art Gallery of Toronto in 1920 and disbanded in 1931, expanding their membership later to form the Canadian Group of Painters. See: Carmichael, Casson, Harris, Jackson, Johnston, Lismer, MacDonald, Thomson, Varley

IMPRESSIONISM: A term assigned to the painting style of a group of highly individual French artists working after 1860. They generally preferred to paint *en plein air,* directly from nature, capturing the fleeting effects of light and colour. In their first exhibition, held in 1874, Claude Monet's painting *Impression— Sunrise* led journalist Louis Leroy to name the whole group "Impressionists." See: Cullen, McNicoll, Suzor-Coté

LUMINISM: A term used to describe mid-19th-century landscape painting, romantic in tone, that featured highly finished depictions of nature, focusing on the sublimity of light and space. See: L. O'Brien

NEOCLASSICISM: A style popular in late-18th- and early-19th-century European art that emulated the heroism and grandeur associated with ancient Greece and Rome. Although the style embraced considerable variation, it was generally characterized by a feeling of equilibrium, linear simplicity, grace and restrained, harmonious colouring. See: Berczy, Berthon, Plamondon

OP ART: An abbreviation of the term "Optical Art," it was a type of abstract art popular in the 1960s that featured exaggerated chromatic and linear contrasts, usually in geometric configurations, to create an optical experience of a pulsating or vibrating image and the illusion of movement on the surface of the canvas. See: Barbeau

PAINTERS ELEVEN: A group of 11 Toronto artists devoted to abstract art who gathered together in 1953 and held their first exhibition under the name of Painters Eleven in 1954. Despite their personal clashes and fragmented, highly individual approaches to abstraction, the members continued to exhibit together until 1960, by which time they had accomplished their aim to create recognition and respect for abstract art in Toronto. See: Bush, Luke, Macdonald, Ronald, Town

PLASTICIENS: A group of four Montreal abstract artists (Rodolphe de Repentigny, Louis Belzile, Jean-Paul Jérôme and Fernand Toupin) who, in 1955, issued their manifesto declaring their allegiance to a rational approach to abstraction inspired by the geometric purity of the work of Piet Mondrian. These artists were important precursors of younger artists such as Gaucher, Molinari and Tousignant.

POP ART: A term used by British art critic Lawrence Alloway to describe an art movement inspired by advertising and popular culture that flourished in Britain in the mid-1950s and in the United States in the 1960s. As a reaction to the inwardness and her-

metic individualism of the abstract expressionists, pop artists embraced representational imagery inspired by consumer culture and mass media. See: Breeze, Curnoe, Thauberger

POST-IMPRESSIONISM: A term introduced by British art critic Roger Fry to describe the work of such artists as Cézanne, Gauguin and Van Gogh, who came after the Impressionists and who transformed the loose, light-filled brush stroke into more formally structured and expressive painting. See: Morrice

PRECISIONISM: A movement in American painting that began around 1915 and continued throughout the 1920s, in which smooth lines, geometric shapes, clear, bright colours and a refined, precise technique were used to render an idealized view of the urban and industrial landscape. See: FitzGerald, M. Scott

PRISME D'YEUX: In early 1948 and in opposition to Paul-Émile Borduas' interpretation of automatism, as well as his domination of the Contemporary Arts Society, Alfred Pellan and other artists broke away from the group and formed Prisme d'yeux (Prism of the Eyes). In their manifesto, they declared their aim to "seek a painting liberated from all contingencies of time and place, from all restrictive ideology." See: Bellefleur, Pellan, Roberts

PROFESSIONAL NATIVE INDIAN ARTISTS INCORPO-RATED: A group of seven native artists, including Daphne Odjig, Alex Janvier and others, who were displeased with the federal government's efforts to promote native art. In 1974, they founded a formal organization in an effort to develop a marketing and exhibiting plan involving established galleries and to encourage art and art scholarships in the native communities. By 1975, the group had disbanded. See: Janvier, Odjig

REALISM: A term used generally to imply fidelity to the world of appearances, incorporating an intention to depict objects accurately and objectively.

REFUS GLOBAL: A manifesto inspired by the liberal attitudes of Surrealism and automatism and signed in 1948 by Paul-Émile Borduas and fellow artists to protest the artistic, political and social oppression in postwar Quebec society. They called for a "resplendent anarchy" exemplified by their emotionally charged abstract paintings. See: Barbeau, Borduas, Ferron, Leduc, Riopelle, Sullivan

REGINA FIVE: A name given to the five abstract artists affiliated with the University of Saskatchewan, Regina, who participated in the so-named 1961 exhibition circulated by the National Gallery of Canada. Diverse in their backgrounds and philosophies, they shared an interest in strong central images and allover compositions and were encouraged in their artistic endeavours by American Barnett Newman, who led the Emma Lake workshop in 1959. See: Bloore

ROMANTICISM: A movement that developed in Europe in the late 18th and early 19th centuries whose chief proponents were J.M.W. Turner in England and Delacroix and Géricault in France. In contrast to the structure and restraint in the work of their earlier neoclassical predecessors, they used colour and light for dramatic and emotional effects. See: Field, L. O'Brien

ROYAL CANADIAN ACADEMY OF ARTS: In Ottawa, in March 1880, the Marquis of Lorne, then Governor General of Canada, presided over the first exhibition of the Royal Canadian Academy of Arts. Seeking to create a foundation upon which the arts in Canada would flourish, the Marquis also recommended that the artists who were elected to the new Academy should donate a work which would establish a collection for the National Gallery of Canada, also founded that year. The first president of the Academy was

Lucius O'Brien. Artists continued to donate diploma works until 1976. See: Comfort, O'Brien, Schreiber

SURREALISM: In 1924, French poet André Breton issued his Surrealist manifesto proposing that the source of artistic inspiration lay in the subconscious and dreams. For the circle of Canadian writers and artists around Paul-Émile Borduas, this highly influential document led to an exploration of Surrealism, described by Breton as "pure psychic automatism, by which it is intended to express verbally, in writing or in any other way, the true process of thought... free from the exercise of reason and every aesthetic or moral preoccupation." See: Borduas, Pellan

TRIPTYCH: A picture or carving comprising three parts featured side by side and sometimes hinged together, designed so that the two lateral elements fold over to cover the central one. This format was often used in Europe in medieval times for portable altarpieces. See: Cardinal-Schubert, Falk

TROMPE L'OEIL: A French term meaning "to trick or fool the eye," used in reference to carefully painted depictions of objects whose fidelity to detail leads viewers to believe that they are looking at an actual object rather than an illusion.

Further Reading

CANADIAN ART

General

Béland, Mario, ed., *Painting in Quebec, 1820–1850: New Views, New Perspectives,* Musée du Québec, Quebec, 1992.

Bell, Michael, *Image of Canada,* Public Archives of Canada, Ottawa, 1972.

———, *Painters in a New Land,* McClelland & Stewart, Toronto, 1973.

Harper, J. Russell, *Early Painters and Engravers in Canada,* University of Toronto Press, Toronto, 1970.

———, *Painting in Canada: A History*, 2nd ed., University of Toronto Press, Toronto, 1977.

Hill, Charles C., *Canadian Painting in the Thirties*, National Gallery of Canada, Ottawa, 1975.

———, *The Group of Seven: Art for a Nation,* National Gallery of Canada, Ottawa, 1995.

Lord, Barry, *The History of Painting in Canada: Toward a People's Art,* NC Press, Toronto, 1974.

Reid, Dennis, *A Concise History of Canadian Painting,* Oxford University Press, Toronto, 1973.

———, *"Our Own Country Canada," Being an Account of the National Aspirations of the Principal Landscape Artists in Montreal and Toronto, 1860–90,* National Gallery of Canada, Ottawa, 1979.

Villeneuve, René, *Baroque to Neoclassical: Sculpture in Quebec,* National Gallery of Canada, Ottawa, 1997.

Canadian Women Artists

Farr, Dorothy, and Natalie Luckyj, *From Women's Eyes: Women Painters in Canada*, Agnes Etherington Art Centre, Kingston, Ontario, 1975.

Graham, Mayo, *Some Canadian Women Artists,* National Gallery of Canada, Ottawa, 1975.

Luckyj, Natalie, *Visions and Victories: 10 Canadian Women Artists, 1914–1945,* London Regional Art Gallery, London, Ontario, 1983.

Tippett, Maria, *By a Lady: Celebrating Three Centuries of Art by Canadian Women,* Penguin, Toronto, 1992.

MODERN AND CONTEMPORARY ART

Bradley, Jessica, and Diana Nemiroff, *Songs of Experience,* National Gallery of Canada, Ottawa, 1986.

Burnett, David, and Marilyn Schiff, *Contemporary Canadian Art,* Hurtig, Edmonton, 1983.

Davis, Ann, *Frontiers of Our Dreams: Quebec Painting in the 1940s and 1950s,* Winnipeg Art Gallery, Winnipeg, 1979.

Ellenwood, Ray, *Egregore: A History of the Montreal Automatist Movement,* Exile Editions, Toronto, 1992.

Fenton, Terry, and Karen Wilkin, *Modern Painting in Canada,* Hurtig, Edmonton, 1978.

Five Painters from Regina, National Gallery of Canada, Ottawa, 1961.

Leclerc, Denise, *The Crisis of Abstraction in Canada: The 1950s,* National Gallery of Canada, Ottawa, 1993.

————, *The Sixties in Canada,* National Gallery of Canada, Ottawa, 2005.

Nemiroff, Diana, *Canadian Biennial of Contemporary Art,* National Gallery of Canada, Ottawa, 1989.

Pluralities/1980/Pluralités, National Gallery of Canada, Ottawa, 1980.

Pontbriand, Chantal, *The Historical Ruse: Art in Montreal,* The Power Plant, Toronto, 1988.

Varley, Christopher, *The Contemporary Arts Society, Montreal, 1939–1948,* Edmonton Art Gallery, Edmonton, 1980.

Visions: Contemporary Art in Canada, Douglas & McIntyre, Vancouver, 1983.

INUIT ART

Historical, Modern and Contemporary

Blodgett, Jean, *The Coming and Going of the Shaman: Eskimo Shamanism and Art,* Winnipeg Art Gallery, Winnipeg, 1979.

————, *Eskimo Narrative,* Winnipeg Art Gallery, Winnipeg, 1979.

————, *Grasp Tight the Old Ways: Selections from the Klamer Family Collection of Inuit Art,* Art Gallery of Ontario, Toronto, 1983.

Driscoll, Bernadette, *The Inuit Amautiq: I Like My Hood To Be Full,* Winnipeg Art Gallery, Winnipeg, 1980.

————, *Uumajut: Animal Imagery in Inuit Art,* Winnipeg Art Gallery, Winnipeg, 1985.

"The Eskimo World," artscanada, December/January 1971/1972, vol. 28, no. 6.

Hessel, Ingo, *Inuit Art: An Introduction,* Douglas & McIntyre, Vancouver, 1998.

Houston, Alma, ed., *Inuit Art: An Anthology,* Watson & Dwyer, Winnipeg, 1988.

In the Shadow of the Sun: Perspectives on Contemporary Native Art, Canadian Museum of Civilization, Hull, 1993.

The Inuit Print, National Museum of Man, Ottawa, 1977.

Jackson, Marion, and Judith Nasby, *Contemporary Inuit Drawings,* Macdonald Stewart Art Centre, Guelph, Ontario, 1987.

Leroux, Odette, Marion E. Jackson and Minnie Aodla Freeman, eds., *Inuit Women Artists: Voices from Cape Dorset,* Chronicle Books, San Francisco, 1996.

Routledge, Marie, *Inuit Art in the 1970s,* Agnes Etherington Art Centre, Kingston, Ontario, 1979.

Seidelman, Harold, and James Turner, *The Inuit Imagination,* Douglas & McIntyre, Vancouver, 1993.

Wight, Darlene, *The First Passionate Collector: The Ian Lindsay Collection of Inuit Art,* Winnipeg Art Gallery, Winnipeg, 1991.

Zepp, Norman, *Pure Vision: The Keewatin Spirit,* Norman MacKenzie Art Gallery, Regina, 1986.

NATIVE ART

Historical, Modern and Contemporary

Berlo, Janet C., and Ruth B. Phillips, *Native North American Art,* Oxford University Press, New York, 1998.

Brownstone, Arni, *War Paint: Blackfoot and Sarcee Painted Buffalo Robes in the Royal Ontario Museum,* Royal Ontario Museum, Toronto, 1993.

Holm, Bill, *The Box of Daylight: Northwest Coast Indian Art,* Seattle Art Museum and University of Washington Press, Seattle, 1984.

In the Shadow of the Sun: Perspectives on Contemporary Native Art, Canadian Museum of Civilization, Hull, 1993.

McLuhan, Elizabeth, and Tom Hill, *Norval Morrisseau and the Emergence of the Image Makers,* Methuen, Toronto, 1984.

McMaster, Gerald, and Lee-Ann Martin, eds., *Indigena: Contemporary Native Perspectives,* Douglas & McIntyre, Vancouver, 1992.

Nemiroff, Diana, Robert Houle and Charlotte Townsend-Gault, *Land Spirit Power: First Nations at the National Gallery of Canada,* National Gallery of Canada, Ottawa, 1992.

Taylor, Colin F., *Buckskin and Buffalo: The Artistry of the Plains Indians,* Rizzoli, New York, 1998.

Museums and Galleries

Public Sources for *Canadian Paintings, Prints and Drawings*

Art Gallery of Alberta
2 Sir Winston Churchill Square
Edmonton, AB T5J 2C1
Telephone: 780-422-6223
www.artgalleryalberta.com

Art Gallery of Greater Victoria
1040 Moss Street
Victoria, BC V8V 4P1
Telephone: 250-384-4101
www.aggv.bc.ca

Art Gallery of Hamilton
123 King Street W
Hamilton, ON L8P 4S8
Telephone: 905-527-6610
www.artgalleryofhamilton.on.ca

Art Gallery of Nova Scotia
1723 Hollis Street
Box 2262
Halifax, NS B3J 3C8
Telephone: 902-424-7542
www.agns.gov.ns.ca

Art Gallery of Ontario
317 Dundas Street W
Toronto, ON M5T 1G4
Telephone: 1-877-225-4246
www.ago.net

Art Gallery of Windsor
Devonshire Mall
3100 Howard Avenue
Windsor, ON N8X 3Y8
Telephone: 519-977-0013
www.artgalleryofwindsor.com

Beaverbrook Art Gallery
703 Queen Street
Box 605
Fredericton, NB E3B 5A6
Telephone: 506-458-8545
www.beaverbrookartgallery.org

Canadian Museum of Civilization
100 rue Laurier, CP 3100
succursale B
Hull, QC J8X 4H2
Telephone: 1-800-555-5621
www.civilization.ca

Canadian War Museum
1 Vimy Place
Ottawa, ON K1R 1C2
Telephone: 819-776-8600
www.civilization.ca

Glenbow Museum
130–9th Avenue SE
Calgary, AB T2G 0P3
Telephone: 403-268-4100
www.glenbow.org

Indian Art Centre
10 Wellington, Room 928
Hull, ON J8X 4B3
Telephone: 1-800-867-1684
www.ainc-inac.gc.ca/art/
 art/index_e.html

Justina M. Barnicke Gallery
Hart House
University of Toronto
7 Hart House Circle
Toronto, ON M5S 3H3
Telephone: 416-978-2453
www.arts.utoronto.ca/Galleries/Justina
 _M___Barnicke_Gallery.htm

Leonard & Bina Ellen Art Gallery
Concordia University
1400 boul. de Maisonneuve W
Montreal, QC H3G 1M8
Telephone: 514-848-2424 ext. 4750
www.ellengallery.concordia.ca

Library and Archives of Canada
395 Wellington Street
Ottawa, ON K1A 0N4
Telephone: 1-866-578-7777
www.collectionscanada.ca

London Regional Art and Historical
Museums
412 Ridout Street N
London, ON N6A 5H4
Telephone: 519-661-0333
www.londonmuseum.on.ca

MacKenzie Art Gallery
3475 Albert Street
Regina, SK S4S 6X6
Telephone: 306-584-4250
www.mackenzieartgallery.sk.ca

McCord Museum of Canadian History
690 Sherbrooke Street W
Montreal, QC H3A 1E9
514-398-7100
www.mccord-museum.qc.ca

McMaster Museum of Art
Alvin A. Lee Building
University Avenue
McMaster University
1280 Main Street W
Hamilton, ON L8S 4L6
Telephone: 905-525-9140 ext. 23081
www.mcmaster.ca/museum

McMichael Canadian Art Collection
10365 Islington Avenue
Kleinburg, ON L0J 1C0
Telephone: 1-888-213-1121
www.mcmichael.com

Mendel Art Gallery and Civic
Conservatory
950 Spadina Crescent E
Box 569
Saskatoon, SK S7K 3L6
Telephone: 306-975-7670
www.mendel.ca

Montreal Museum of Fine Arts
P.O. Box 3000, Station H
Montreal, QC H3G 2T9
Telephone: 514-285-2000
www.mmfa.qc.ca

Musée d'art contemporain de
Montréal
185, rue Ste-Catherine Ouest
Montreal, QC H2K 3X5
Telephone: 514-847-6226
www.macm.org

Musée des beaux arts du Québec
Parc des Champs-de-Bataille
Quebec, QC G1R 5H3
Telephone: 1-866-220-2150
www.mnba.qc.ca

Musée des Ursulines de Québec
12, rue Donnacona
Quebec, QC G1R 3Y7
Telephone: 418-694-0694
www.museocapitale.qc.ca

National Gallery of Canada
Box 427, Station A
380 Sussex Drive
Ottawa, ON K1N 9N4
Telephone: 1-800-319-2787
www.gallery.ca

The Rooms Provincial Art Gallery
9 Bonaventure Avenue
P.O. Box 1800, Station C
St. John's, NL A1C 5P9
Telephone: 709-757-8040
www.therooms.ca/artgallery

Royal British Columbia Museum
675 Belleville Street
Victoria, BC V8W 9W2
Telephone: 1-888-447-7977
www.royalbcmuseum.bc.ca

Royal Ontario Museum
100 Queen's Park
Toronto, ON M5S 2C6
Telephone: 416-586-8000
www.rom.on.ca

Vancouver Art Gallery
750 Hornby Street
Vancouver, BC V6Z 2H7
Telephone: 604-662-4700
www.vanartgallery.bc.ca

Winnipeg Art Gallery
300 Memorial Boulevard
Winnipeg, MB R3C 1V1
Telephone: 204-786-6641
www.wag.mb.ca

Title Index

361

General Index

Numbers in bold refer to the main entry for each artist.